Photography
OUTDOORS

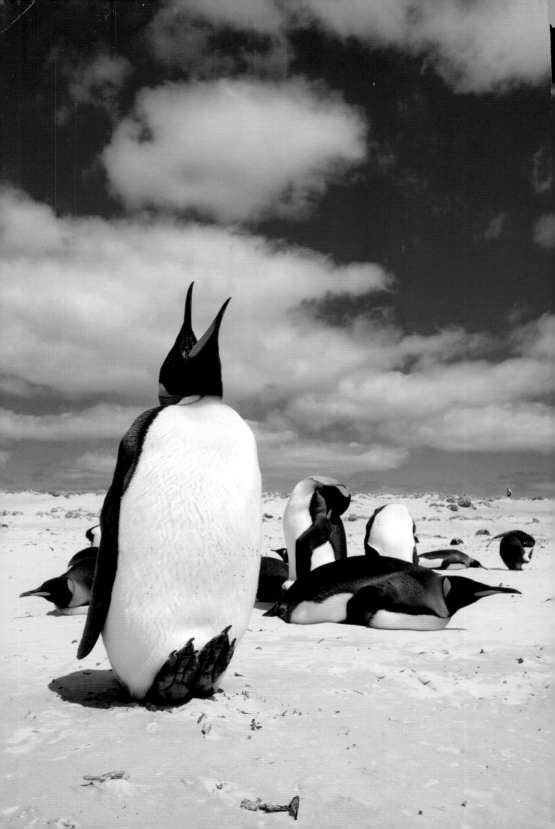

Photography
OUTDOORS

Third Edition

A Field Guide
for Travel and
Adventure
Photographers

JAMES MARTIN

**MOUNTAINEERS
BOOKS**

Mountaineers Books is the publishing division of The Mountaineers, an organization founded in 1906 and dedicated to the exploration, preservation, and enjoyment of outdoor and wilderness areas.

MOUNTAINEERS BOOKS

1001 SW Klickitat Way, Suite 201 • Seattle, WA 98134
800.553.4453 • www.mountaineersbooks.org,

Printed in China

Distributed in the United Kingdom by Cordee, www.cordee.co.uk

First edition, 2004. Second edition, 2007. Third edition, 2014.

Copy editor: Heath Lynn Silberfeld / enough said
Cover design and layout: Peggy Egerdahl
All photographs by the author unless otherwise noted.
Cover photograph: *Mount Garibaldi and Garibaldi Lake, from Panorama Ridge, British Columbia*
Frontispiece: *A king penguin wakes from a nap.*

Library of Congress Cataloging-in-Publication Data
Martin, James, 1950-
 [Digital photography outdoors]
 Photography outdoors : a field guide for travel and adventure photographers / James Martin.–Third edition.
 pages cm
 Revised edition of Digital photography outdoors / James Martin. 2007.
 Includes index.
 ISBN 978-1-59485-780-5 (pbk.)
 1. Outdoor photography. 2. Photography–Digital techniques. I. Title.
 TR659.5.M27 2014
 778.7'1–dc23
 2013033486

ISBN (paperback): 978-1-59485-780-5
ISBN (ebook): 978-1-59485-781-2

CONTENTS

FOREWORD

I met Jim Martin during a busman's holiday that Joe Van Os had arranged for his Photo Safari trip leaders, a weekend of photographing captive hawks, eagles, and owls in Colorado. I was shooting medium-format film, which delivers much greater resolution and richness than 35mm slide film. Medium format demands patience and care. Motor drives, when they are available, are slow, and even changing film takes more time. I often lose photo opportunities, especially with wildlife photography, but the impact of a magical moment caught on medium format more than makes up for the trouble. Unlike the rest of the trip leaders, Jim also shot medium format, so I suspected I had encountered a sympathetic soul.

My suspicions proved correct. Jim also sought the highest possible quality and went to great lengths to attain it. At the time he was working on a photo book about the North Cascades crest, carrying camping and climbing gear plus an assortment of medium-format camera equipment into high mountains. He crisscrossed trail-less terrain and camped on mountaintops over several summers to get the images he had in mind.

Over the years we traveled together to Africa and the Galápagos. When Jim visited my studio, I showed him my early work in Photoshop. I fed high-resolution scans into a computer before enhancing my photographs or creating fanciful images. (I think I can take credit for planting the notion of digital's potential in his mind in the early 1990s.)

On our trips, the conversation turned inevitably to photographic styles and techniques: improving image quality, innovative compositional styles, and the likely future of the medium. Both of us enjoy pushing the limits of our photographic visions, and our creative energy has always been stimulating and inspiring for each other.

In *Photography: Outdoors* I see that same passion for creating the best-quality image, both technically and artistically. This book reviews the essential precepts that digital and film photography share and then outlines the steps needed to draw the best out of digital while avoiding catastrophic errors. It's easy to send all those zeros and ones into the ozone with a misplaced keystroke, so heed the warnings scattered throughout this book. If you take Jim's lessons to heart, not only will your photography improve but your files will be waiting for you where you left them, undamaged and properly cataloged. I consider the information contained in the following pages essential to getting the most out of your digital equipment as well as expanding your ability to create beautiful images.

Jim Zuckerman

Jim Zuckerman is a noted travel and stock photographer and the author of several books on photography, including Perfect Exposure: Jim Zuckerman's Secrets to Great Photographs *and* Jim Zuckerman's Secrets of Color in Photography. *He teaches online classes for www.betterphoto.com.*

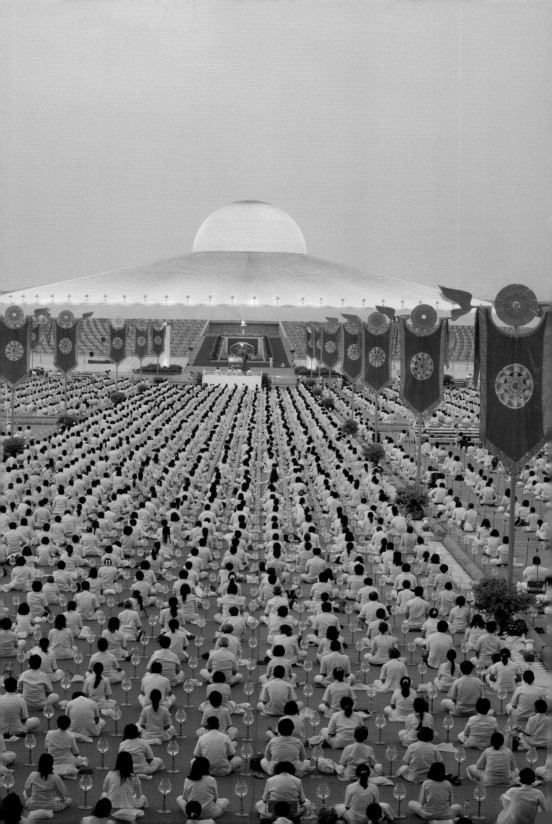

ACKNOWLEDGMENTS

I owe thanks to Scott Stulberg for reviewing the original manuscript, keeping me abreast of the latest whiz-bang features in Photoshop and its attendant plug-ins, and, most of all, encouraging me to take the plunge into the digital ocean. Jim Zuckerman introduced me to digital editing at the dawn of Photoshop and opened my eyes to the possibilities. Without Art Wolfe's generous instruction, my photography would be weaker than it is and my storehouse of practical jokes and puns would be smaller. I reserve my greatest appreciation for my wife, Terrie, who puts up with a husband who spends an inordinate amount of time amusing himself—and even encourages him.

Opposite: *Ceremony celebrating Magha Puja at Wat Phra Dhammakaya, Thailand*

INTRODUCTION

When I was in high school, I used to hitchhike to Yosemite on weekends. I often saw Ansel Adams at work, unloading his car in front of Best Studios (now the Ansel Adams Gallery) or leading workshops. I eavesdropped on the workshops, trying to pick up tips. He saw me lurking but only smiled. His explanations of the Zone System could have been in Phoenician for all the good they did me, but I could follow his comments on light and composition. I tried to apply his lessons when I shot photographs in the mountains, and his principles informed my shooting, but I had no patience for darkroom work. A small, dark cubicle was the last place I wanted to spend my time. Since black-and-white photography requires facility in the darkroom, I drifted into color photography.

Years later, a magazine assignment for the Smithsonian Institution sent me to Africa with Art Wolfe, one of the world's most prominent nature photographers. While we worked, he taught me the basics of his approach, and his instruction became the basis for my future shooting. Joining the crew at Joseph Van Os Photo Safaris brought me in contact with a diverse group of nature photographers, including John Shaw and Jim Zuckerman. While they agreed on the basics of photography, each employed a different way of seeing and working. World-renowned alpine climber Mark Twight introduced me to alternative films, processes, and perspectives.

GOING DIGITAL: THE EARLY YEARS

In the early 1990s, I visited Jim Zuckerman's office. He scanned his 6x7-inch transparencies and then loaded these files onto two Macintosh Quadra computers connected to a stack of hard drives. Any command took a long time to execute. Rotating an image, which takes a fraction of a second these days, consumed about a minute. The system frequently crashed. Jim possesses a large measure of patience and determination, evidenced by the large number of manipulated images he had created. I was intrigued, but the expense (his collection of electronics totaled tens of thousands of dollars) and laborious demands of using early versions of Adobe Photoshop put me off. Even so, the magic Jim had produced attracted me.

In the years since, Photoshop was improved, low-resolution digital cameras appeared, computers became quicker and cheaper, and scanner prices fell. The shape of the future was becoming clear. I bought a scanner so I could enter the digital world while I waited for digital cameras to improve sufficiently for professional work. I played with a Nikon "prosumer" model (a high-resolution point-and-shoot camera) to get acquainted with digital capture. When the Canon 1Ds digital camera body cracked the 30-megabyte file-size barrier, I jumped in—and I haven't shot a frame of film since.

For years, professional outdoor photographers resisted the inevitable switch from film to digital. In addition to experiencing anxiety in response

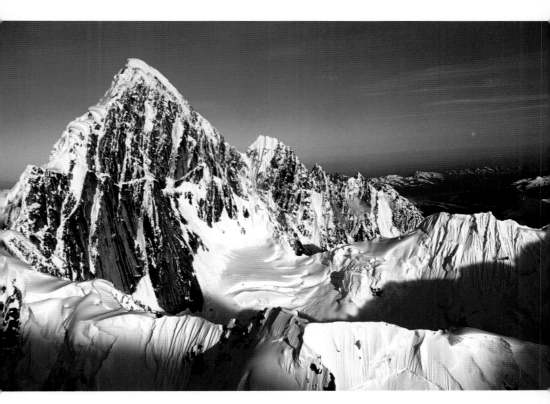

An aerial photograph of Mount Huntington in the Alaska Range

to the unfamiliar, they held back because digital couldn't deliver acceptable quality and performance. A lag between tripping the shutter and exposing the shot led to missed opportunities, which disqualified digital for shooting action. Long exposures in low light produced "noise"—digital artifacts that looked like snow. Most important, digital images didn't equal the resolution the best slide films produced. But those days are now over.

THE DIGITAL REVOLUTION

The latest state-of-the-art digital cameras create images that surpass film in resolution, do not suffer from the grain found in film, and are not afflicted by excessive noise except on very long exposures. The delay between clicking the shutter button and capture is now shorter than that allowed by the best film cameras. Even relatively inexpensive point-and-shoot digital cameras can match their film equivalent in most areas and surpass them in others.

I believe we can work more efficiently and creatively with a digital camera. After shooting, we see the photograph on the spot and can correct mistakes immediately. Unconstrained by the cost of film, we are free to experiment with composition, filters, blurs, and exposure. Photography becomes more like play.

Some critics object to digital because they associate it with manipulation, but photographers have always manipulated film-based images to fashion their effects. A polarizer boosts saturation and removes glare present at the moment of exposure. Ansel Adams dodged and burned every print he ever made. Velvia and other dramatic films—staples of the pros—generate heightened contrast and color saturation not found in nature. While these effects are easy to achieve in digital, it is possible, if desired, to create more tonally accurate images in digital than in film. The latest digital medium-format systems rival view cameras in resolution and tonal range, albeit at a stiff price premium.

Like any emerging technology, digital photography presents its own set of challenges and disadvantages. Storing images safely must become an obsession. In addition, archiving pictures electronically is more time consuming than organizing slide pages in a filing cabinet. A digital photographer must pay attention to batteries and chargers. Professionals spend more time preparing digital submissions, providing their agencies with varying file formats and sizes, printing thumbnails, and creating digital captions and keywords.

Still, digital photography's results trump its inconveniences. As photographers learn the freedom and control that digital photography affords, their ability to realize anything they can imagine soars.

HOW TO USE THIS BOOK

This book is intended for serious outdoor photographers—not necessarily professionals, but certainly individuals who care about quality. In the pursuit of that end, we aim for maximum resolution, the widest range of color, and the largest file size with the least degradation over time. Thus, we relegate compressed file formats to the realm of snapshots, focusing our attention on the large file formats needed for high-quality large prints and for professional uses. In every case, we try to capture and retain the greatest amount of information.

It's impossible to make specific recommendations regarding computers and cameras. Both technologies are rapidly advancing, and the needs of each digital photographer evolve as competence and interest grow. I do cover the principal issues to consider before deciding on a given class of equipment, but I don't make specific recommendations because they would be obsolete by the time of publication and wouldn't apply to many readers.

Chapter 1: The Old Rules of Photography Still Apply covers basics such as composition and light. Chapter 2: Digital Equipment and Chapter 3: The Digital Darkroom bring digital tools such as cameras, lenses, filters, computer hardware, and peripherals to the discussion. They also cover file formats, photo-editing software, and color management. Chapter 4: Taking Digital Photographs compares old-school and digital approaches to exposure and offers steps to take before shooting in the field.

Chapter 5: Workflow presents a comprehensive description of a completely digital workflow. This includes imagining the end result, capturing the image, and bringing out its best form in the digital darkroom. Although

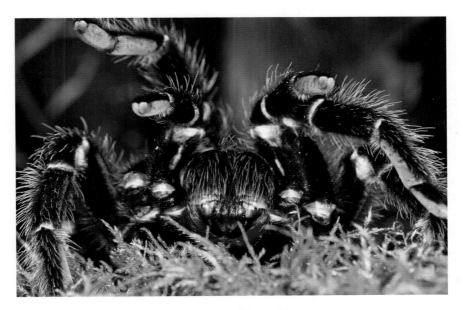

A low perspective brings us into the tarantula's world.

the combination of photographing with film and scanning the result provides raw materials for the digital darkroom, the photographer ends up importing the deficiencies of film and missing the benefits of pure digital images. Therefore, this book ignores film photography and scanning except to compare the strengths and weaknesses of digital versus film photography.

In Chapter 6: The Power of Photoshop, I outline how to achieve useful effects in Photoshop and with plug-ins, without wandering into the surreal or the world of prepress. I use Photoshop CS6 to illustrate step-by-step examples, because it is the industry standard, even though other programs—including Elements, Adobe's own simplified version of Photoshop—can accomplish many of the same tasks. Each program has its own strengths and weaknesses. Because Photoshop is a labyrinthine program offering multiple ways to solve any problem, I concentrate on the day-to-day enhancements every image requires, especially contrast control and color correction.

Chapter 7: A Digital Approach to Subjects offers insights into digital photography of certain types of subjects such as the environment, wildlife, people, and close-ups. The glossary at the back of the book defines terms, and Resources provides information sources, including books and Internet sites.

The information in this book should arm you with an understanding of how to create and store high-quality digital images that will look as fresh years from now as they do today.

THE OLD RULES OF PHOTOGRAPHY
STILL APPLY

Opposite: *Shi Shi Beach, Olympic
National Park, Washington*

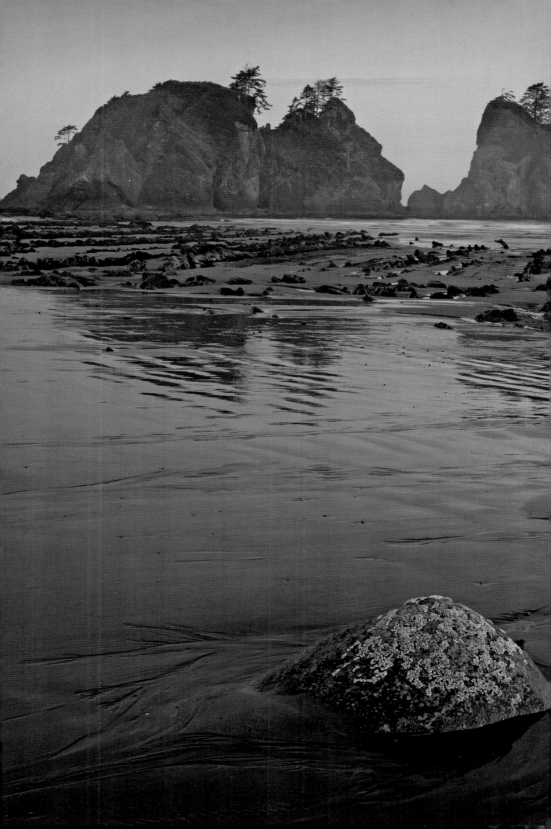

Although digital photography opens new possibilities, the old rules of photography still apply. To get the best results, photographers need to pay attention to composition, light, and color.

COMPOSITION

The art of photography lives in composition. A great photograph is born in the eye and made tangible with the mind. The eye sees and the mind selects or imagines what could be. The juxtaposition of shape and space, the

A tight shot of a stranded iceberg works as an abstract composition.

arrangement and movement of lines, the interplay of tone and color, and the angle and quality of light evoke emotional responses and elevate the resulting images from snapshot to composition.

Galen Rowell took his famous shot of a rainbow over the Potala Palace in Lhasa, Tibet, by recognizing that the elements of a great image were converging and then working to record what he imagined. He saw a rainbow some miles from the palace and knew it would bathe the palace in color if he could move to the right perspective. He set off on foot with a bag of cameras. He recognized that he was moving too slowly, so he stashed the cameras and ran a mile to the correct position with a single camera body and a few rolls of film. By the time he got to the best perspective, the rainbow had faded, but he waited in the gathering gloom for a burst of sun-driven color and was eventually rewarded with the shot he imagined: the Potala wrapped in tinted mist with a rainbow arching into the sky.

Composition can't be reduced in entirety to a set of rules such as the Rule of Thirds or the use of complementary colors. Dissonance has its place in photography, as it does in music. If we confined ourselves to major and minor scales, jazz wouldn't exist. Rules are tools, not laws.

Composition involves much more than arranging subjects in a frame. Color, tone, sharpness, and depth of field are involved as well. Imagine Picasso painting a version of *Whistler's Mother* (officially titled *Arrangement in Grey and Black No. 1*). Even if every element occupied the same space in the frame, no one would consider a Picasso version to be the same composition. Every component would be deconstructed and reassembled. Picasso's colors alone

Photographs can be more about design than subject.

would overturn the original emotional impact. His style reflects an alternate universe. Photographers can create the same kind of varying effects by composing in their imaginations, capturing the critical moment, and bringing the image to life on the computer.

SCALING AND PLACING THE SUBJECT

Most good photographs have a center of interest anchoring the composition. The photographer must decide how to use the scale and placement of this subject—and surrounding elements—to create the desired impact, whether it's design-governed or subject-focused.

USING THE RULE OF THIRDS

Use the Rule of Thirds to draw the eye away from the center of the image. This avoids static or excessively unbalanced compositions and imparts dynamism.

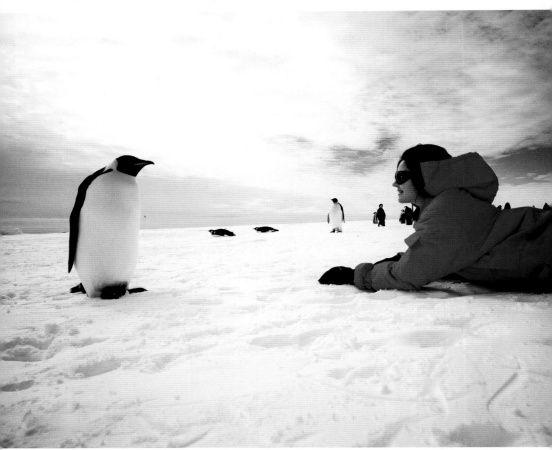

The positions of the tourist and the emperor penguin balance each other.

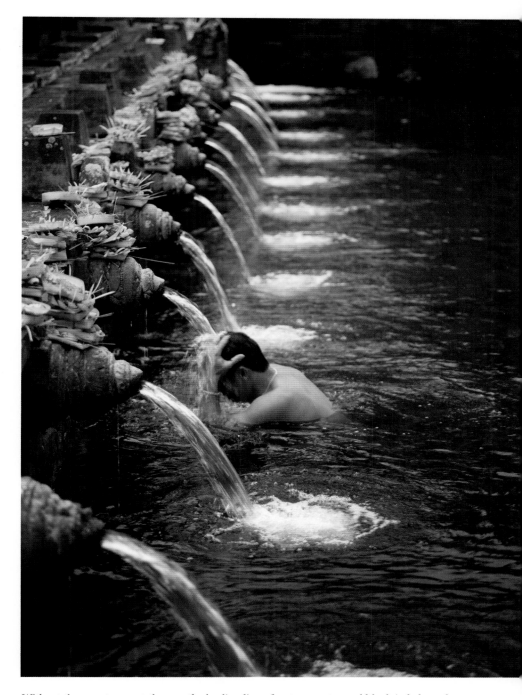

Without the man to arrest the eye, the leading line of water spouts would look imbalanced.

When pattern is the point, feel free to toss the Rule of Thirds.

First, imagine a grid of nine identical rectangles created by two horizontal lines and two vertical lines overlaying your image. Place your subject where grid lines intersect (there are four intersections). At the intersections, your subject will be about a third of the way toward a corner from the center of the image.

The Rule of Thirds can apply to multiple subjects in the same photograph or to strong lines such as trees or horizons. In most cases, a horizon passing through the center of a photograph produces a static composition. A dominating foreground or dominating sky occupying two-thirds of the frame combines balance and dynamism. The symmetry of splitting an image down the middle leaves the eye with nothing to do.

The Rule of Thirds fails some subjects. For example, pattern and texture can be subjects in themselves. A close-up of a beehive emphasizes uniformity, and imposing structure on the image would blunt its impact. At other times, stasis is the point, and symmetry contributes to the composition. A single eye centered in the frame can startle us.

DIRECTING ATTENTION

Try to direct the eye of the viewer toward the main subjects. When you photograph a subject such as a person or an animal, if the eyes of your subject are looking into the frame or directly at the camera, they will direct the attention of the viewer to the subject. This is usually more effective than a subject looking out of the frame. A person standing to one side looking out of the frame directs attention away from the substance of the photograph. However, as with every rule, ignore this one when doing so bolsters the effect you seek.

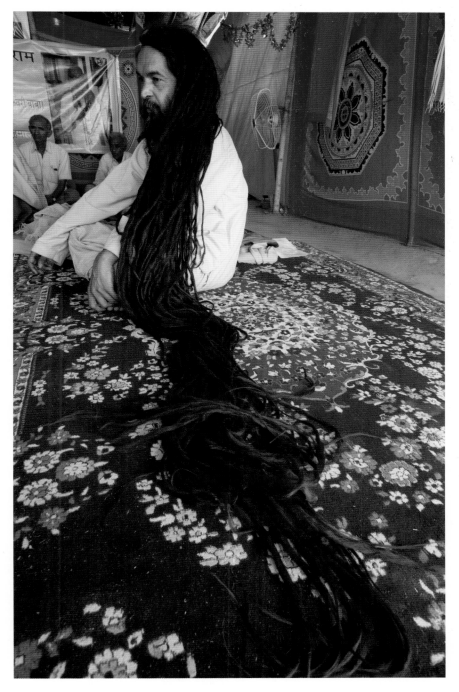

The sadhu's long hair is both the subject and the leading line to his face.

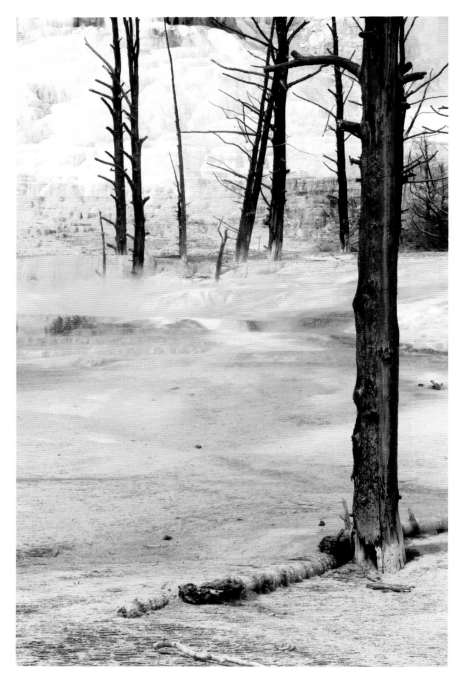

Look for details in a grand scene. This shot of dead trees at Yellowstone's Mammoth Hot Springs works better than a bland, "descriptive" composition of the travertine terraces.

TIP GET HIGH OR DROP LOW

Photographers tend to shoot from comfortable positions, generally the height of a fully extended tripod. While this works for long-lens photography, it rarely delivers the best results for shorter focal lengths. Discard habits of vision and find something new.

Looking down from the heights can reveal patterns. From an Olympian point of view, a herd of animals may become a sinuous line.

Try dropping low to include smaller objects in the foreground or to emphasize elements that only that perspective will deliver.

I shot this ice almost at water level.

Such a composition can underscore a sense of solitude or alienation, which may be the point of the photograph.

You can let the foreground lead the viewer's eye to the main subject or establish a point of reference to create depth. A lake or river in the foreground may lead toward a mountain in the background. When natural lines move from lower left to upper right (preferred in the West because we read in that direction) or from lower right to upper left, the sense of motion increases. An object in the foreground also suggests depth by providing a sense of perspective.

We look at the brightest parts of an image first. If there is a splash of white in one corner of the frame, it becomes a distraction unless it is the starting point for the eye movement the photographer had in mind.

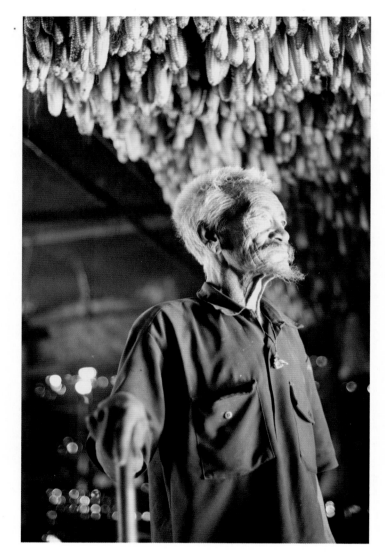

An elderly villager drying corn in his house in Nagaland, India

Check to see if the background enhances or detracts from the image. Look for pleasing tones and colors. Moving a few feet to one side may make a big difference. Throw busy backgrounds out of focus with large apertures. In the same way, unwanted foreground details such as a stray branch distract the eye. Again, moving a few feet may remove the offending object from the frame.

Occasionally, symmetry and stasis are the point of the image, but more often than not moving the viewer's attention from point to point creates greater engagement.

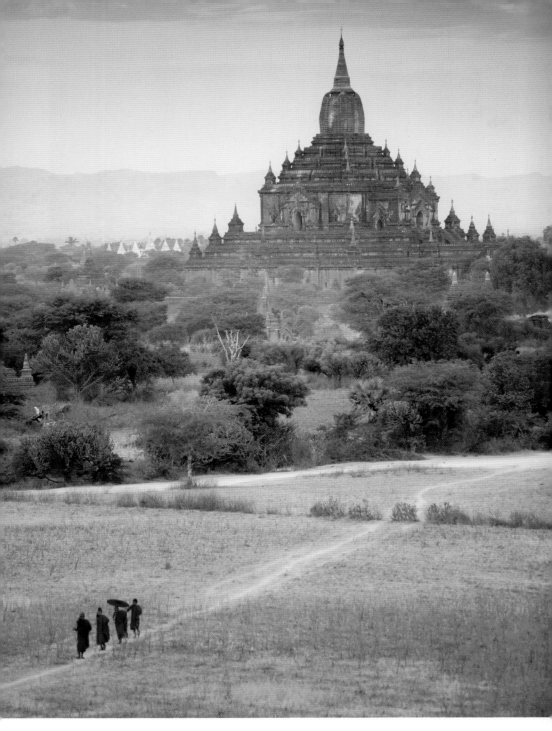

People add interest to travel photography. These young monks walking a trail in Bagan, Myanmar, also serve to balance the composition, which follows the Rule of Thirds.

Since photographers tend to use telephoto lenses for most wildlife shots, I look for any opportunity to use a wide-angle lens for a different perspective.

SHOOTING VERTICALS

Beginning photographers tend to shoot exclusively horizontal images, but some subjects demand a vertical frame. Verticals allow you to focus on mountains, trees, waterfalls, and human faces, whereas horizontal compositions bring in more of the surrounding environment. Verticals provide room for interesting foregrounds. Choosing whether to shoot verticals or horizontals depends on what you wish to emphasize.

Aspiring professionals shoot verticals because they fit the page shape of most books and magazines. If you hope to sell an image for editorial or advertising use, shoot verticals and leave some blank space in the composition for text.

USING SHARPNESS VERSUS BLURS AND MOTION

The sharpness of an image is a function of (1) lens quality (see "Lenses" in Chapter 2: Digital Equipment), (2) depth of field (see the next section), (3) sensor or film quality, and (4) shutter speed (see "Old-School Exposure" in Chapter 4: Taking Digital Photographs) in relation to the movement of the subject. First, the very best lenses are sharp from corner to corner at any aperture. Zoom lenses tend to be a little soft in the corners and at the largest apertures. For maximal sharpness, stop down one or two f-stops from the fastest setting. Second, if your camera has a depth-of-field preview button, use it to confirm that the important elements are in focus. Third, if your intention is to freeze a moving subject, use a shutter speed that is fast enough to do that.

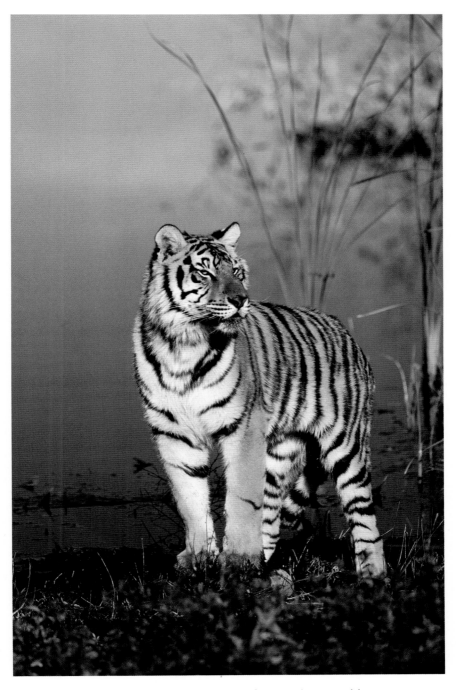

This is a good, sharp animal portrait but it is also a static composition.

TIP	SAVE YOUR KNEES

Low-angle photography ravages the knees. Pebbles dig into the sensitive patellar tendon, and disability eventually will result. Carry a small square of closed-cell foam to cushion your knees, or buy the foam-and-plastic knee pads that roofers wear.

Photographers can convey movement by blurring the subject. For example, falling water looks crystalline if shot at a fast shutter speed. Letting water blur a little restores the impression of movement. Deliberate blurring of flying birds or running animals generates the same impression.

The portrait of the tiger looks nice and sharp, but the blurred version creates dramatic movement and produces a pleasing impressionistic effect. To blur the tiger, I reduced the shutter speed and panned to keep the subject almost immobile in the viewfinder. In this example, I shot the tiger at $1/30$ second.

The ideal shutter speed is a function of the speed of the animal, the length of the lens, and your distance from the subject. Experiment to find the right relationship for any given situation. This is a snap with digital cameras because of the instant feedback they afford. Digital cameras record aperture and shutter speed for each shot. To learn which shutter speed yields the best result for a given lens length and subject distance, when editing your photos, check the

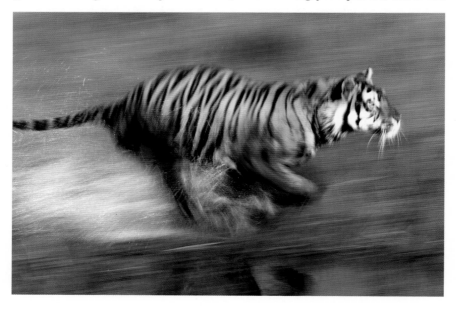

Focusing on the tiger and panning while using a slow shutter speed blurs both the tiger and the background, creating a sense of speed and power.

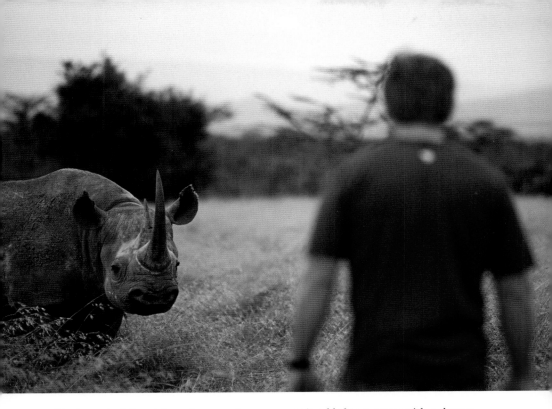

The impact of the picture changes when a person is added to a scene with a dangerous animal. This rhino was raised by wardens in Kenya, so the risk is illusory.

metadata (a complete record of exposure information found in Photoshop and other programs) for the shots that worked best.

Very long exposures transform some subjects. Stars become arcs in the sky, water looks like glass, and surf crashing against the rocks becomes smoke. In bright conditions, a strong neutral-density filter blocks enough light for long exposures.

USING DEPTH OF FIELD

Each composition requires a specific depth of field: the range of focus.

A very shallow depth of field isolates and emphasizes one element in a composition. In a portrait of a person or animal, a busy background distracts attention. Opening up the aperture collapses the depth of field, blurring the background and focusing attention on the subject. Look for opportunities to truncate depth of field. A single sharp flower set in a wash of color created by a field of out-of-focus flowers directs the eye to the desired subject. Bright conditions may demand a small aperture even at the lowest ISO. Again, a sufficiently strong neutral-density filter can cut enough light to allow for wider apertures with shallower depth of field.

Depth of field varies with lens length. A wide-angle lens captures more depth of field at any given f-stop than does a long telephoto lens. Depth of

TIP	THE ONE-THIRD/TWO-THIRDS RULE

If you don't have time to calculate depth of field, focus just in front of the main subject. The one-third/two-thirds rule suggests the critical part of the image will be in focus. This is less likely to work when you are close focusing because the one-third/two-thirds rule collapses to 50/50 in such cases.

field is fixed for that focal length without regard to the format of the camera in use. A 100mm lens at f/8 will provide the same depth of field whether used on a 35mm point-and-shoot or a 4x5 view camera, even though the angle of view changes dramatically.

A landscape that needs sharp focus from foreground flowers to distant mountains requires a small aperture setting such as f/16 or f/22. Smaller f-stops can keep the background sharp even when the primary focus point is not set on infinity. The point of maximal focus that creates the greatest depth of field from infinity to foreground is called *hyperfocal distance*. Some lenses have markings to indicate where a hyperfocal focus point is for each major f-stop, and charts are available for manual settings.

Unfortunately, hyperfocal distance is a judgment call, not a law of physics. There is only one point of perfect focus, and sharpness degrades the farther the subject is from that point in both directions. Hyperfocal distance tables are a starting point. Test the distances on the charts and, if distant objects seem too soft, try focusing somewhat farther away than recommended until you are satisfied. You give up some foreground depth of field by doing so, but by framing to exclude the soft areas, the image will be acceptably sharp throughout.

Most professional cameras feature a depth-of-field preview button near the lens. When you focus, the lens automatically defaults to the widest aperture, letting the maximum available light reach the eye for easy focusing. When you press the depth-of-field preview button, the lens manually stops down to the actual aperture setting. This reveals the depth of field seen at the film plane. However, very small settings pass scant light to the viewfinder, so

HYPERFOCAL DISTANCE TABLE

Lens Length	f/8	f/11	f/16	f/22
16mm	3.5 feet	2.55 feet	1.75 feet	1.27 feet
20mm	5.47 feet	3.98 feet	2.73 feet	1.99 feet
35mm	16.75 feet	12.18 feet	8.37 feet	6.09 feet
50mm	34.18 feet	24.85 feet	17.09 feet	12.43 feet

Note that wider lenses and smaller apertures increase depth of field.

This composition demonstrates how to use depth of field to enhance the subject.

determining depth of field visually becomes difficult. To determine the range of focus, wait a few moments for your eyes to adjust to the darker image. If the camera offers Live View on the liquid crystal display (LCD), you can focus and stop down manually as described. Live View brightens the images so the area in focus is easier to see. Some systems allow for magnification to confirm critical focus.

A rough guide to depth of field is the *one-third/two-thirds rule.* It states that, for any given f-stop, the depth of field expands twice as far behind the point of maximum focus as in front of it. For example, if you focus on a boulder 30 feet away and the picture looks in focus 10 feet in front of the boulder, the picture will be in focus 20 feet behind the boulder as well. You can eyeball this effect with the depth-of-field preview button; or rely on it when subjects are moving too fast to allow you to calculate and the lens lacks a depth-of-field scale.

LIGHT

When Art Wolfe and I visited Tanzania, we hired a van with a pop-up top and a driver. Art generously imparted his thinking while he worked and let me look though his viewfinder so I could see examples of what he was talking about. Watching him create a composition was revelatory. He infuriated our driver by repeatedly instructing him to move a few inches forward or back to eliminate distracting backgrounds or foregrounds as a tiny flycatcher flitted among the reeds. He preached simplicity, balance, and powerful perspective, but his sensitivity to the quality of light and color impressed me most.

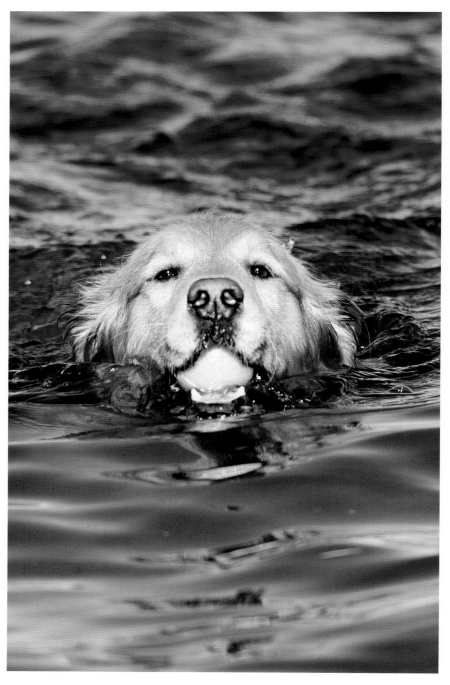

Front light evenly illuminates the golden retriever's face.

Without the right light, the other elements of composition couldn't bring an image to life.

I remember my first close-up lion. Our van was parked 15 feet from a big male. He lay in tall grass under the noon sun, with eyes staring at me. I set up with excitement. The lion's face filled the frame. I metered, focused, and looked behind me. Art stood with his arms folded, shook his head no, and explained that the light was too hard. I took the picture anyway, but when I placed the slide on the light table, I understood what he meant. Contrasting highlights and shadows robbed the image of color, and shadow masked the heart of the photograph, the lion's eyes. Over the course of the next few weeks, I photographed dozens of lions in different light, and each angle and quality of light produced a different effect.

THE DIRECTION OF LIGHT

The quality and effect of light vary with its direction and intensity.

Front light. When the sun is behind you, few shadows appear on the subject. This is front light. The closer the light source is to the horizon, the fewer the shadows. Although front lighting delivers a lot of detail, it sacrifices drama and three-dimensionality.

Sidelight. Especially with a low-angle light source, sidelight adds drama. Shadows on one side create depth and isolate the most important elements of the subject. For example, an animal in profile facing the setting sun will have eyes that gleam compared with the shadowed back of its head.

Backlight. This creates bold shapes. A deer in silhouette at sunset will be fringed by a penumbra of golden light. Placing a backlit subject against a dark background amplifies the effect. Fill light from a reflector or flash adds detail to the subject without obliterating its outline.

Indirect light. For some subjects, nothing beats indirect light. Studio photographers avoid the harsh direct light of a single flash by diffusing light, either by sending it through a translucent membrane (soft box) or by bouncing it off a large reflective umbrella. These techniques banish unwanted shadows, and we experience the reduced contrast as soft light.

Outdoors, indirect light can be diffused by overcast skies or fog, either of which can act as an immense soft box. This allows midtone colors to pop. You can shoot wildlife or forests from dawn to dusk on a persistently overcast day.

Art Wolfe and I got up early one drizzly morning in Samburu National Park in Kenya. Trees buzzed with iridescent bee-eaters, ostriches patrolled the brush, and reticulated giraffes nibbled on leaves. The rain abated, but thin clouds still muted the sun. The colors glowed with supernatural richness.

At 10:00 AM, we were about to shoot a small group of waterbucks, but the sun burned through the mist. Art mumbled a few choice phrases and told the driver to take us back to camp. The equatorial sun had leached the color out of the scene. We knew we would toss the results of any further shooting.

Backlight gives a domestic scene an aura of mystery.

A large soft gold reflector illuminates the backlit woman.

Outdoors, you can also look for natural reflectors to capture indirect light. In canyon country, light bounces off colored walls and illuminates subjects in shadow. A snowy hill or brightly lit lake reflects light equally well. If you have room in your pack, a small reflector can elevate a nice shot to a great one if the subject is small enough. I prefer a reflector with white on one side and soft gold on the other. Soft gold simulates late afternoon light.

FLASH

When the light doesn't cooperate and reflectors can't do the job, a small flash (aka a strobe) can save the day. Flash tends to look artificial. Its white light can be overpowering, calling attention to itself. The color of the flash may clash with the prevailing color temperature. Depending on circumstances, turning down the flash's power, changing the angle of illumination, or adding a gel (or gel effect on the computer) will minimize the artificial look of the flash's light. After mastering the basics, you can use flash for special effects, to illuminate small subjects, and to add to the reach of a small flash with a Fresnel lens, which acts as a magnifying glass for strobes.

Fill flash. A flash picture often looks like someone trained a floodlight on the foreground subject, a distraction that calls attention to technique and away from the subject itself. This happens when the flash tries to match the light intensity of the background. Reducing the power of the flash remedies the problem; you need just enough light to make the subject look natural or to banish unwanted shadows. This is called fill flash. Usually, reducing intensity between one and two stops does the trick. In the old days fill flash required math and actual thinking, but the latest systems automate the adjustments.

Backlighting transforms this action image, taken at Lake Louise Falls, into a strong graphic statement.

Use fill flash in situations where a reflector would help. People get raccoon-eye shadows when the sun lights all of the face except the eyes. A flash set underexposed about one-and-a-half f-stops will "fill" the eyes with light and create a small highlight without blowing out the rest of the face. The same technique works when the subject is backlit.

Underexpose, 1:1 flash. To obtain that glamorous *Sports Illustrated* swimsuit look, where the subject pops against a relatively dark background, set the flash to a normal setting and set the camera to -1 stop exposure. I prefer to use the manual exposure mode to underexpose one stop and let the through-the-lens (TTL) flash work automatically.

Bounce. Indoor photographers often bounce light off a reflective wall or ceiling to generate soft, even light on a subject, and we can do the same outdoors. A subject situated close to a white boulder can be lit by flashing the boulder. Reflected light picks up the color of the reflector, so a pale object is required.

Off-camera flash. A flash placed directly beside the lens, such as a camera-mounted flash, can cause red-eye, which is simply the color of light bouncing off the back of the eye. While computer programs such as Photoshop can eliminate red-eye, it's better to capture the best possible image in the camera instead of fixing flaws later.

To prevent red-eye, move the flash a few inches higher or to the side. Connect the flash to the camera with a sync cord or a wireless trigger mechanism. Canon and Nikon offer infrared triggers, while other companies employ radio-frequency devices with greater range that don't require line of sight to work. PocketWizard is the most popular brand of radio-frequency trigger.

Many point-and-shoot and consumer cameras with built-in flashes feature a red-eye reduction setting. The camera triggers the flash quickly a few times, causing the pupils to contract before the actual exposure so little light hits the back of the eye.

Front light, which an on-camera flash creates, flattens a subject, masking curves and textures. To emphasize these elements and bring the shapes into relief, try placing the flash at about 45 degrees to the subject. Sidelight often casts harsh shadows, so place a reflector on the opposite side to illuminate those areas. In a pinch, my white backpack does a decent job as a reflector.

Multiple flash. If you have a radio slave or infrared trigger, you can fire one or more flashes remotely. It's also possible to connect flashes to the cameras with cords, but that presents all kinds of problems. Adjust the flashes to create a pleasing ratio of light falling on the subject. Thus, a second flash can take the place of a reflector, highlight a subject by backlighting, or illuminate a dark background.

Macro flash. A lens loses depth of field the closer it has to focus. With macro photography at magnifications of 1:1 or greater, depth of field collapses to a few millimeters even at the smallest apertures. In low-light conditions that demand artificial light, a background turns black because small apertures drastically underexpose it. Only the main subject receives enough light. The

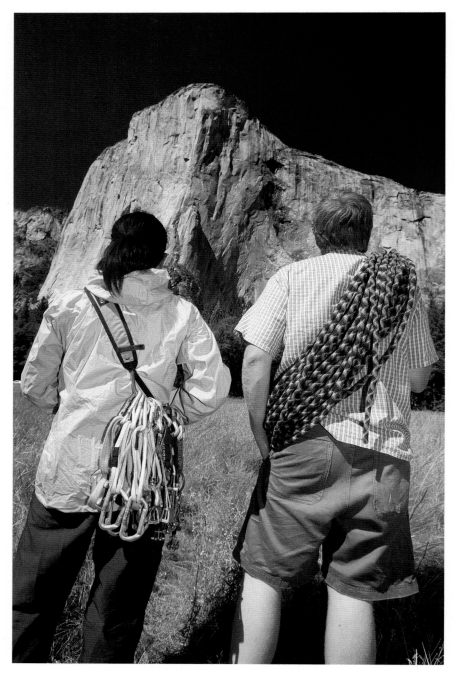

Underexposing the background while using a flash to make the foreground pop is a common technique in fashion photography.

inverse square law dictates that light falloff will turn daylight to midnight behind the subject.

The solution is a second flash to brighten the background. Set a flash to underexpose the background a stop or two. The foreground subject will pop against a recognizable background.

Fresnel lens. When a lion on a hill or an eagle in flight refuses to approach within range of a flash, the solution has been to get a faster lens, or a more powerful flash, or to use a higher ISO. The first two options are heavy and expensive, and the third adds grain or noise. However, a Fresnel lens in front of the flash concentrates the light like a magnifying glass, adding two to three stops of light at little cost in money or weight. When used within the normal range, the flash of the Fresnel lens consumes less power with each burst, thus shortening recycle intervals between flashes.

Fresnel lenses designed for use in flashes consist of a thin, plastic rectangle held a few inches in front of the flash by plastic wings or fixed at the end of a plastic box. The wings often attach to the flash and lens with a hook-and-loop fastener, such as Velcro. The wings and lens are the size of a couple of small cards when stowed in your camera bag. The plastic box version doesn't fold for transport.

Slow sync. To suggest speed or to create an impressionistic effect, use flash at a slow shutter speed. Set the camera or flash to second curtain. The default setting is first curtain, meaning the camera triggers the flash the moment the shutter is fully open. With a slow shutter speed, the camera captures a sharp image of the subject; however, the blurred movement created by the slow speed precedes the subject, a distracting element that evokes nothing. Second curtain blurs the subject until the flash freezes movement just before the shutter closes, creating a sharp edge with a trailing blur.

THE COLOR OF LIGHT

The color temperature of light affects an image as much as the direction of the light does. Color temperature is defined as the color that a blackbody (imagine a lump of black metal) would radiate at any given temperature in the Kelvin scale. Kelvin begins at absolute zero (-459.67° F) and uses the same increments as the Celsius scale. When the blackbody first reaches a temperature that emits visible light, it glows dull red, hence the term *red-hot*. As the temperature rises, the color changes: first yellow, then white, and then blue, until it winks out of the visible spectrum as it passes into ultraviolet. (Note: We consider oranges and reds warm colors and think of blue as cool, but in the world of physics the opposite is true.) We experience 5500° K—the color temperature of light at high noon—as neutral white light. Different light sources have different color temperatures.

Color temperature changes with atmospheric conditions, the quality of reflective surfaces, and the time of day. (See Figure 1.) Film manufacturers designed specific films to record white accurately for various color temperatures. When planning a shoot, try to recognize how changing color temperature

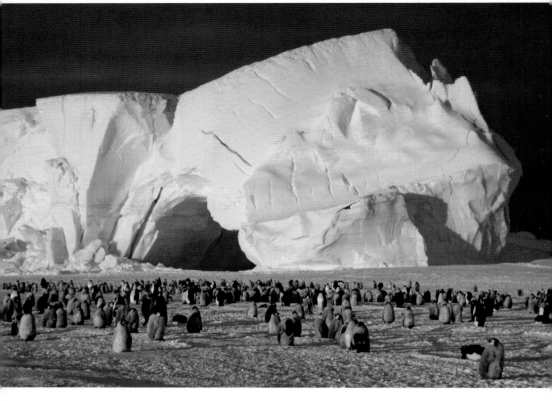

A colony of emperor penguins surrounds this grounded iceberg in the Weddell Sea in Antarctica. Although polar regions enjoy magic light for hours at a time in the right season, this day the sun burned through the thick fog for only a few minutes.

will affect the color of your resulting photograph so you can select the most appropriate film, white balance setting, or filters to compensate.

Daylight. This corresponds to around 5500° K. Daylight film is calibrated to deliver accurate tones in daylight after the warmth of sunrise light cools and before sunset tones appear.

Open shade. This ranges from 7000° to 9000° K. The dome of blue sky colors the light below. When shot in open shade on a sunny day, daylight-balanced film or a digital camera set to Daylight White Balance records a blue cast. Daylight films require the use of a warming filter to restore neutral color. Setting white balance to Shade accomplishes the same thing digitally; however, a blue cast may enhance a composition. A blue hue contributes to the impression of cold in a photograph of a shaded frozen waterfall. Clouds and haze diminish the blue effect, and when they block the blue sky completely, the blue cast disappears.

Overcast. An overcast sky ranges from 6000° to 7500° K, a slight tilt to the blue side of the spectrum as seen by a daylight film. Generally, there's no need to compensate for the shift in color temperature.

Sunrise and sunset. When the sun is near the horizon, its light refracts as it passes sideways through Earth's moist and dusty atmosphere. The refraction shifts color and endows a scene with rich warm tones in the 2000° to 3000° K range. Photographs benefit from the added warmth, combined with a pleasing effect of low-angle light, hence the term *magic light.*

Twilight. Some of the best light is found about 30 minutes before dawn and 30 minutes after sunset when the light of the sun barely illuminates the sky. This corresponds to about 12,000° K. You can see a boundary where a faint pinkish tone meets the dark blue of night. When that pinkish tone falls upon a landscape, the subjects glow faintly against a dark background, an interplay of colors worth capturing.

Artificial light. When we photograph a city at twilight, the streetlights, neon signs, and buildings glow with different color temperatures. An ordinary incandescent lightbulb shines at about 3000° K; its light looks yellow to daylight film. Mercury vapor lamps emit a greenish light. Because there's no single color temperature in the scene, there is no absolutely correct white balance

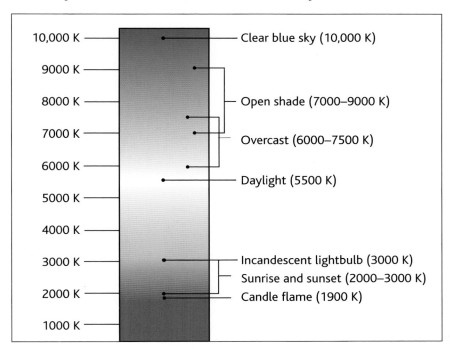

Figure 1. Color temperatures in degrees Kelvin. Temperatures are approximate because the intensity of light varies based on the position of the sun or the wattage of artificial light.

setting. If you can't determine which color temperature will deliver the most neutral results in mixed light (e.g., incandescent bulbs and daylight in a room), set the camera to Auto white balance, but don't be afraid to experiment with other color temperatures to create different effects.

Except in natural light, avoid Auto White Balance. Auto White Balance bleaches the yellow and orange tones of sunset, subtracting the drama and impact. I end up changing the color temperature when I would have used a color-correction filter if shooting film. For example, I would use an 81a or 81b filter to banish the blue cast of open shade; with digital, I change the white balance to Shade to get the same correction.

SUBJECT COLOR

People respond to color photographs. Although black-and-white images have their own power, color taps into our emotions. We react to the tint, hue, and saturation of individual colors and the relationship between colors. An image composed of vivid primary colors triggers a reaction different from what an identical picture composed of pastels triggers, and the juxtaposition of complementary colors triggers a reaction that differs from what harmonious colors trigger. When you become aware of the quality of colors and their relationships, you can select a composition that takes advantage of their attributes.

COMPLEMENTARY COLORS

Complementary colors consist of a primary color and the secondary color opposite it on a color wheel. The primary colors are blue, red, and yellow; secondary colors, derived from mixing two primary colors, are green, purple, and orange. When set against each other, complementary colors appear especially rich and dramatic. Artists use complementary colors to create impact. For example, the red berries of a green holly bush or green trees standing next to the red rock of the Southwest seem to leap out of the frame.

HARMONIOUS COLORS

Neighboring colors on the color wheel are called harmonious colors. They have similar hues and produce a pleasing and more muted effect than complementary colors. Sunset clouds fall into this category when we see reds, yellows, and oranges interlaced in the image.

DESATURATED COLORS

Whereas bold colors demand attention and create drama, desaturated colors such as pastels invoke a gentle impression. Sometimes these colors are inherent in the subjects, such as a field of flowers or a fading sunset, and at times atmospheric conditions such as haze or smoke leach vividness out of the original colors.

HOMOGENEOUS COLORS

A scene consisting of variations of a single hue is the color equivalent of black and white. The drama of color is removed, leaving the opportunity to

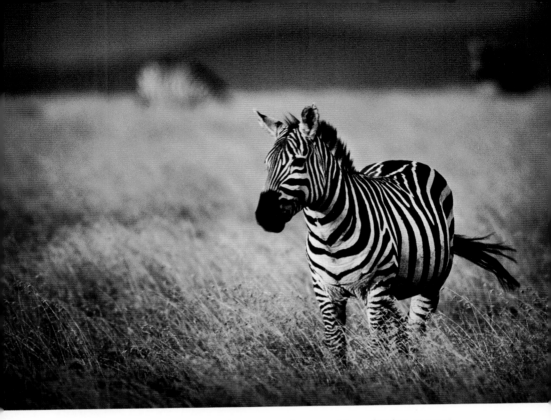

Blue and orange, which are complementary colors, provide a pleasing contrast.

emphasize shape, line, and texture. A forest of Douglas fir becomes a pattern of vertical lines without a center. Snowy hills with the sky cropped out become an exercise in pure form.

SHOWING UP

People say 90 percent of life consists of showing up; hence, the photographer's dictum "f/8 and be there." In other words, a photographer must anticipate where photographic opportunities will appear and then show up at the right time. Many of my best images required neither intellectual effort nor artistic talent. The composition was irresistible, and a baboon could not have missed it. In such situations, if the light cooperates, you are almost forced to photograph it.

Luck is the residue of design. Plan your days so you can be in position when the light takes a turn for the good. Scout for good positions when the light is mediocre. This discipline invites serendipitous moments.

Working with Art Wolfe in Africa opened my eyes to the realities. Although we had a good time, there was no doubt this was a serious enterprise. Every day we rose before dawn, photographed for several hours, ate and rested, scouted for a good position for sunset and the following sunrise, and then set up for the sunset shots. The universe rewarded us for our efforts. At the end of

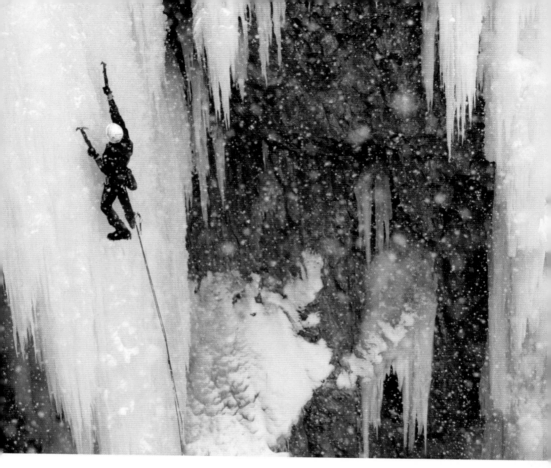

A mild snowstorm transforms this shot, taken in Ouray, Colorado, from ordinary to atmospheric.

a rainy afternoon at Lake Manyara in Tanzania, a double rainbow formed at sunset over a line of buffalo, with hippopotamuses in the foreground glowing in the golden light.

Jack LaLanne once said that some days he would rather take a beating than get up for a workout, and I often feel the same way when I'm exhausted after days of shooting, but I've learned never to give up on the light. Late in a trip to the Serengeti, heavy rains swept the savanna just before sunset. We encountered a group of zebras huddled together as the downpour pounded us. A long lens captured an atmospheric image of the zebras seemingly shrouded in smoke.

I made the mistake once of giving up on Easter Island. Toward the end of the day, I saw a wall of gunmetal gray clouds approaching. The sun was an hour from setting, and I was certain I wouldn't see it again, so I drove into town for dinner. As I waited to be served, I noticed from the little restaurant that the light was turning pink. I ran outside and was confronted by

a horizon-to-horizon spectacle of brilliant color. With just a little patience, I would have photographed the tall stone moai silhouetted against an improbably vivid sky. As it was, I missed what could have been the best shot of the trip.

These days, I wait to the bitter end. Although I often go home empty-handed, when the sun cooperates, slashing under the cloud cover for a moment and infusing the scene with color, I take some of my best images.

2

DIGITAL EQUIPMENT

Opposite: *We can find patterns and movement in something as unpromising as pond scum.*

Digital technology doesn't overthrow the eternal verities of photography. The tasks needed to capture an image differ little between film and digital. The rules of composition still apply, the precepts of exposure diverge only slightly, and filters generate identical effects. But digital technology removes constraints that once blocked the realization of photographers' visions. Although digital photography calls for a new set of habits for efficient workflow, the largest change is conceptual.

A digitally captured image represents the first step of a work in progress. But even before shooting, a digital photographer may imagine how the image will change as it passes through an editing program en route to the final product, whether a print or an archival file. A pretty scene may gain drama if converted to a high-contrast black and white, or it may cry out to become a panorama. Although we can make such decisions after shooting, imagining a final result and taking the steps to realize it are the crucial steps toward mastery.

Learn the basics step-by-step (see Chapter 4: Taking Digital Photographs). Establish a repeatable and efficient workflow (see Chapter 5: Workflow). Experiment to learn the range and limits of digital exposure. Master color and contrast optimization. Acquire the special techniques needed to replicate classic films and effects, the punchy saturation of modern slide films or old low-contrast sepias, the sweep of a panorama, or the depth and perspective of a view camera (see Chapter 6: The Power of Photoshop). Once these techniques are firmly in your grasp, wander into the surreal if you wish.

This chapter reviews the different types of digital cameras as well as other equipment used in digital photography. The effective focal length of lenses changes according to digital sensor size, but the qualities needed in a lens are the same for digital photography as for film. Filters behave the same in both film and digital photography. Tripods remain a necessary evil in both worlds. As always, vision, imagination, and craftsmanship count for more than equipment quality.

Although this is a book on digital photography, computer image editing inescapably comprises a large portion of the text. Hence, among the digital equipment you need to get started is a photo-editing computer program (and a computer to run it). Much of the power of working digitally is found in programs such as Adobe Photoshop in its various incarnations, its myriad competitors, and add-on plug-ins. In this chapter, I review the essentials and allude to other capabilities. The basics—color correction and filing—are easy to learn, but facility with all the tools available requires a steep learning curve that includes topics beyond the purview of this book.

CAMERAS

The quality of a film camera is almost irrelevant. A brand's entry-level camera body and its top-of-the-line body will both produce an identical image when using the same film and lens. In a film camera, film acts as a sensor. Camera bodies differ primarily in ruggedness and features. Some features, such as the speed of the motor drive or quick autofocus, affect performance in the field,

but most of the time there is no difference in performance. However, with digital cameras, the size and resolution of the digital sensor, combined with the speed and sophistication of the signal processing, determine the quality of the final image and ease of use.

CAMERA BASICS

Getting professional-quality results with digital cameras demands a significant outlay. A professional digital camera body costs thousands of dollars, and the memory cards and storage needed to preserve files can add thousands more. An entry-level digital camera, on the other hand, costs little more than a film camera and saves the recurring costs of film.

A professional recoups the cost of switching to digital after a few assignments, from savings in film cost alone. On an African safari, it's not uncommon to shoot twenty or thirty rolls a day. A month-long trip could have twenty shooting days or more. This translates to a minimum of four hundred rolls of film. The cost of the film and processing would total more than $4,000. After a few such trips, a professional photographer who switches to digital will be in the black, with the savings going directly to the bottom line.

The number of pixels (short for picture elements) the digital sensor can capture constitutes one measure of digital performance. The more pixels, the greater the resolution. This can be expressed two ways: either as the number of pixels available in the sensor or as the uncompressed file size. The Canon 5D III is a 22.3-megapixel (22.3 million pixels) camera that yields a 66-megabyte 8-bit TIFF file (after RAW processing).

Unfortunately, file size doesn't tell the whole story. Sometimes a lower-resolution camera produces a more pleasing and accurate result than a higher-resolution camera. The quality of the camera's signal processing electronics and the size of its sensor sites account for the variation. The innards of digital cameras generate noise (a kind of digital grain) and other digital artifacts while doing a better or worse job of interpreting color. Checking the file size specification of the digital sensor is a good first step when shopping for a digital camera, but the only way to tell how well it works is to take test shots.

To test cameras, take a memory card to a camera store. While you are there, if possible, shoot the full range of tonal values. A midtone such as green grass or blue sky will give a good idea of color accuracy. Shoot dark shadows; lesser cameras often produce noticeable noise in deep shadow. Try some shots of shadow areas at higher ISO settings because these are most likely to generate noise. A very bright subject may overwhelm the digital sensor so that no detail appears. Then take the card home, download it onto your computer, and blow the image up to at least 100 percent. This will reveal digital noise, pixelation, and unevenness of color if any exists. If the file quality meets your standards, the camera is a candidate for purchase, and you can make your decision based on features, feel, and price.

Sensor size. A full-size sensor has the same dimensions as a 35mm slide and equivalent magnification for any given focal length lens. Smaller sensors

| TIP | MAGNIFY THE LCD SCREEN |

For a better view of the LCD screen, carry a 4x loupe, a small magnifying glass designed for editing slides. Placing it over the camera screen blocks outside light so glare doesn't obscure the image. Because the screen is composed of small dots in a field of black, sharpness remains tough to determine. Wrap the edges with gaffer's or electrical tape where the loupe meets the screen to prevent scratching. This is useful even if the LCD can magnify the image. Today's high-resolution LCD screens reveal a lot of detail.

add magnification. Professional models add 30 percent magnification; consumer cameras add 50 percent to 60 percent.

Although sensor-induced magnification increases the reach of a telephoto lens—a 300mm lens may have the same angle of view that a 450mm lens would have with a full-size sensor—wide-angle lenses become less wide. On an APS crop sensor, a 28mm wide-angle lens becomes a 36mm, a big difference and hardly wide angle at all. Additional magnification allows wildlife shooters or birders to capture tight shots without spending the money for and carrying the weight of longer telephoto lenses, but landscape photographers will miss the wide-angle view.

Viewfinder versus screen. Single-lens reflex cameras bounce light from the lens to the viewfinder with a mirror. The photographer sees what the sensor sees. Most consumer digital cameras use electronic viewfinders (EVF) that project the image from the sensor to an LCD screen. An EVF camera can produce an equally good photograph, but focus can be confirmed only by checking the camera's LCD screen after exposure. These screens are often too small to verify focus, although they work well enough for double-checking exposure.

The light meter in a single-lens reflex (SLR) camera reads the light after it passes through the lens and any filters, but digital viewfinder cameras often place the light meter on the body of the camera; this means it won't compensate for changes in exposure caused by added filters. When using a polarizer or a graduated neutral-density filter in situations where calculating the exact filter factor is difficult, hold the filter in front of the light meter on the camera body. I prefer to use manual exposure in such situations so the camera doesn't change exposure after I move the filter from the light meter to the lens.

CAMERA TYPES

Digital cameras come in all sizes and shapes. The camera phone has become the most popular way to capture images; mirrorless cameras are challenging the market supremacy of digital single-lens reflex cameras (DSLRs); and high-resolution medium-format cameras remain essential for a small group of professionals and passionate amateurs.

Camera phones. The rise of camera phones is the most significant event in the annals of digital photography. Suddenly, half the world has a camera ready to shoot at any moment. Events are celebrated from multiple points of view, crimes are uncovered, and anyone abusing authority must now watch his or her back. Camera phones capture precious family moments that would've been unrecorded, and they accumulate billions of tedious images documenting people's lives. At any moment someone may take a picture of their lunch or an event that ends up on the cover of a news magazine.

While most people use camera phones to document their lives, others see an opportunity to create art and share it online. A host of apps designed to enhance camera phone photography has proliferated. For a few dollars, you can get a program that blends several images into a High Dynamic Range (HDR), stitches a panorama together, or applies special-effects filters with a tap of the screen to transform an image into something surreal, old-fashioned, or enhanced. New apps appear all the time, but current favorites include Snapseed, Filterstorm, Hipstamatic, Pro HDR, and PhotoStitch.

The first camera phones suffered from tiny file sizes, poor processing, and awful lenses, but the latest models produce a serviceable 8x10-inch print equal to the point-and-shoot cameras from a couple generations ago. Instead of working like an old Instamatic with static shutter speeds, aperture, focus, and white balance, the new models adjust these settings automatically, within limits. Sharpness, noise suppression, and freedom from artifacts don't match those of a dedicated camera, but for many people the result is satisfactory.

Chase Jarvis has said that the best camera is the one you have. Most people don't lug a DSLR around, and opportunities fly by like leaves in an autumn windstorm. The precepts of good composition may be practiced just as well with a camera phone as with a view camera. It may look silly to use a camera phone with a tripod, but a tripod will allow the camera to take a sharper image.

Even a camera phone can capture serviceable images, albeit without the resolution and range of features of a DSLR.

Compact cameras. Reports that camera phones killed compact cameras are premature. While camera phones may be convenient and ubiquitous, they soon frustrate anyone wishing to improve as a photographer. The latest compacts come equipped with features once the sole province of DSLRs. In terms of image quality, handling, and flexibility, they all beat any camera phone, and the best ones approach entry-level mirrorless models.

Camera phone image sensors cover only a quarter of an inch while the largest compacts reach an inch—providing 16 times as much surface area. This represents a tremendous design advantage, a head start in resolution, and low noise. Many compacts shoot in RAW as well as JPEG, a more flexible format without baked-in sharpening and color correction. Manual shutter and aperture settings and exposure compensation permit the photographer to override errant automatic settings.

Larger, faster, clearer optics send sharper images with less noise to the sensor, especially in low light. Some camera phones include a digital zoom, but unlike an optical zoom, digital zooms do little more than crop, blowing up a portion of what the sensor sees. Compacts enjoy faster focus and the ability to take a burst of images, several per second, when the action heats up.

Mirrorless cameras. These cameras entered the market recently and have carved out a substantial niche. They can be much smaller than DSLR cameras because they can dispense with the complexity demanded by mirrors used to bounce light from the lens to the viewfinder. The light travels directly to the digital sensor and then is represented on an LCD screen, either on the back of the camera or within a viewfinder.

The advantages are many. The interchangeable lenses can be much smaller, much the same as rangefinders. The LCD screen allows for Live View, and most enable screen zooming, allowing an increase in magnification by a factor of 5 or 10 for critical focusing.

However, dispensing with the mirror is the greatest advantage of all. It reduces the price because it reduces the complexity required to move the mirror out of the way when actually taking the photograph. At no time does the image have to be eliminated from the viewfinder, whereas when the mirror is moved out of the way in a DSLR, the viewfinder goes dark. In a DSLR, the mass of the mirror creates vibration as it moves and stops abruptly during exposure, causing a lack of sharpness. This is usually most visible around $1/15$ to $1/30$ of a second.

Nonetheless, most people prefer to shoot with an optical viewfinder. LCD viewfinders can be noisy in low light and at normal magnifications more difficult to manually focus. Many of the mirrorless cameras have only an LCD screen as opposed to a viewfinder. To frame and focus you have to hold the camera away from your face, which is less stable and intuitive. On a bright day, the glare can obscure the view.

Some professional photographers shoot with a mirrorless camera as their principal tool, but many more use them as backups. They don't take up much space in the bag and provide high-quality images if the principal camera goes

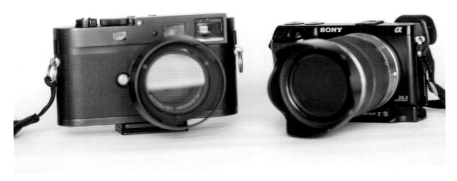

Mirrorless and rangefinder cameras can equal the resolution of a DSLR, but in a smaller package.

down. With the use of adapters, you can use lenses from Nikon or Canon DSLRs or the Leica M-series rangefinders. Sony, Nikon, and Olympus make adapters retaining automatic functions, but with aftermarket adapters you lose auto-focus while retaining image stabilization in some cases. Program and shutter priority go by the wayside (the cameras can't control the aperture of the lens), but manual and aperture priority remain. This is a relatively inexpensive and compact insurance policy. Plus, they are easy to carry after shooting to catch unexpected opportunities.

Mirrorless cameras first appeared in the Micro 4/3 format, which refers to its small sensor size and yields a 2x crop factor. Later designs offered larger APS-C sensors with a 1.5x crop, and the first full-size sensors on mirrorless cameras are just arriving at this writing. The larger sensors demand somewhat larger lenses for full coverage, but they deliver a better balance of resolution and low noise compared to smaller sensors.

Rangefinders. In 1913 Oskar Barnack, an engineer at Leitz, designed a rangefinder camera using 35mm movie film, a departure from the large view cameras then in use. In 1925 the first Leica resulted in a form recognizable today in their M-series digital rangefinders. They remain simple yet elegant tools.

Instead of looking through the lens via a mirror in an SLR camera to frame and focus, one looks through a viewfinder. Dispensing with a moving mirror permits a more compact design with smaller lenses placed closer to the film or sensor plane. There is no mirror movement vibration. To focus, align split images in a split screen, framing within frame lines that appear based on the focal length of the lens. This makes for a very small frame area with longer lenses and demands careful focusing. There is no autofocus on any Leica M, but the latest models include an LCD screen for framing and focus—a boon to those of us with imperfect vision.

An unobtrusive rangefinder is the perfect tool for street photography.

The standard viewfinder provides an added benefit. Leica placed it to one side so the other eye can see the surroundings more easily. You can see elements of a moving scene coming together and anticipate the right moment to capture the image.

If you can master its idiosyncrasies, it can deliver spectacular results. Leica lenses deliver unsurpassed clarity, and the workmanship is a step above other brands. When you nail a shot, the image glows. With its small size and diminutive lenses, it is an ideal backpacker's camera and a staple among photojournalists and street photographers.

The price of entry is steep. An M camera with a single lens will cost over $10,000, but many photographers still shoot with decades-old Leica lenses.

Digital single-lens reflex (DSLR). A single-lens reflex camera is distinguished by the mirror box, a space within the camera where the mirror—used to bounce light to the viewfinder—swings away from the film or sensor. The mirror box adds bulk and creates the thick profile of these cameras. Most professional cameras employ this design. Despite their bulk and weight, DSLR cameras are the workhorses of the world, found in studios, the streets, war zones, and the wild.

Crop sensor. A crop sensor is any sensor smaller than a 35mm slide. In a 35mm film camera, a 50mm lens is "normal," evincing neither a telephoto

Only the tamest wildlife will permit a photographer to approach close enough to shoot with a rangefinder.

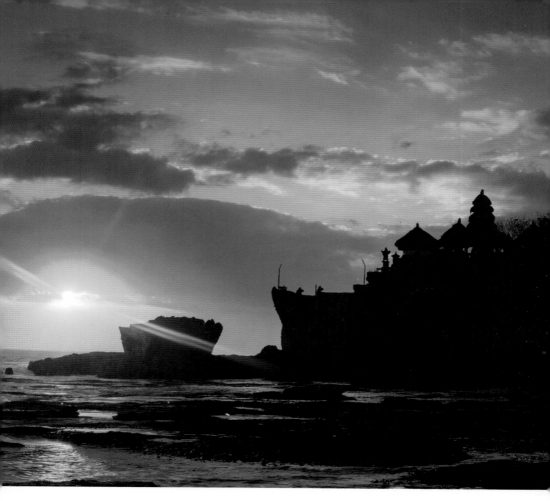

Sunset at Tanah Lot, Bali, shot with a Phase One IQ180, a medium-format camera

nor wide-angle effect. Since a crop sensor captures some fraction of that 35mm surface, it appears to magnify the image by 30 percent to 50 percent, its crop factor.

In some cases, this can be an advantage. Shooting wildlife usually demands long, expensive lenses. With a crop sensor, a 400mm f/4 lens has the reach of a 600mm f/4 without the weight or expense, and a 600mm f/4 becomes a 900mm f/4. While the crop sensor is a boon for sport and wildlife photographers, it challenges landscape aficionados. To get the same angle of view as a 16mm wide angle on a full-frame sensor would require about a 10mm on a crop sensor. A 10mm is exceedingly wide and difficult to manufacture without distortion.

Crop sensors appear in entry-level DSLRs because they are cheaper to manufacture than full frame, but the best crop cameras are as sturdy and well sealed as professional-grade full-size sensor models, and they are priced accordingly.

Full-frame sensor. Full-frame sensors enjoy advantages over crop models. There is more real estate for larger photo sites (the millions of individual sensors that capture light), which translates to less noise and more resolution. Professional-grade wide-angle lenses are available. Manufacturers pack their flagship DSLRs with the most powerful signal processing, drawing the highest performance from the raw data.

Medium-format camera. If you are the sort of person who would pass on a bottle of 1977 Domaine de la Romanée-Conti as too unrefined or find the steering of a Ferrari 599 somewhat vague above 170 miles an hour, medium-format photography is for you. It didn't just win the megapixel wars; it redefined the meaning of high resolution, although at a price.

Sensors are no longer the limiting factor. One easily discerns misalignment of the sensor on the focal plane no greater than the thickness of a human hair as a smearing of all detail and the obliteration of the finest lines. Any lens short of the best available at its perfect aperture clouds an image that still appears startlingly real. When everything is optimized—sensor, glass, alignment, and skillful execution—the gap between good and great yawns incredibly wide.

The physics of sensor design give all the advantages to medium format. More surface area gives a designer room for more and larger photo sites. A full-size sensor on a medium-format camera is 6cm by 4.5cm compared to 3.5cm by 2.4cm for a full-size DSLR, more than three times the area. There is room for three times the resolution at any given pixel density.

The advantages multiply. Anti-alias (AA) filters designed to minimize moiré slightly blur digital captures, so medium-format cameras or backs don't include them. The latest medium-format lenses are optically sharper. The in-camera signal processing is more sophisticated. Some allow the photographer to optimally align the sensor. The highest-resolution medium-format sensors

Phase One back, body, and lens

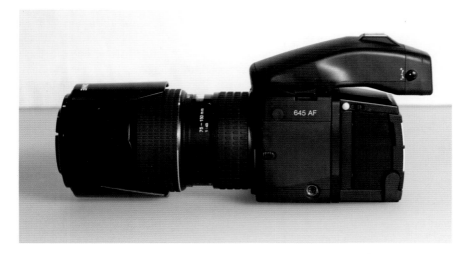

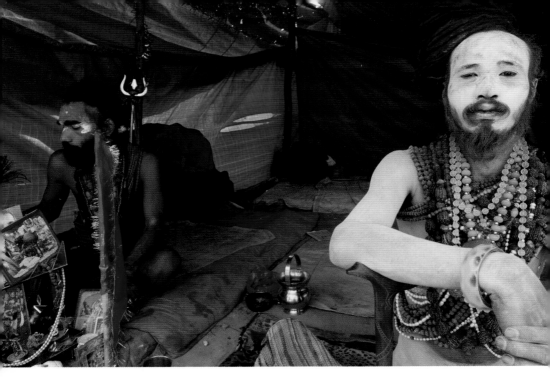

Sadhus at Kumbh Mela in Hardiwar, India, photographed with a Phase One 40-megapixel camera

have more than twice the megapixels of today's DSLR leader, and the photo sites can be larger. Forgoing the AA filter, aligning the sensor in the camera, and employing better glass combine to deliver resolution and tonal gradation that blow away the best DSLRs.

However, excellence comes at a price. A state-of-the-art medium-format rig including a few lenses can cost as much as a luxury sedan. However, the price for entry-level models represents a modest premium over pro DSLRs.

Today's medium-format cameras come in several forms: all in one, camera body with digital back, and technical camera with digital back. Medium-format cameras from the film days tended to look and feel like bricks. The old Hasselblads and Mamiyas were square or rectangular boxes with lens attached. The Pentax 6x7 looked like an overgrown SLR, and film backs in 6x7 format or larger could be attached to the back of a technical 4x5 view camera. These are the same templates used today in digital medium-format.

The cheapest cameras in the digital medium-format world come from Pentax and Mamiya: all-in-one designs with interchangeable lenses. Mamiya is a division of Phase One, a relatively new player that has achieved dominance in the marketplace due to superlative design and an aggressive acquisition strategy. In addition to Mamiya, Phase One also purchased Leaf.

The Phase One system consists of the camera body based on the venerable Mamiya 645 medium-format film camera and several removable backs ranging from 40 to 80 megapixels as of this writing. The company has developed

a series of digitally optimized lenses, including leaf shutter lenses to minimize vibration and increase strobe sync speeds.

Hasselblad remains a major player with a series of all-in-one cameras and a digital back. With the correct adapter, both Phase One and Hasselblad backs can be used on older medium-format bodies or technical cameras.

Leica offers a single medium-format camera: the S2. This follows the tradition of the Pentax 6x7, a medium format in 35mm SLR form. The Leica excels at ease-of-use and handles almost as easily as a DSLR. The Leica lenses include leaf shutter models, and all are, as always, impeccable.

Monochrome camera. A disproportionate number of the iconic images in the history of photography were shot in black and white, and even today some of our most accomplished photographers continue to shoot monochrome photographs. Black and white emphasizes the structure of a photograph and often reveals a tonal richness that color obscures.

The digital realm offers some advantages to dispensing with color. The Bayer array, the distribution of sensors that capture three particular colors, smudges resolution by combining up to three sites, interpolating to produce the correct color for a single point. Chromatic aberration, a consequence of the interaction between lenses and the sensors, also disappears. A black-and-white

A retired headhunter sits in front of his home in Nagaland, India. Shot with a Leica Monochrom.

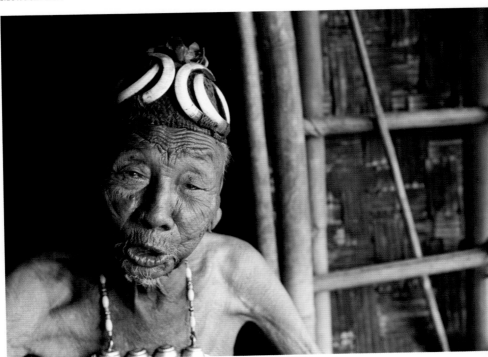

image shot on monochrome sensors, each perfectly focused, produces higher resolution per megapixel. Two examples are available at the moment: a tiny rangefinder and a state-of-the-art digital back. Neither employs an anti-alias filter, the absence of which further increases resolution.

The Leica Monochrom is a small 18-megapixel rangefinder with minimal features. The camera plus several lenses is smaller and weighs less than a 70–200 2.8 zoom lens for a DSLR. It easily fits in the palm of one's hand. Based on the legendary M platform in use since the days of Henri Cartier-Bresson's first work, it offers few frills. All the lenses are manually focused, and the only shooting modes are aperture priority and manual. Given the exquisite lenses produced for the M mount, the Monochrom can produce incredibly sharp images and yields usable files even at ISO 10,000.

Phase One's IQ260 Achromatic is a 60-megapixel monochrome iteration of its IQ backs. When mated with a medium-format body and first-class lenses, it offers all the advantages of the Leica with megapixels to spare. If you want the equivalent of an 8x10 view camera from the age of Ansel Adams, this is the back for you. With tilt/shift lenses, to a certain degree you can even mimic view-camera movements. Both systems are at the top of their respective price categories.

Ne plus ultra camera. To create the highest-resolution images, pair a state-of-the-art digital back with the modern heir to technical cameras. It turns out that the best platform is the simplest.

Photographer Mark Dubuvoy shooting with an Alpa/Phase One/Rodenstock kit in Iceland

Alpa of Switzerland manufactures a series of cameras that tease the last, elusive resolving power out of the lenses and sensors. The cameras themselves are little more than frames to hold a lens board on the front and a digital back behind, which is similar to a view camera, but the fit and finish are immaculate. One can perfectly align the back with the lens board by stacking ultra-thin shims. Alpas use view-camera lenses. These lenses are not only a step sharper than other lenses, they are also relatively light and compact. They employ leaf shutters within the lens, providing a low-mass, low-vibration solution. With no mirror slap vibration or shutter shudder, the sensor records an immense amount of detail.

Other manufacturers make similar technical cameras, but none achieve the tolerances or offer the fine adjustments of the Alpas.

WHAT IS THE BEST CAMERA FOR YOU?

You can't tell what camera fits your needs best by looking at specifications. Megapixels give you a sense of resolution but no idea how well the internal hardware and sensor will render tonality or colors, no sense of how much noise will be generated during long exposures or at high ISOs. Beyond resolution, the handling of the camera and its interface go a long way toward making it an effective tool. If the function you need is buried under layers of menus, the buttons are in the wrong place, the balance of the camera seems off, or the body fits poorly in your hand, using it will always be frustrating. Before making a decision on a camera, make your best guess regarding what you want to photograph and how, assess what matters to you most, and if possible spend some time fiddling with the camera.

No camera does everything well. Bulky and expensive medium-format cameras boast the highest resolution in the world, but fast, long lenses are not available and the bodies shoot only a frame or two per second, making them poor wildlife cameras compared to a DSLR firing at 10 frames a second through a 500mm f/4 lens.

LENSES AND ACCESSORIES

When evaluating a camera, see which lenses and accessories are available so you can grow within the system. In terms of lenses, don't scrimp. If you stay with the same manufacturer for both your camera and lenses, you may be shooting with some lenses for decades while taking advantage of camera upgrades every few years.

LENSES

With film cameras, lens quality contributes more to the sharpness of the image than the camera body does. Because digital resolution depends on the capacity of the camera sensor, lens quality does not impact the character of the final image as much. Still, a poor lens will ruin an image in digital photography as thoroughly as it will on film.

When shopping for a lens, look for sharpness in the corners of the image area as well as at the center. Check for chromatic aberration: color fringing along sharp edges. Look out for vignetting: light falloff in the corners, a common failing in even high-quality wide-angle lenses. Some of these characteristics are represented mathematically as specifications or in reviews, but the effects can be seen in the images themselves on the computer screen.

If possible, rent a lens before buying to confirm that it performs well enough for your intended uses. Take test shots at several apertures; there should be little or no falloff in sharpness at the widest aperture, a common affliction of lower-quality glass.

The speed of the lens—in other words, its largest aperture—doesn't necessarily relate to sharpness. Faster lenses allow you to stop action or shoot handheld in low light at a given ISO (the imaging sensor's sensitivity rating), but the trade-off is increased weight and a loftier price. However, the fastest lenses are often the top of the line and tend to be the sharpest for a given focal length.

Different lens focal lengths create different effects. Some compress depth; others enhance it. Some distort straight lines; others compensate for parallax problems. Specialized lenses focus closely, capture 180-degree views, or maximize depth of field. Lenses with extremely large apertures blur the background for their focal length when shot wide open. The blur is called *bokeh* (Japanese for "blur"), and a creamy look without hard edges is prized.

Note: Digital cameras with sensors smaller than a 35mm slide add a telephoto effect to each focal length.

A 500mm super telephoto lens compresses depth in this image, giving scale to tabular icebergs near Antarctica.

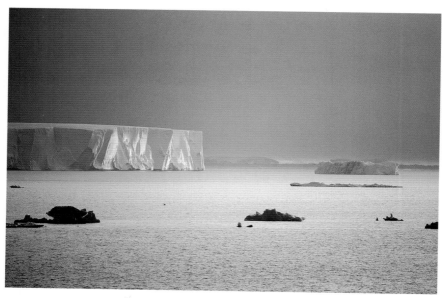

Wide-angle lenses. Useful for providing perspective, whatever the subject, wide-angle lenses are the mainstay of landscape photography. They permit greater depth of field than lenses with longer focal lengths. Wide-angles range from 11mm to 35mm.

Wider lenses tend to distort straight lines, especially when the camera is pointed up. When you are shooting a stand of pine trees with the camera pointed straight ahead, most wide-angle lenses will represent the trees as vertical lines. However, if you tilt the camera up, those vertical lines are forced to converge at the top of the image. Rectilinear wide-angle lenses minimize this effect, and the Free Transform command or Lens Correction feature in Photoshop and other tools can bend the lines back to vertical.

Use wide-angle lenses for landscapes when a strong foreground element is present. Because of the great depth of field of a wide-angle lens, everything remains in focus (assuming you use the small aperture), even when the camera sits very close to the foreground.

Wide-angle lenses help to create a sense of scale and distance. Foregrounds appear relatively large compared to background elements, emphasizing distance. Don't use wide-angle lenses to include everything you see. Good photographers select the most interesting and powerful components of a scene. Trying to capture everything in a single shot often results in a busy, confusing image.

Normal lenses. A 50mm lens produces neither a telephoto nor a wide-angle effect on a 35mm film camera. It behaves the same way on a DSLR camera with a full-size sensor. (With a smaller sensor, which creates a telephoto effect, a 35mm lens or thereabouts possesses the same angle of view as a 50mm lens with a full-size sensor.)

It's easier and therefore cheaper for a lens manufacturer to make a sharp 50mm lens than a sharp wide-angle or long telephoto. Even inexpensive normal lenses tend to be sharp, light, and fast. Some professional photographers carry nothing but a 50mm lens on a camera body when exploring a city and grabbing shots.

Telephoto lenses. Although most people think of telephoto lenses as a means for bringing distant objects closer, I prefer to think of them as a way to select the most interesting part of a cluttered or confusing scene. When I first started shooting, I drove for some professional photographers in search of images. As I drove, they would shout, "Stop! Stop!" I would hit the brakes and look around, not seeing anything worth shooting. When they stopped photographing, I would peer through the viewfinder and be surprised to find a great picture embedded in the surrounding mediocrity. Once I understood the angle of view for each of my telephoto lenses, I began to look for compositions that fit them. I find I use telephoto lenses more than half the time, even for landscapes.

Use medium telephotos to photograph people in street scenes. You can work anonymously or introduce yourself and get permission. Fashion photographers use telephotos because they flatter the subject and isolate them from the background. You can do the same thing when shooting wildlife or people.

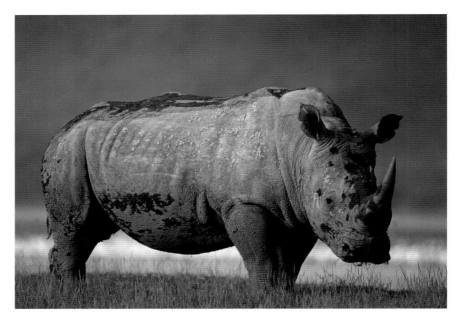

This super-telephoto image of a white rhinoceros compresses the background and isolates the animal. The background—a forest, a soda lake, and thousands of flamingos—becomes a wash of color due to the shallow depth of field of the long lens.

Super telephoto lenses. On a game drive in the Serengeti, you can expect to see batteries of big glass lenses bristling from the vehicles. I'm sure the lenses cost more than the Land Rover carting them around. When dealing with dangerous animals, there is no substitute (except courage or stupidity) for 500mm lenses or larger.

The best long lenses are huge. An f/4 600mm lens resembles a bazooka. They funnel a lot of light to the film or sensor to allow shutter speeds fast enough to freeze moving subjects. Not only are they fast but they also remain sharp at all apertures. Super telephotos compress perspective and exhibit restricted depth of field.

Zoom versus fixed lenses. Although the quality of zoom lenses has improved tremendously, they still don't match the sharpness and color fidelity of top-flight fixed lenses. Stick with fixed lenses when you are going for ultimate quality. On the other hand, zoom lenses have no peer when it comes to capturing a fleeting composition. Because you can change the angle of view instantly, frame the ideal image before conditions change; for instance, before the lion takes off or the sun goes behind a cloud. It's vital to test a zoom lens before purchase. Pay particular attention to sharpness in the corners at the fastest apertures, and to vignetting in wide-angle zooms.

Specialty lenses. Some lenses offer limited utility but deliver extraordinary images when the situation matches their capability.

Fisheye. These lenses encompass a 180-degree angle of view. They necessarily distort straight lines in the image. I like to use them when I need tremendous depth of field and distortion is irrelevant or when the distortion contributes to the composition. For example, shooting straight up in a redwood forest with a fisheye lens gives the impression that all the trees are leaning toward the center of the frame. Sometimes nothing else works at all, such as inside a cave where you want to shoot straight up toward the ceiling while including the surrounding stalagmites. In addition, fisheye lenses boast extremely wide depth of field. Everything, from just inches from the foreground out to infinity, stays sharp.

Tilt/shift. These lenses mimic the ability of view cameras to control parallax distortion and depth of field. Tilting the back of the camera or angle of the lens while the body remains stationary alters depth of field. Many spectacular landscape photographs that include wildflowers in the foreground and mountains in the distance with everything in focus result from tilts on a large-format view camera. A view camera's shift feature allows the lens to move up or down and from side to side to correct for parallax distortion (the

A 15mm fisheye lens tilted downward bends the horizon of the Greenland ice pack.

A tilt lens controls depth of field; a right-angle finder makes low-angle work more comfortable.

A shift lens corrects for parallax distortion.

same distortion a fisheye lens produces). Control of tilts and shifts permits a landscape photographer to create maximally sharp and in-focus images without parallax distortion. However, since straight lines are not common in nature, this capability is not critical most of the time, and digital photographers can use editing tools to mimic the effect of these lenses. Architectural photographers who deal with straight lines every day cannot live without these movements.

Macro. These lenses permit close focusing. Most don't exceed a 1:1 magnification; in other words, the image on the film or sensor equals the size of the subject. For greater magnifications, macro photographers turn to close-up lenses and extension tubes. For most photographers, a featherweight close-up lens (a magnifying filter) attached to a normal lens produces sufficient magnification most of the time. Specialists may use a 5x super macro and the full range of accessories: ring flashes, tubes, and focusing rails.

AUTOFOCUS VERSUS MANUAL FOCUS

Autofocus is a standard feature on modern cameras. It's a godsend for photographers with imperfect vision. When shooting running wildlife, birds in flight, athletes, or other moving objects, servo-focusing (focus tracking) locks onto the subject and captures sharper images than even the best pro could shoot with a manual focusing lens.

TIP	RIGHT-ANGLE FINDER

Before I discovered right-angle finders, I spent many hours crawling in the dirt, peering sideways through my SLR's viewfinder with my camera inches from the ground. While I got the perspective I wanted, composing a picture was a chore.

A right-angle finder consists of two tubes with a mirror where they meet at a right angle. It relays the image from the camera's viewfinder to your eye as you look straight down so you can compose from a dignified crouch instead of a sloppy sprawl. A diopter in the finder corrects for poor vision.

Owners of digital cameras with swinging LCD screens already possess a de facto right-angle finder.

Even with its great strengths, autofocus is stupid. It can't decide what part of an image matters, at least not all the time. In a tight portrait of a wolf, it's just as likely to focus on the nose as the eyes. The photographer must ride herd on the system lest it go astray.

Most systems allow you to set the focal point in the viewfinder—in other words, to place it in the center or to the side. Very sophisticated systems "guess" by applying probability calculations based on a huge database of common situations. Even these systems fail in uncommon situations.

I prefer to keep things simple by leaving the focus point in the center of the frame. With some cameras I hold down the shutter button halfway to focus on the primary subject and then, while still depressing the button halfway, reframe for the composition I want. As long as I don't release the button, the lens keeps the focus I set. If I know I will take several shots or reframe while keeping the same subject in focus, I set focus and then turn off autofocus. A focus lock button, a common feature, serves the same purpose.

Many cameras allow you to reassign a button to focus. Touching the shutter button no longer activates focusing. This method prevents inadvertent refocusing as you press the shutter button. This is my preference when using autofocus.

Often, using manual focus saves time. Close-ups usually confuse an autofocus system. What in the frame should it select for sharpest focus? The base or the tip of the stamens? The rims of the petals or their origins? Flip off autofocus and adjust focus yourself either with the viewfinder or with the LCD.

Although focus tracking can perform miracles, it can't deal with every situation. For example, if a subject passes in front of the lens momentarily, autofocus can miss the moment by hunting for the right thing to lock on. But imagine that you're set up under a jump where a mountain biker soon will fly by. Switch to manual focus and focus on a point the same distance from you as the mountain biker will be. When the biker zooms through the zone of focus, you are ready to capture the moment.

Without fast autofocus, freezing the motion of an approaching albatross would be exceedingly difficult.

FILTERS

Although the digital domain allows us to mimic most photographic filters electronically, it's often easier to use a filter in the field instead of correcting on the computer. My old warming filters stay at home these days, but I always carry a polarizer and at least one graduated neutral-density filter. Some polarizer effects are impossible to replicate in Photoshop, and in some situations a graduated neutral-density filter effortlessly equals computer correction. Glass filters degrade quality less than resin but generally cost more and rarely survive falls.

POLARIZERS

Most people use polarizers to darken the sky. Polarizers create this effect in the right conditions, but it is their least important attribute.

When light strikes dust in the air or on a reflective surface such as water or metal, it scatters. We experience this as haze or glare. A polarizer blocks scattered light—light arriving from the sides—so that only coherent light passes through the lens, removing the glare and revealing colors.

Turn the front element of the polarizer to find the most useful setting. The effect grows strongest at 90 degrees to the light source. For example, a polarizer will do nothing to reduce the appearance of haze when the sun is at your back but will drastically darken the sky if you make a quarter turn to the right or left. A polarizer pointed toward the sun produces no effect on the sky.

Glare on water obscures color and detail. Polarizers remove glare, restoring a forest stream from a flat ribbon of white glare to a dark, variegated rush of water. Don't even think of shooting tide pools or lakes without a polarizer. The detail revealed by the polarizer cannot be recovered by computer manipulation.

I always use a polarizer when photographing plants or forests. At first glance, a forest looks like a riot of green and brown, but that impression springs from the brain, not the camera. In fact, most leaves shine with glare. Film records the glare as bright white, creating a contrasty image. A polarizer cuts the glare, revealing the underlying green while increasing the saturation of all colors. Polarizers enhance color saturation for many subjects even when glare is a minor problem. Clothing, hair, and smooth surfaces all pop more dramatically.

Polarizers can ruin shots, too. They diminish light, up to two stops' worth; in low-light conditions, the resulting loss of shutter speed may prohibit hand-held exposures or allow subject movement to compromise sharpness. When used on a very hazy sky, polarizers can produce a disagreeable gray effect not found in nature. A blue sky may become black when a polarizer is used full strength, or it may turn an unnaturally dark blue, especially at high altitude. Although it can produce a dramatic image, more often than not it distracts and detracts

Used judiciously, a polarizer will do more to improve images in the field than any other filter. Opt for a circular polarizer because linear models can confuse autofocus systems.

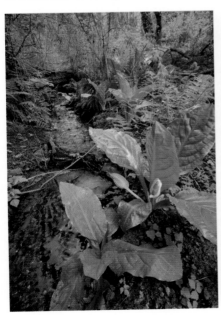

A polarizer suppresses glare. Left: *Without polarizer: Note how the glare obscures the surface of the creek.* Right: *With polarizer: The polarizer cuts glare, revealing the streambed.*

TIP	USING A POLARIZER

When using polarizers on viewfinder cameras, it's impossible to see how much effect the polarizer is having once it's on the camera. Furthermore, polarizers require between one and two stops of exposure compensation. Cameras without through-the-lens metering will underexpose by that amount unless they are set to compensate. Two steps remedy these problems.

Hold the polarizer in your hand and look through it toward what you wish to photograph. Turn the polarizer until it produces the result you want. Look for writing on the outside edge of the filter, and note which way it points. After screwing the polarizer onto the lens, turn the polarizer ring until the writing faces that way again.

However, before fixing the polarizer to the lens, hold it in front of the light meter sensor on the camera body and take a reading. The exposure will increase by one or two stops. This is the correct exposure. After putting the polarizer on the lens, set the camera to that exposure no matter what the light meter reads.

NEUTRAL-DENSITY FILTERS

Neutral-density (ND) filters reduce the amount of light hitting the sensor. In bright conditions there may be too much light to use a wide aperture or slow shutter speed. Photographers use wide apertures to reduce depth of field, rendering the subject sharp but the background blurred, thus reducing distracting elements. If the camera lacks a shutter speed fast enough for a small aperture, reducing the light by several stops with a filter is the only way to get the shot. Slow shutter speeds can yield dreamy effects. A long exposure of a waterfall or ocean water swirling around rocks produces soft lines and a smoky look. Sometimes an ND filter is the only way to get a long enough exposure, even at the smallest aperture.

Photographers carry NDs of varying strengths to respond to differing conditions and goals. Placing a second ND of a different strength over the first amplifies the effect, and two NDs give you three options: two NDs of different strengths plus the combined effect. If you find many opportunities for NDs in the field, consider a *variable neutral-density filter*. A variable filter can dial in many stops of darkening, and some include a polarizing surface to cut glare at the same time.

GRADUATED NEUTRAL-DENSITY FILTERS

Graduated neutral-density (GND) filters help control excess contrast. Film and digital sensors see only five stops of contrast, whereas the human eye can

Opposite: *A variable neutral-density filter cuts enough light for a long exposure, transforming falling water into gossamer strands.*

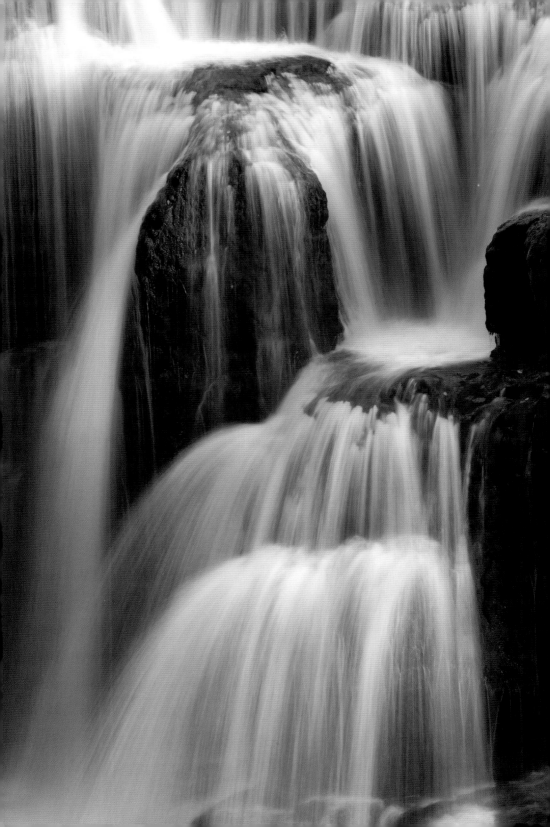

resolve eleven. For example, when we look at a sunset with the foreground in shadow, the sky may be eight stops brighter than the darkest part of the foreground. If we expose for the sky, the foreground turns black, but if we expose for the foreground, the sky loses all color. If we expose for midtones, both sky and shadow lose most detail, becoming undifferentiated white and black. The solution? By darkening the bright part of the frame, GNDs work perfectly for ocean sunsets or other situations in which the boundary between bright and dark is a straight or nearly straight line.

GNDs consist of glass or resin, clear on one half and tinted neutral gray on the other. They come in one-, two-, and three-stop strengths, each with a gradual or abrupt transition. With a rectangular GND, we can move the filter in front of the lens so the line of demarcation matches the area where radical change in brightness occurs—such as at the horizon line in the example at right. I always carry, at minimum, a rectangular two-stop GND with a gradual transition.

To use the GND filter, slide it into a special rectangular filter holder (Cokin is a popular brand) or hold it against the lens. If you hold the GND, make sure no gap exists between it and the lens; otherwise, the filter will bounce unwanted reflections into the lens. Hand-holding the filter almost requires using a tripod. However, I prefer to hand-hold the filter because I can work faster, though I must concentrate on avoiding transmitting vibration mechanically and on holding the GND motionless during a long exposure.

Adjust the filter so the transition area aligns with the horizon. When tall objects project into the bright sky, the filter darkens them when it shouldn't. In these cases, mimicking a GND in Photoshop or another program will produce more natural results because the computer applies filtering to areas that are actually bright, not to regions above an imaginary line.

When exposing with a GND in place, center-weighted metering (the default in most cameras) works most of the time. Spot metering through the filter—taking care that the light passes through the correct part of the filter—should give the same result as center-weighted metering. The spot meter setting samples a narrow angle of view so you can meter highlights or shadows without the surrounding scene influencing the reading.

COLOR CORRECTING AND WARMING

Color-correction filters adjust color to compensate for shifts in hue induced by shadows or film color temperature. Warming filters remove the blue cast

TIP	HAND-HOLDING A GND

If the horizon is a little jagged, rather than a straight line, try moving the filter slightly during exposure. This will blur the demarcation between darker and lighter. Take care to avoid moving the camera during this procedure.

The graduated neutral-density filter reduces exposure for part of an image to balance foreground and background brightness.

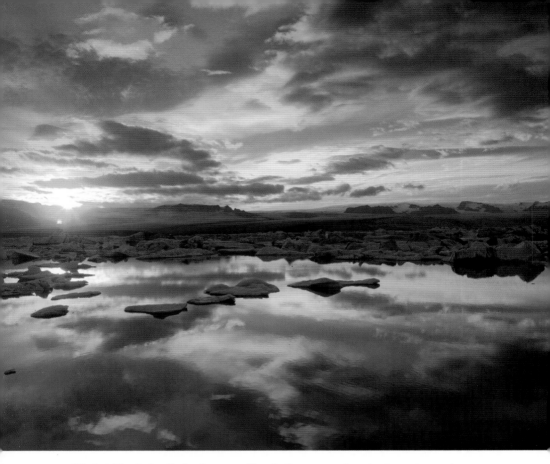

Jökulsárlón, Iceland's ice lagoon, offers both warm and cool colors at sunset.

found in shaded areas under a clear blue sky. Tungsten film and other formulations designed for the color temperatures of artificial lights require compensatory filters in daylight.

Color-correction filters are passé in the digital world. Photoshop includes digital color-correction filters; numerous plug-ins mimic their effect; RAW editors (see "RAW" in Chapter 3: The Digital Darkroom) offer color temperature modification of RAW files; and most digital cameras provide for various color temperature settings. Because these adjustments are available with the click of a button on the camera or in every RAW editor, carrying a bundle of filters to compensate for cool open shade or yellow incandescent light makes no sense when shooting digitally.

TRIPODS AND HEADS

Tripods are vital and often cursed tools. No one relishes carrying the extra weight, but their benefits are many and essential.

The small apertures needed for great depth of field demand slow shutter speeds. Nobody can hand-hold a 15-second exposure and expect a sharp image

to result. Super telephotos are too heavy to hand-hold, even when panning. Unless you are using very fast shutter speeds, you can't hand-hold a GND filter and a camera simultaneously.

The bigger the camera and lens, the bigger the tripod and tripod head must be. Mass provides a sturdy platform and dampens vibration caused by the shutter. On an SLR, the movement of the mirror shakes the camera, too. You can add mass in the field by hanging a camera bag from the tripod if carrying heavy loads is an issue.

Tripods force you to slow down. This gives you time to consider composition and to notice details that augment or diminish the final image.

Choice of materials affects performance. Aluminum tripods conduct more cold and vibration than wood or carbon-fiber tripods. Aluminum tripods weigh more than equivalent carbon-fiber models, too; however, carbon fiber exacts a higher price. After handling a metal tripod on a cold day and lugging it over hill and dale, you might find that the extra cost of carbon fiber seems trivial.

Tripod heads come in two versions: ball head and panning. Most outdoor photographers prefer ball heads for their quick versatility. You can position the camera as you wish without fussing with the tripod legs.

Super telephotos work best on a C-shaped tripod head pioneered by Wimberley in 1991. The camera and lens balance inside the C on a gimballed plate so the weight doesn't shift regardless of the angle of the lens. This prevents tipping, a potentially expensive disaster. Kirk Enterprises manufactures a similar gimballed head, the King Cobra.

Panning heads move only vertically and horizontally, so further adjustment requires changing the length of the tripod's legs.

3

THE DIGITAL DARKROOM

Opposite: *No Photoshop magic here;*
luck plays a part in good photography.

Photographers have always manipulated their images to achieve the effects they desire, either to replicate the scene they photographed with maximum accuracy or to craft a new or more glamorous vision. Ansel Adams underexposed and overdeveloped negatives and then dodged and burned while printing to bring his signature dramatic tonality to life. Later film photographers used supersaturated Fuji Velvia and other pumped-up emulsions to add punch to their images. Digital photography gives the photographer even more power and control using components that most people already own: a computer and color printer. Of course, depending on your needs, the cost and complexity of your setup can vary widely. And the photo-editing software you install on your system comes into play here as well.

The other aspect of your digital darkroom is, of course, the photo files themselves. When a digital camera records an image, the information consists of code written by the camera's software. No photo-editing program can interpret this information and shape it into a photograph. First, software must convert the data into a file in an imaging format such as RAW, JPEG, or TIFF. Once we shot film; now we create files. The difference is more than chemistry and physics; it represents a new way of looking at the finished product

COMPUTER AND PERIPHERALS

Unlike the war between VHS and Betamax videotapes, the conflict between PC and Macintosh computer platforms still rages. Because Adobe Photoshop and all other major photo-editing programs work on both platforms, and both offer comparable speed, choose based on your preference or experience. If you use a PC or a Mac at home or work, stay with it. Learning the software is tough enough without compounding the difficulty by using an unfamiliar operating system. If you work with an older operating system, upgrade to the latest version; some software and peripherals require the newest updates. Hands-on experience will prove more valuable than the hottest hardware.

COMPUTER

Get the fastest computer you can afford. Operational speed is largely a function of processor speed and available memory. The processors on new machines are plenty quick, so get as much memory as you can so the machine can handle large files without slowing to a crawl. With too little random-access memory (RAM), the computer is forced to write and read from the hard disk, which is frustratingly slow. You can't be too thin or too rich or have too much RAM.

You will need at least five times the RAM of the largest file you create. For example, if you want to stitch together four pictures of 30 megabytes each, the calculation would be 4 images of 30 megabytes each = 120 x 5 = 600 megabytes. In this case, you will need more than half a gigabyte (500 megabytes) of RAM.

Make sure the computer has either FireWire 800 or USB 3.0 ports—or both; these are the fastest ports, a feature that is critical when transferring large

amounts of data. Apple features a new standard, Thunderbolt, the fastest of all, but few peripherals exist for it.

Hard drives. Get at least two large hard drives. A few hundred large files add up quickly. The main drive will contain programs and images you wish to access quickly. If this drive approaches capacity, the computer will lose speed. Archive on the second disk and use it as a scratch disk, a region of memory the computer uses while performing other functions on the primary drive. If the primary disk crashes, your image files will be unaffected if archived on the backup drive. You can obtain software that backs up everything automatically or set up a RAID array, which does the same thing. Many photographers keep a disk off-site and update it every few weeks in case some disaster befalls the home or studio.

BLU-RAY/DVD BURNER

Because all hard drives fail eventually, back up your hero images on DVDs or Blu-ray discs. Burners are inexpensive, and DVDs store 4.4 gigabytes of information on each disc. (They are rated at 4.7 gigabytes but can write only 4.4.) Dual-layer and double-layer DVDs offer 8.5 gigabytes. It appears that gold discs last years or decades longer than other materials. Blu-ray or high-capacity DVDs store huge amounts of data—as much as 50 gigabytes on a single disc at a premium price.

MONITOR

Get the largest, highest-quality LCD monitor possible. If the monitor lacks resolution or color fidelity, you will not be able to tell when color is off, and the resulting file will suffer. Choose a high-quality video card. Most are designed for 3-D gaming applications. Look for a card with a high rating for 2-D graphics and a lot of memory.

Photoshop menus can clutter the screen. You can move the menus to a second monitor if your video card and operating system allow it. There is no need for high quality for a second monitor used to view these menus, but you may prefer the esthetics. It's also possible to "hide" the menus until needed in most programs; in Photoshop, the Tab key toggles between hiding and revealing the on-screen menus.

Once you have your monitor you need to pay attention to color management. Volumes have been written about color management and the perils that await anyone who shirks its mastery. But the primary concerns of color management consist of choosing a color space and calibrating the computer monitor to reflect the exact color the computer produces.

COLOR SPACE

Programmers define color spaces—specific ranges of colors that necessarily omit some colors found in nature—to accommodate the limitations of computer monitors and printers. In Photoshop, the default color space is sRGB IEC 61966-2.1 (RGB = red, green, blue—the colors used in television and computer

monitors to simulate the full color spectrum). This color space was originally designed to avoid overtaxing the limitations of older color monitors. CMYK is the color space used by the printing industry (CMYK = cyan, magenta, yellow, and black—the four colors used to create four-color printing). The color space demanded by photo agencies is Adobe RGB (1998); ProPhoto RGB is even larger.

CALIBRATION

Because the monitor provides the first and most important view of your digital files, accurate calibration of it is essential. Instructions for approximating ideal monitor calibration can be found in most comprehensive Photoshop books. Use either the calibration software in the operating system or, for optimal calibration, use a dedicated calibration kit that includes a sensor you attach to the screen. Software menus lead you step-by-step to create a color profile. Some of the leading producers are X-Rite, Pantone, and Color Vision.

For recent versions of Apple's OS X, open System Preferences>Displays >Color>Calibrate. The program leads you through the calibration process. In Microsoft Windows 7 or 8, go to the Control Panel and click on More Settings. Select Appearance and Personalization>Adjust Screen Resolution>Make Text and Other Items Larger or Smaller>Calibrate Color. A wizard takes you through the steps. The operating systems produce a decent but imperfect color profile.

You must calibrate your monitor to ensure that your photos show the true colors of your subject.

PRINTER

Selecting a printer depends on your goals. If you want gallery-quality prints, a high-resolution, large-format inkjet printer using archival ink is the way to go. These printers employ as many as a dozen ink colors to work their magic, and the costs add up quickly. The latest inks last longer than C prints, have superior color range, and produce rich black-and-white prints. The cost of ink can exceed the price of a printer quickly. The larger the print, the more ink is used.

SCANNER

If you have a collection of images on film, you may need a film scanner. The scans of these film images will serve as a new slide collection, so obtain the highest-quality scanner possible. Fortunately, prices have fallen dramatically in recent years. Nikon and Microtek manufacture excellent units at modest prices. Imacon scanners deliver drum-scanner quality (almost) at a fraction of drum prices but still cost five or ten times as much as Nikon's best scanners. True drum scanners cost a Midas ton and require bathing slides in oil before scanning.

If only a few images need scanning, use a local pro. For large collections, consider shipping your images overseas. Companies in India and elsewhere scan hundreds of images at Imacon quality for a few dollars per scan, about one-tenth the price of a drum scan in the States.

FILE FORMATS

Before you take your first digital picture, you need to decide what file size and file type will satisfy your requirements. For example, if you want to send a picture of your dog to Grandma in an email, a highly compressed JPEG file will do the job nicely, but that same file would be rejected by any magazine photo editor. Stock-photo agencies insist on very large TIFF files, currently on the order of 50 megabytes.

TIFF

Tagged image file format (.tiff or .tif) is an uncompressed or "lossless" file format. It is the standard in the imaging industry and works across platforms; in other words, it works on both PCs and Macs. If you need to send a file to a publisher or agency, TIFF is the way to go.

PSD

Photoshop (.psd) files resemble TIFFs in that they are lossless. An 8-bit PSD is the only uncompressed file format wherein all the features in Adobe Photoshop work. I do most of my work in this format and then convert the result to make a TIFF or JPEG copy, which I eventually toss after use to free disk space. I keep an archival PSD with all layers intact so I can make new edits without losing information.

JPEG

Joint photographic experts group (.jpg) is a compressed file. Compression reduces file size, sometimes dramatically. An 18-megabyte file collapses down to 1 megabyte. When you open an image after compression, the system re-creates the missing pixels through interpolation, a kind of digital guessing.

When a camera creates a JPEG file from the RAW camera data, it applies color correction and sharpening. The original data are lost forever, and you are stuck with whatever sharpening artifacts are created at that time.

Unfortunately, with each compression of a JPEG file, pixels disappear forever. After a series of saves, much or even most of the original pixels vanish. If you look at a highly compressed JPEG file on your screen at 100 percent, it's easy to see jagged, checked patterns. This is especially noticeable when the image has sharp features such as straight edges.

Compression is useful when you need to send an image over email or display it on the Internet, but it is a poor choice for archiving. If you must shoot in JPEG format, photograph at the highest available resolution setting and save the files as TIFFs or PSDs before saving the JPEG. This creates an archival file that preserves the maximum amount of information.

RAW

As the name implies, a RAW file is uncompressed and unprocessed. In order to be manipulated in Adobe Photoshop or other editing programs, it must be converted to another format such as JPEG or TIFF. However, a RAW editor program permits manipulation of a RAW file (actually a copy of the original) without losing any original data. Thus, one may alter saturation, color, brightness, contrast, and other attributes without losing information in the original file. Even after saving the file, you may return the image to its original settings. Once these enhancements have been performed, the RAW file can be converted to a 16- or 8-bit TIFF or PSD file format for additional work in Photoshop or a similar editing program.

Serious photographers should shoot in RAW format. It provides the most versatile and information-rich digital negative because each RAW file contains unprocessed information. When software converts the camera's data into an imaging format such as JPEG or TIFF, some information is lost with each adjustment of color, contrast, or brightness in its new format. To see how this happens, open the histogram for a new TIFF file. A TIFF with dark, midrange, and bright areas will look like a stock-exchange graph with no gaps. Then adjust the levels and curves, fiddle with brightness and contrast, and add a color cast. The histogram will now have gaps—in other words, lost information. Compression formats such as JPEG compound the problem by tossing out data each time the file is saved.

Many other file formats are available. Some work best in certain operating systems; others are targeted toward specific uses such as text or raster (line-art) graphics—in other words, not photo files.

DNG

Camera companies have created a host of proprietary RAW file format varia-tions. Adobe has proposed moving to a single archival RAW format called Digital Negative (DNG). As DNG files, proprietary RAW formats become uni-form and usable by all. It is hoped that DNG files will be readable years and decades in the future. DNG is now available in Adobe Camera RAW editing software, as a free download from Adobe, and as the default file format from some camera companies.

RAW VERSUS JPEG CHART

FILE FORMAT	ADVANTAGES	DISADVANTAGES
RAW	Large file size Nondestructive editing	Slow camera processing Requires conversion
JPEG	Small file size Common format	Compression loses pixels Lower resolution Adds sharpening

RAW EDITOR PROGRAMS

RAW editor programs retain the original information as they alter the image. The instruction set changes the values for color, brightness, and so on without affecting the original pixels. Thus, you can change all the settings and then change them back without altering the pixels in the RAW file. This also allows you to change your camera settings after you've taken the photograph. If the camera's white balance was set for bright sun (about 5500° K) but you shot in open shade, the image will appear blue. Changing the file to the proper white balance setting corrects the image without changing the original pixels.

Camera manufacturers such as Nikon and Canon have developed propri-etary RAW editor programs. Some claim that using a camera manufacturer's proprietary RAW file converter has inherent advantages. They argue that only software designed for specific cameras can compensate for in-camera process-ing and other manufacturer-specific idiosyncrasies. If this is so, the advantages are exceedingly subtle.

The manufacturers' programs may optimally compensate for lens deficien-cies; they know how their lenses vignette or generate chromatic aberrations. That should allow them to optimize RAW editor settings to repair inherent lens problems. However, filters induce analogous aberrations, and the manufactur-ers' software possesses no advantages when filters degrade the image.

In my opinion, workflow efficiency counts more than these tiny improve-ments in accuracy. Adobe Camera RAW (ACR) works seamlessly with Adobe Photoshop, and Phase One's Capture One delivers unparalleled ability to process a large number of images with maximal control. Since the camera

This RAW file of a scene near Siem Reap, Cambodia, looks too dark, lacks contrast and appears desaturated.

Boosting Exposure, Shadow, and Color Temperature settings makes the image look like it was shot on saturated film.

manufacturers include their software with their cameras, compare their results against ACR or other similar programs, and decide which system allows you to work the way you prefer.

Using ACR, included in Photoshop, you can adjust and correct many aspects of the RAW image before conversion. You can open a RAW file by double clicking on its thumbnail in Bridge or with the Open command in the File pull-down menu. The RAW editor opens automatically, displaying the image and a set of sliders in the Adjust menu for altering white balance (temperature and tint), exposure, shadow, brightness, contrast, and several saturation settings. A histogram displays red, green, and blue (RGB) channels. You can toggle between 8 and 16 bits and between various color spaces. The program provides for setting resolution and altering image size. A zoom tool permits close inspection of the image, and an RGB histogram reflects the tonality of the image.

Other icons in ACR display more tools: Curves; Detail (noise and sharpening settings); HSL (hue, saturation, and luminance) for eight colors and Grayscale; Split Toning; Lens Corrections (vignetting and chromatic aberration controls); Camera Calibration; and a folder for custom presets. With these tools, many images will need no Photoshop work.

Given that changing any setting won't harm the original file, the RAW editor program delivers unprecedented power in optimizing and enhancing images. For example, you can boost a washed-out image by increasing Saturation, warming with Temperature, and boosting Shadow. Drag an overexposed image into perfect balance with the Exposure slider in seconds without altering a pixel. Then save your results under different file names to preserve the original. You can save a cluster of settings in the Settings menu.

4

TAKING DIGITAL PHOTOGRAPHS

Opposite: *The pastel clays of Landmannalaugar, Iceland set off the emerald green of summer grasses.*

Although most of the precepts of film photography work when shooting with digital cameras, digital photography demands a few alterations in the way we shoot. Capturing an ideal exposure in digital requires a shift in technique. Decisions on file types, color temperature, and file transfer must be addressed before taking a single shot. Photographers using a DSLR must fear dust or resign themselves to hours spent despeckling their files. Finally, imagining how an image can change in the computer and shooting to create the best raw materials are the keys to harnessing the full power of digital photography.

OLD-SCHOOL EXPOSURE

Exposure—the amount of light reaching film or a sensor—is often determined by using a light meter. A light meter measures the intensity of light falling on its photosensitive cell. In-camera meters detect light reflected off the subject; handheld incident meters measure light falling on a subject. Meters are calibrated to define ideal exposure as 18 percent neutral gray, approximately midway between black and white. It doesn't matter what the subject is; meters always suggest an exposure in which tones average to neutral gray. Metering green grass or a blue summer sky works ideally.

However, the same meter measuring light reflecting off snow will suggest underexposing enough to turn the snow gray. To expose correctly, the photographer must compensate by overexposing between one-and-a-half and two stops to restore the correct amount of brightness.

The meter commits the opposite mistake in a very dark scene, such as a black bear standing in shadow. In this case, it suggests an exposure converting the black bear to gray. To compensate, the photographer must deliberately underexpose between a stop and a stop and a half. See "Exposure Compensation" later in this chapter.

LIGHT METERING MODES

Advanced cameras offer several metering modes; typically, these are average metering, spot metering, and matrix metering. Rather than depend on any automatic system, learn to recognize the conditions that cause meters to lie, and compensate manually.

Average metering. The light meter averages the brightness of the whole scene.

Spot metering. The light meter focuses on a small part of the frame. This works wonderfully when the scene contains a medium-toned object, such as a sunlit deer in a dark forest. By spot metering on the deer, we determine the correct exposure, whereas an averaging meter would insist on overexposure. We can also check highlights to make sure our exposure won't blow out bright details.

Matrix metering. This applies algorithms to guess how to expose a complex scene. Sometimes matrix metering performs miracles. Matrix systems may nail backlighting every time, but other situations might trip them up.

ESTIMATING EXPOSURE SETTINGS

Ask any pro. Determining correct exposure can confound experts, even after years of practice. There are many techniques but no single right answer.

I participated in a shoot with a group of professionals photographing captive raptors in Colorado. John Shaw, a respected nature photographer and author of some of the best instructional photography books, attended the shoot. Many times each day, one of the other photographers would call out, "What's the exposure, John?" He dutifully played his part as human light meter, explaining how to determine the correct exposure for the light and the subject. For instance, it was a "bright bluebird day."

John depended on the Sunny 16 rule, which is always simple, infallible, and even easy when conditions are right. If your camera's shutter speed is accurate, nothing beats Sunny 16. Sunny 16 means setting your shutter speed as close to the ISO as possible, with your aperture at f/16 for a front-lit subject on a sunny day. Thus, a digital camera set at ISO 100 would have a shutter speed of $\frac{1}{125}$ second (the closest shutter speed to 100) at f/16. Open up one stop for sidelight and two stops for backlight. Thus, the backlit exposure on a sunny day would be $\frac{1}{30}$ second at f/16.

Remember that f/16 at $\frac{1}{125}$ second represents only one way to get a given exposure. If you open the aperture one stop (f/11), which lets in twice the light, you overexpose one stop. Doubling the shutter speed halves the light. Thus f/11 at $\frac{1}{250}$ second is the same exposure as f/16 at $\frac{1}{125}$. And f/4 at $\frac{1}{2000}$ second is the same exposure (with much less depth of field).

Other lighting situations or difficult subjects require specific compensation (see the Sunny 16 chart). Open one stop from Sunny 16 for light overcast (f/11) and two stops for heavier overcast (f/8). When no shadows are visible at midday, open three stops (f/5.6). With really bright subjects, such as snow or a brightly lit beach, stop down one stop (f/22).

SUNNY 16		
APERTURE	LIGHT	SHADOW DETAIL
f/16	Sunny	Distinct
f/11	Light overcast	Soft edges
f/8	Overcast	Faint
f/5.6	Heavy overcast	No shadows

Other photographers habitually employ different techniques. Art Wolfe usually looks for a medium-toned component of the scene and reads the reflected light with the spot meter in his camera. Jim Zuckerman prefers a handheld incident meter to measure light falling on the subject; however, most of the time, he predicts the correct exposure within half a stop no matter how difficult the light. When he explained how he does it, it made my head hurt.

TIP	CALIBRATING THE METER

If the meter recommends f/11 at $^1/_{125}$ second at ISO 100 for a front-lit subject on a sunny day, the resulting exposure will be one stop overexposed, because according to the Sunny 16 rule the correct exposure should be f/16. Setting the Exposure Compensation to -1 tricks the meter into suggesting f/16 at $^1/_{125}$ second, a correct exposure for Sunny 16. The meter is now calibrated without the expense of a trip to the photo technician.

To confirm that they nailed the exposure, some digital photographers depend on the histogram (a bar graph, available on the LCD screen on digital cameras, that measures light intensity across the visible spectrum). The histograms on cameras are JPEG versions of the RAW file and may be a bit off, unlike histograms in software programs; nonetheless, they are still vital. Learn to work with the histogram in your camera.

Each of these methods can yield good results, but Sunny 16 never fails—although the photographer may. John Shaw recommends calibrating your in-camera meter against the Sunny 16 rule (see "Tip: Calibrating the Meter") because most in-camera meters are a little bit off, sometimes as much as a whole stop. Set the Exposure Compensation to adjust for the metering errors.

EXPOSURE MODES

Digital cameras come equipped with various exposure modes designed to simplify capturing a good exposure. Except for manual mode and some program settings, they all deliver an average exposure. In other words, shutter speed and aperture may vary for each mode, but they all allow the same amount of light to hit the sensor, based on an averaged reading of the scene.

Manual. In manual mode, the photographer decides whether to over- or underexpose and how to select aperture and shutter speed. If you want to shoot Sunny 16 or learn how to control every aspect of exposure, practice with manual to learn how meters behave and how to determine optimal exposure when lighting deviates from 18 percent gray. Nothing improves exposure mastery faster than shooting in manual.

Program. Program, or matrix metering, employs complex algorithms to deduce the correct exposure. The algorithms nail tough exposures such as a dark backlit scene, but just as often they fail when things get complex. They also have a bias for faster shutter speeds, as if they expect everyone to hand-hold the camera. Use program metering when subjects and light change quickly and unpredictably.

One time when I was in Africa, a herd of elephants surrounded my vehicle. They were front lit, backlit, and sidelit; they were standing, walking, and waving their trunks. I switched lenses while they approached and as they skirted

my Land Rover. I didn't have time or the inclination to determine exposure, and the program setting performed splendidly amid the stately chaos.

Aperture priority. This is an averaging setting in which the aperture remains fixed and the shutter speed changes to accommodate different light intensities. This is the automatic setting of choice when you need to define a specific depth of field and shutter speed doesn't matter. For a landscape in which everything from foreground to infinity must remain in focus, set the camera to a small f-stop, such as f/16. If you want a shallow range of focus to isolate a flower from its background, set the aperture at f/2.8 or thereabouts.

Shutter priority. In this averaging setting, shutter speed remains constant and the aperture varies to suit light intensity. Use shutter priority when depth of field doesn't matter but shutter speed does. If you wish to freeze the motion of a running deer, set shutter speed at $^1/_{250}$ second or faster. The aperture will open wide so depth of field will collapse, but the deer will look sharp. If you want a blurred effect for moving water or while panning on a moving object, set the shutter at a slow speed.

Subject icons. Many digital cameras come with exposure modes suited to particular subjects represented by icons. A flower icon signifies macro; a running man means action mode. These modes combine exposure and focus settings to match these subjects. Since most landscape shots require maximal depth of field without regard to shutter speed, selecting the mountain icon (or equivalent) will set the camera to a small aperture and slow shutter speed; selecting the running man will do the reverse.

EXPOSURE COMPENSATION

When a scene deviates from neutral gray, automatic settings require compensation, and modern cameras include ways to enter the amount needed. For example, a bright snowy scene needs one-and-a-half to two stops of overexposure. Setting Exposure Compensation to $+1^1/_2$ tells the camera to let in the extra light. In manual mode, simply alter the exposure to compensate.

DIGITAL EXPOSURE

A surprising number of talented photographers I otherwise admire are stuck in the 1990s. They shoot digital as if it were film, underexposing to add saturation, and in the process throw away much of the information the sensor could record. Worse, they advise their students that this is best practice.

In the days of film, we concerned ourselves with emulsions rather than pixels, underexposing to boost saturation. Velvia greens would pop more vibrantly while slightly underexposed Kodachrome skies became icy blue. In the digital world, film precepts have been turned upside down. For the most detail and least noise, overexpose without clipping the highlights.

Sensors don't behave like film. Instead of particles in film—a film emulsion reacting to light during exposure and chemicals during development—a digital sensor responds linearly to additional light. One stop of added brightness triggers twice the voltage. More voltage translates into more tonal

TIP | WHAT IS A HISTOGRAM?

Digital cameras display a histogram—a jagged graph that looks like a stock-exchange chart during interesting times. The spikes and flat lines represent the relative amount of light at each frequency of the visible range. The histogram for a dark picture with a lot of shadow will be heavily weighted toward the left. A snowfield on a cloudy day will shift the histogram to the right. Since a histogram reveals the distribution of light by frequency, it acts as a retroactive light meter.

People regard histograms the same way ancient Greeks regarded oracles. We don't know exactly what they mean, but we know they are important.

Histograms are bar graphs that represent the tonal range of an image. If you can read a one-year chart of the Dow Jones, you can understand a histogram. The bottom of the histogram defines the tonal range from 0, absolute black, to 255, brightest white. The bars rise above the base to indicate the proportion of the image occupied by a given tone. If most of the image were midtoned, such as a green meadow and blue sky at midday, the bars would congregate around the middle of the graph. A picture of a white rabbit in snow would produce a histogram with most of the bars on the far right. In short, a good histogram reflects the tonal content of the image.

With experience we learn what to expect. If the histogram of our blue sky and green meadow shot bunches to the left, it must be underexposed. We can compensate by shooting again at a wider aperture or longer exposure. Brightening an underexposed image in Photoshop works but introduces unwanted noise.

If the histogram bunches to one side and falls precipitously at either end of the histogram, it is clipping the image. The exposure exceeds the range of the sensor so the camera records everything beyond the boundary as the

CONTINUED ⇥

information, a doubling per stop. Half of all the tonal information a sensor captures resides in the brightest stop. Conversely, the darkest stop contains almost none. (See Figure 2.)

Current digital cameras employ an analog-to-digital converter to translate analog information into the digital realm. Data are presented in 12, 14, or 16 bit, with the larger bit rates containing more information (i.e., resolution). A 12-bit conversion displays 4098 values from black to white, whereas 16-bit conversion displays 65,536 values. Opt for the highest bit rate.

If we have a camera capable of recording ten stops with 8 bits, we find half of the 4098 tonalities in the brightest stop, which includes all the tones from pale white to pure white. The next brightest stop contains half of the remainder, 1024. By the time we get to the darkest stop, only 32 tonal gradations remain,

WHAT IS A HISTOGRAM? (CONTINUED)

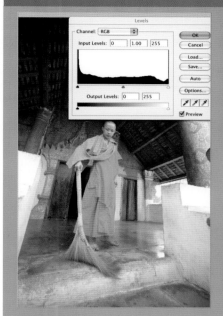 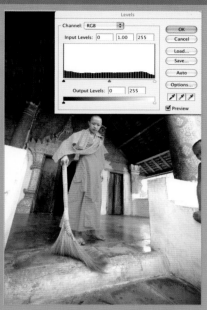

The histogram reflects the even tonality of this image.

I purposely clipped the extremes to illustrate tonal dropouts in the histogram—the comb effect.

brightest or darkest tone on the histogram. The camera is failing to record information, which reduces detail and dynamic range. Try an exposure that doesn't clip the histogram.

and those tones are overwhelmed by noise. (Noise is produced by the sensor itself and by light hitting the sensor. The effect is similar to cassette tape hiss with the Dolby turned off. Even without noise reduction, loud music masks the hiss, a consequence of the signal-to-noise ratio tilting toward signal. With a digital image, more tonal values equal more signal, which masks the noise. It's still there but more difficult to discern.)

"EXPOSING TO THE RIGHT"

When shooting digitally, you can increase shadow detail and decrease noise by "exposing to the right." This allows the sensor to capture the maximum amount of information. The resulting image will appear overexposed, but adjusting brightness on the computer will restore proper color and tonal balance.

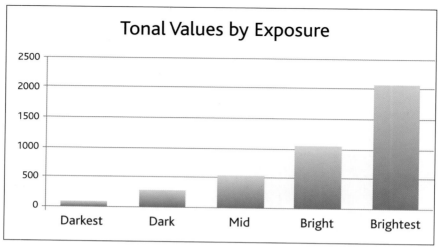

Figure 2. Tonal information in a 12-bit image file from the darkest stop to the brightest

Take a test shot and check the histogram on the camera. An average exposure of a midtoned subject will produce a bar chart with flat lines at the right and left margins, which tells you that there is little information at the exposure extremes.

Now overexpose the next shot so that the histogram information almost touches the right-hand border of the chart. If the histogram indicates that the exposure exceeds the sensitivity of the sensor and blows out the highlights (known as clipping), reduce exposure slightly. When the right-hand information almost touches the right side of the histogram, you know you have captured the maximum amount of data. The resulting image will appear much too light, but you can reduce brightness in a RAW editor or another editing program (see Chapter 5: Workflow). This ideal exposure displays the greatest tonal range and fewest artifacts.

Digital sensors can't deal with blown-out highlights. Once light intensity crosses a threshold past the right side of the histogram, the sensor no longer records the increasing brightness. When the light is very intense, such as a streetlight on a dark street or the sun setting, we get an ugly halo around the light source. This is a result of "charge leakage," where excess electrical charge from the overloaded sensor corrupts neighboring sensor sites, creating halos. If this happens, you can clone neighboring bright areas into the halo. While not strictly accurate, it looks more natural than leaving the halo intact.

Overexposing to move the histogram to the right resembles shooting with lower ISO film. Slower film tends to have finer grain. Shooting to the right (overexposing) with a digital camera requires longer exposures or larger apertures and produces less noise (digital "grain").

Shooting to the right only works for a few stops of overexposure. Over-exposing by many stops yields weird colors. Since camera histograms are JPEG approximations of the RAW data, it is often possible to extract a little more detail from highlights than the histogram suggests with exposure tools in RAW editors.

NOISE

Digital cameras introduce noise during long exposures. After only a few seconds of exposure, tiny dots resembling snow or colored glitter appear in the image's dark areas—that's noise. Because exposures shot at the first and last light of the day often require 30 seconds or more, especially with low ISOs or small apertures, noise is a concern. Noise will obliterate a 2-hour exposure for star trails. Also, higher ISOs generate more noise per unit of time than lower settings.

Digital cameras feature noise suppression. Most editing programs and a herd of plug-ins tackle noise in the computer with good results.

However, sometimes noise enhances an image. Adobe Photoshop includes a scalable filter for introducing noise to an image to mimic high-ISO films. A high-contrast black-and-white image, with minimal Gaussian blur applied, takes on the features of an infrared image after noise is added. Plug-ins that mimic film stocks, such as Alien Skin Software's Exposure or DxO's FilmPack, deliver convincing film grain.

BEFORE SHOOTING DIGITAL

Testing equipment and redundancy prevents most digital mishaps from spinning into catastrophes, although gremlins will always be with us. Before leaving home the first time, make sure all your equipment works together.

SET THE WHITE BALANCE

Before shooting, set your camera's white balance to deliver the effect you want. White balance adjusts color temperature so that white objects appear white. Most digital cameras provide for automatic settings, color temperature presets, and manual calibration.

Automatic White Balance. The automatic setting evaluates a scene captured by the sensor. The camera's algorithms—a set of instructions and assumptions—essentially guess which white balance will produce unshifted color. In practice, Auto White Balance delivers adequate calibration that frequently desaturates colors present in the scene. Auto settings can drain color from a sunset as they try to create white whites.

White balance presets. These do a decent job when you know the approximate color temperature of the scene. These presets are usually represented by icons such as a sun or a lightbulb. Although these presets merely approximate optimal settings, they work well enough for most applications.

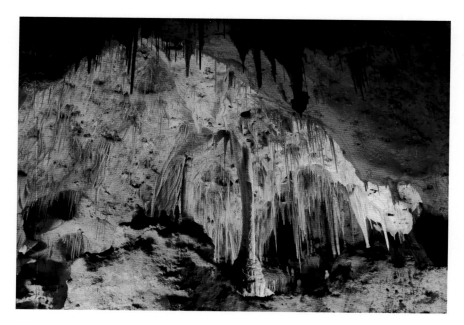

The artificial light in Carlsbad Caverns looks warm with a daylight white balance.

Film photographers who are converting to digital feel comfortable using the Daylight setting since it replicates the white balance of traditional daylight film. It captures the warm tones of magic light and endows most subjects lit by artificial light with a yellow or green glow.

Manual white balance. You can calibrate the white balance of your camera manually to guarantee an ideal setting. Take a picture of a bright white card with a fine line drawn through it. Ensure that no objects with bright colors are adjacent to the card, because they can reflect colors onto the card. Overexpose by one-and-a-half to two stops to obtain proper exposure. If you overexpose more than that, the line drawn on the card will look too pale. When you have the right exposure, you can use the camera's manual white balance procedure to complete the calibration.

SHOOT A DIGITAL GRAY CARD

Some studio photographers ensure correct color balance by shooting a gray card at the beginning of the session in the same light they will use on their subject. After transferring files onto the computer, they go to the Levels or Curves palette, select the midtones eyedropper, and click on the image of the card. The program adjusts the color appropriately. With the correct setting in hand, they apply the correction to the remaining files.

You can do the same thing in the field if you want to be very precise. If you know you are getting a blue color cast in open shade under a blue sky, photographing a gray card in one of the shots and performing the adjustment

at the computer will work with greater accuracy than the Shade setting on your camera, which is an approximation.

However, gray cards are not always an option. The lion under the tree may object to your placing the card on his front paws, and a distant sunlit mountain is out of reach. In these situations, substitute your physical gray card with a virtual one. Add a digital gray card to the first image in a series, calibrate, and apply the correction to the rest of the images taken in that light.

At the computer, open the image, and then open a new layer by clicking the New Layer icon at the bottom of the Layers palette (a rectangle inside a rectangle) or within the pull-down Layers menu. Fill it with 50 percent gray by clicking Fill and then Foreground Color in the Edit menu. Set the Blend mode near the top of the Layers palette to Difference. Choose Threshold from the Create New Adjustment Layer menu in the Layers menu or by clicking the icon on the Layers palette, a half-black circle.

A histogram appears. Drag the middle slider left until the image turns white. Then slowly drag it right until just a bit of black appears. That black is neutral gray in the actual image. Depress the Shift key and click on a black spot. This inserts a color sampler mark.

Cancel Threshold and drag the gray layer to the Layer palette trash can. Open the Levels or Curves dialog and select the gray-point eyedropper. Click at the marker placed on the image by color sampler. Voilà. Proper color balance is achieved.

No law insists you must employ a neutral white balance. You can calibrate with a color opposing your desired hue. For example, a light blue card will add warmth to a scene; a light yellow card will cool it down.

TURN OFF IN-CAMERA SHARPENING

Before you shoot, turn off in-camera sharpening. If you can't turn it off, use the lowest setting to reduce the effect.

CHECK MEMORY CARDS

Add up how much memory you carry. Calculate how many shots you can get on a memory card in the format you choose. I like to carry enough memory cards to shoot twice as much as I expect on the busiest day. You can stretch your cards' capacity by editing in-camera during the day and deleting the obvious mistakes. Just remember that reviewing images with the camera LCD screen gobbles battery power.

Decide how much faith you want to place in a single memory card. As the capacity of memory cards increases, the potential for disaster grows as well. With my 22-megapixel Canon 5D III, an 8-gigabyte card gives me about 266 30-megabyte files when I shoot in RAW format, which is a lossless compression format. That translates to almost eight rolls of film. If the card fails for any reason, that is the limit of my risk. A 16-gigabyte or 32-gigabyte card, although convenient when shooting, doubles and quadruples the risk. If I were to photograph in the compressed JPEG format, I could lose thousands of images

and days of effort in a moment. The wise digital photographer will carry a few smaller cards instead of a single big one.

CHECK IMAGE STORAGE SYSTEMS

For years my storage in the field relied on hard-disk drives. These are inherently fragile, so I always brought at least two drives, sometimes three. Each night I downloaded my memory cards onto both drives. I was still at risk because I wouldn't be able to download to the drives if my laptop failed. I added a digital wallet—a hard drive with a built-in card reader—to my arsenal and sometimes left the computer and hard drives at home, relying on two wallets.

Digital wallets pack a lot of storage in a small package. If you want to travel with a couple of wallets in lieu of a laptop computer, make sure one of them has a screen so you can confirm that your camera and cards are working correctly. If you are shooting RAW files, make sure the wallet can read that format. When your wallets are filled, you can free up space by deleting the real stinkers. If you shoot with a high-resolution camera, get as much storage as you can. After a day's shooting, I download each card to both wallets, confirm that the files arrived intact, and then format the card to ready it for the next day. Before each trip I always test each drive.

Lately I've resorted to carrying a handful of 32-gig SD or CF cards. Lightweight, compact, and shock proof, 200 to 400 gigabytes of storage cost less than a digital wallet. I can back up with a card reader if I bring a computer.

While you can store your images on a laptop computer, it's wise to back up to portable drives or SD/CF cards.

PREPARE FOR ELECTRICAL COMPATIBILITY

When traveling to a foreign country, bring an assortment of adapter plugs and use a transformer to ensure that the voltage won't fry your gear. Retailers and websites specializing in foreign travel can point you in the right direction.

PRE-SHOOT CHECKLIST

Nothing is more disappointing than equipment failure, unless it's operator failure. The digital workflow can break down in both these ways, in myriad fashions. In addition to the usual camera failures, you can experience memory card malfunctions, digital wallet crashes, computer meltdowns, recharger mishaps, and battery collapse. Compound these miseries with incompatible connectors, missing cables, operating system conundrums, and conflicted formatting, and you begin to envy the film photographer shooting with an old mechanical Leica rangefinder that still shoots with a dead battery.

Paranoia is a healthy state in the digital world. Make sure everything you need is packed and ready before you leave.

1. Recharge all rechargeable batteries, including those in wallets and computers. Bring extra batteries for flash.
2. Test and clear your memory cards.
3. Lay out your computer and other storage devices.
4. Lay out all cables and power supplies (I like to keep mine in labeled, resealable plastic bags).
5. Lay out chargers.
6. Lay out the primary camera and backup body.
7. Lay out lenses, filters, flashes, cleaning supplies, and whatever accessories you use, such as reflectors.
8. Don't forget the tripod.
9. Clean everything, especially the camera sensors.
10. Check to confirm that your camera settings conform to your preferences or the situation you expect to find. Look at ISO, white balance, file format, focus and exposure setting, motor drive, and exposure mode. Otherwise, a fleeting opportunity may pass you by while you fiddle with the body. Worse, you could fire a burst toward a startled critter only to discover that the camera was set for low-resolution JPEGs using aperture priority set at f/22, leaving you with one blurry, pixelated image.

IN THE FIELD

A digital photographer must carry a load of gear in the field. You must pay attention to transporting the gear, keeping it operational, and preserving the images. After you are satisfied that everything is ready to go, pack it in your camera bag. You may need to transfer items to other bags for transport, but make sure you can carry your kit once you are on site.

CARRYING THE GEAR

Whether you are embarking on a full-scale expedition or a stroll down the street, you have to carry the gear somehow. There are infinite variations of shoulder bags, suitcases, and backpacks designed for photographers. Your choice depends on how and where you photograph.

Rigid suitcases protect gear best, and some are waterproof enough for white-water river trips—they even float. Usually made of metal or rigid plastic, they come with open-cell foam on the inside. Cut the foam to fit each piece of equipment. This defends against shock, dust, and moisture. The shiny metal versions reflect heat, which affords some protection to delicate electronics in very hot climates. On the downside, they become very heavy when fully loaded, so walking around with them is like carrying a dumbbell in one hand. They scream "professional photographer," an invitation to thieves. I use them when I must check baggage, but I place each one in a cardboard box to camouflage its value. When I arrive at my destination, I transfer the gear to a more convenient case.

It's easy to work out of a camera bag with a shoulder strap. Most open from the top, so you can see all your gear at once. I find they work well when I carry a single camera body and a couple of lenses, but when I'm toting a lot of gear, the shoulder strap digs in and the weight makes my back ache by the end of the day.

I prefer photo backpacks for longer trips or anytime I carry super telephoto lenses. A photo backpack distributes the weight across the shoulders, back, and hips; provides plenty of pockets; and makes it easy to find your gear. Also, the more you look like a backpacker, the more likely it is that thieves may suspect your pack contains dirty socks rather than valuable camera gear.

Traveling by air. As carry-on restrictions become more stringent each year, traveling with photography gear becomes more trying. When I first flew to Africa, the airlines allowed me to carry on all my photography gear (not counting a tripod) and a bag of film the size of a basketball. Digital photography doesn't require the basketball anymore, but computers and storage devices pose new challenges.

I carry on everything fragile. This includes zoom lenses, my primary camera body, all memory cards, and anything with a hard disk, such as a digital wallet or a laptop computer. Fixed lenses, tripods, backup bodies, and so on go into hard-case luggage. It's wise to disguise an obvious photo case by putting it in a box, but regular suitcases do a good job and don't attract attention. I wrap the gear in my clothes to protect it from the gentle attentions of baggage handlers.

Make sure to lock luggage after the security staff scans it. Transportation Security Administration (TSA) staff carry master keys that open certain approved locks. They will open your locked case and relock it when they finish inspection. Luggage retailers stock TSA-approved locks.

Backpacking. A different set of issues confronts the digital photographer who leaves the grid and sets out afoot. When backpacking, weight is the enemy.

Canny compromises shed the most weight while maintaining the greatest possible flexibility in the field.

Bring an ultralight tripod. It may be a bit rickety, but hanging something heavy from it, such as a camera pack or a food bag, adds stability. Carbon-fiber tripods minimize vibration, don't conduct the cold, and are lighter than metal equivalents, albeit at a premium price.

Although professional camera bodies deliver the highest resolution, they are heavy. Consider bringing a lighter, more fragile, lower-resolution body on longer hikes. I leave my 16-megapixel Canon 1Ds II at home and bring the much lighter 8-megapixel Digital Rebel. Not only is the body lighter, but it runs on featherweight batteries, too.

To counter the reduction in file size, I create wide-angle shots by stitching together two or three adjacent vertical images using a longer focal length lens. The composite gives me the same angle of view as a wide angle but more than doubles the file size and therefore the resolution. On a rock climb when every ounce counts, 8-megapixel point-and-shoots produce acceptable results while weighing about a pound total.

When I carry a single-lens reflex body, I bring one zoom lens. I like something in the 24mm to 105mm range. Instead of carrying a special macro lens, I add a close-up lens, a magnifying filter that permits tight focusing. Not only is it lighter than a macro lens or an extension tube, but a close-up lens suffers no light falloff and thus requires no exposure compensation.

BRINGING EXTRA BATTERIES

Good luck finding an outlet for your battery charger in the wild. Carry more than enough batteries to last for and during the entire trip. When calculating your battery needs, remember that cold conditions reduce battery life. Solar chargers are nifty, but they add weight and drain the wallet.

PROTECTING YOUR GEAR

Sometimes it seems as though the natural world is bent on destroying photographic equipment. Rain, snow, dust, and windborne sand work their way onto and into cameras and lenses. Don't count on camera bags to protect them.

For travel in really wet environments, such as rafting, sailing, or hiking in the tropics, put your delicate gear in dry bags; these are found at kayak and canoe dealers. For less-soggy conditions, large resealable plastic bags suffice; they also work just as well in dusty conditions. I always carry extras.

When preparing to shoot in rainy or dusty situations, protect the camera and lenses with a resealable plastic bag and some rubber bands. Cut the zipper off the bag and slit the bottom of the bag. You now have a plastic tube. Place the camera in the tube and wrap a rubber band around the lens near the front. Make sure the plastic doesn't interfere with the lens. Use an ultraviolet (UV) filter to seal the lens. If the viewfinder protrudes from the body, gather enough plastic to cover it, cut a hole for the viewfinder, and fasten the plastic

with another rubber band. For very long telephoto lenses, make a tube with a larger garbage bag.

When changing smaller lenses, use a large plastic bag or an old film changing bag to block dust. Keep the end caps on the lenses until just before you affix them to the camera body. Compared to loading film in a medium-format camera blind, swapping lenses is a snap.

In some conditions, no matter how fast you swap lenses, dust will make its way inside. Imagine shooting on Kenya's Amboseli Plain; the least wind kicks up a fine dust from the dry lake bed. In such nasty conditions, I bring a separate camera body for each lens I intend to use on a given day. For example, in Amboseli I put my primary body on my 500mm lens and a 70mm–200mm zoom lens on my backup camera. This presupposes that you carry a backup and can live with only two lenses over the course of the day.

Some cameras seem to attract dust more than others. A lot of unproven notions are out there, all unsupported by evidence. Some people believe charge-coupled device (CCD) sensors attract more dust than complementary metal-oxide semiconductor (CMOS) sensors; other people swear you must turn off the camera so the sensor isn't charged while exposed to the open air. Others insist the movement of the mirror during "motor drive" shooting stirs up dust inside the camera, causing dust to adhere to the sensor glass. Who knows?

KEEPING CLEAN

After shooting, dry your gear or blow off dust before storing it. I try to take dust in stride. If I can see a few small spots after cleaning, I usually decide to deal with the problem later in Photoshop using the Clone tool or Healing Brush. If things get really vile, let a technician clean the camera when you get home. The technician is likely to remove dust destined for your sensor inside the body.

Cleaning the sensor. If you shoot with a digital camera and interchangeable lenses, sooner rather than later you'll notice motes on your images: the signature of dust on your sensor. Sensor cleaning gladdens the hearts of obsessives, but I find it the most annoying part of digital photography. Fixed-lens cameras deny dust entry to the chamber, so their sensors remain clean.

The dust doesn't accumulate on the sensor proper. A glass cover or filter protects the sensor from damage and dust. This glass can be scratched, smudged, or otherwise degraded, and the first rule of cleaning is do no harm.

If you must clean the sensor, find a brightly lit work space. Make sure the battery is charged or plug the camera into an electrical outlet. If a camera loses power while you are cleaning the sensor, you will need to take it to a repair shop. Activate the cleaning protocol in your camera. This will open the shutter and swing the mirror out of the way, giving you access to the sensor surface. Remove the lens and hold the camera so the opening faces sideways or down. This may reduce the amount of dust landing on the sensor glass as you clean it.

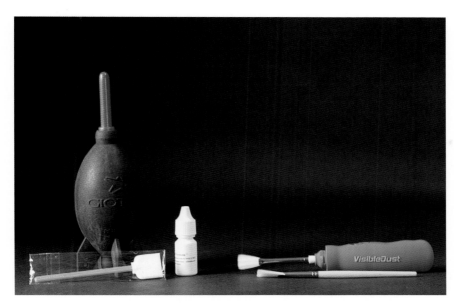

Cleaning tools: blower, swab, liquid, static brushes

Charging and cleaning the VisibleDust Arctic Butterfly brush

Before touching the sensor glass with anything, try blasting it with air. Don't blow into the camera. The safest method involves a hand-squeezed blower bulb. It's hard to get enough force with small bulbs, so look for one that fills your whole hand. Move the nozzle of the blower into the camera, taking care to avoid touching the glass with the nozzle. Squeeze vigorously a few times. After a visual inspection replace the lens.

To check for dust after cleaning, shoot a frame of blue sky or any other uniformly bright or midtoned subject. Turn off the autofocus and throw the lens out of focus manually. Bring the image up on the LCD and magnify it as much as possible. Scan the image for dust. If any dust remains on the sensor, it will be easy to see.

For a hardware solution, buy a loupe ringed with LEDs that lights up the sensor to reveal any remaining dust.

Some photographers use compressed carbon dioxide (CO_2) gas rather than squeeze bulbs. Ordinary compressed air, which contains propellants that accumulate on the sensor surface, must be avoided; CO_2 cartridges designed for air rifles contain additives that may cause problems too. Regular CO_2 cartridges produce a very strong stream of air; although CO_2 gets the dust moving, it can also force it into inaccessible parts of the camera. Another disadvantage is that CO_2 cartridges are not welcome on airplanes these days.

The most effective and easiest solution for removing dust and other particulates is with the Sensor Brush from VisibleDust of Canada. Various sizes are available for use on different-size sensors. The brushes are reusable and washable. To clean a sensor, blast the bristles with either condensed air or with puffs from a large bulb. This removes dust from the bristles and gives them a positive charge. Sweep across the sensor once, and blast the bristles again to clean and charge them before sweeping again. Repeat as needed. VisibleDust also offers brushes with twirling devices that clean and charge the brush. The Arctic Butterfly is such a unit with small brushes, suitable for touch-up cleaning. The Sensor Brush SD attaches to the larger brushes for tougher jobs. If the bristles acquire bits of gunk that blasting with air or twirling won't remove, wash the brush with mild soap or isopropyl alcohol. (Don't use methanol; it will destroy the bristles.)

Moisture can weld dust spots to the sensors that the brushes can't remove. Just breathing on the sensor transfers moisture, which attracts dust. When this happens, a liquid solvent must be used. With my lack of dexterity and inability to apply just the right amount of cleaning fluid, I often end up with streaks that take many frustrating minutes to eradicate. Sensor Swabs or VisibleDust's Swabs minimize streaking. Shaped like miniature white brooms, these swabs allow for precise application of cleaning solution. Each swab can be used twice. Sweep in one direction, which should cover half the sensor, and then sweep in the other direction with the other side of the swab so that both halves of the sensor receive one swipe. Larger sensors require two Sensor Swabs or one large VisibleDust Swab. Swabs are pricey gizmos; use them only when air or brush cleaning fails. Phase One offers a two-step solution using a quick-drying liquid and absorbent cloths.

A few DSLR cameras come with dust-reduction technology, which removes dust automatically from the sensor. While not perfect, these systems take care of most dust. Soon, most cameras will feature some form of dust reduction, thus removing the most annoying tasks SLR shooters face: cleaning sensors and retouching images in Photoshop.

Don't forget to give your electrical contacts a blast of air when you're done with the sensor. You don't want the connection with a computer to fail during downloading. Every now and then, treat the contacts with an antioxidizing contact cleaner. These can be found at high-end hi-fi stores.

STORING AND ARCHIVING

Disasters could befall a film photographer, but with a moment's inattention or the failure to back up data, a digital photographer can lose hours, days, or weeks of work. Film can overcook in the back of a car or fall into a creek, but nothing compares to your only digital wallet crashing midtrip with only a few memory cards in reserve.

Take to heart Firesign Theatre's Department of Redundancy Department. Back up your backups. Download your images to a digital wallet and back those up on a laptop and an external hard drive. Burn CDs or DVDs of your best images while on the road. Fill extra cards with duplicate files. Storage media vary in capacity, stability, convenience, and reliability; only CDs or DVDs are reasonably stable, and of those, gold lasts the longest.

These habits will save you sooner rather than later.

5

WORKFLOW

Opposite: *Artificial lights make Bangkok's Wat Arun,*
the Temple of the Dawn, glow golden after sunset.

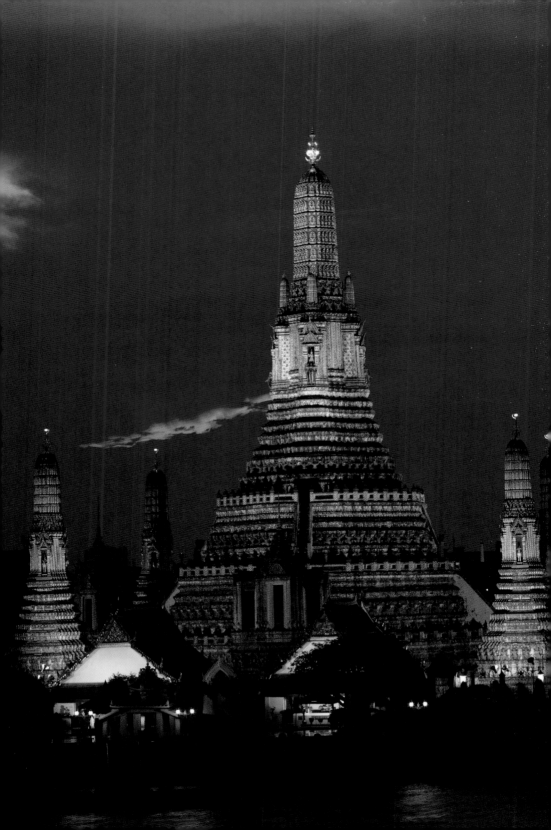

Workflow for slide film is a simple matter: take the picture; get the roll developed; edit, label, and file the slides. The order of tasks is self-evident and relatively quick. Workflow for digital photographers is full of opportunities, choices, and pitfalls because we control every step of the process, from exposure to print. Establishing a sequence of tasks to master the workflow yields the best possible results and reduces the chance for missteps, such as losing or damaging an image.

Everyone needn't follow the same steps. Goals differ. Shortcuts that satisfy amateurs may prove disastrous for professionals. For most photographers, only a few images per day truly deserve the most fastidious repair or color and contrast optimization. As you work with digital files, you can decide where to put your energy and which compromises work for you.

TIP	EDITING

Editing has two meanings in the digital darkroom. First, it refers to managing images in a collection. Second, it means altering color, contrast, exposure, and other elements of an image.

WORKFLOW: AN INTRODUCTION

I used to depend on Adobe Photoshop for the majority of my editing chores, but Adobe Lightroom has supplanted it in my workflow. For most people, the tools found in their RAW editor (e.g., Lightroom, Adobe Camera RAW, Capture One, DxO, or Apple Aperture) are sufficient for performing the critical image editing functions. I use Lightroom for initial edits and to house and organize my images.

When I edited in Photoshop, I placed my images in folders, but it was easy to lose track of images: Did an image of a penguin go in "Birds" or "Antarctica"? I then converted the RAW images into TIFFs or PSDs and performed corrections and enhancements to the image in Photoshop. Simple corrections in Photoshop were baked into the file after saving unless I saved large, layered images. If I modified contrast in Curves and added a tint, the program would change the pixels, and there was no way to undo the operation. This was a destructive workflow.

It was possible to edit without irreparably changing pixels by using layers of various types or Smart Objects (discussed in Chapter 6: The Power of Photoshop). However, this added a level of complexity to the workflow and increased the file size. Editing with a RAW editor means any changes are reversible. Leaving the world of folders for a database simplifies organization and management of a large collection. Before outlining an effective workflow, let's look at how Lightroom and its peers work.

RAW EDITORS, BROWSERS, AND DATABASES

Editors, browsers, and databases fulfill different functions. Editors apply settings to RAW files and convert them to different file types. Browsers view files in a folder and can apply caption and metadata settings and perform limited searches. Databases create searchable virtual catalogs that contain information on images from one or many disks. Some databases include an editor as well.

WORKING IN RAW

Once you've decided to shoot and work with RAW or DNG files, you need to choose a RAW editor. A RAW editor at minimum converts a RAW or DNG file into a format that Photoshop or another image editor can manipulate. Most RAW editors are appended to a suite of other features that allow for direct nondestructive image editing of the RAW file before output to another format such as TIFF, JPEG, or PSD. While camera manufacturers often include proprietary RAW editors to decode files straight from the camera, most folks opt for an editor within an image editing and filing program. Adobe Camera RAW (ACR), a component of Photoshop, Elements, and Lightroom, is the current heavyweight champion, but excellent alternatives exist.

Nothing you do to a RAW file changes the file itself. It applies a set of instructions to the file to be applied during the conversion from RAW to a format editable by Photoshop et al. After conversion, the original file remains, its instructions intact. Those instructions can be altered at any time or deleted to return the file to its original state. You can create multiple versions of the file, but every version is merely a tiny subfile of instructions that takes up almost no space on your drive. The original file is always preserved.

While Adobe's products dominate the market, several worthy competitors offer attractive features and interfaces.

Aperture. Apple's Aperture does a first-rate job of RAW conversion with the Mac's customary ease of use. The interface harkens back to iPhoto, the image editor that comes with the Mac's OS X operating system, albeit with more capabilities. Like Lightroom, Aperture features targeted adjustments via brushes to paint in changes to parts of an image with controls for brush size, softness, and intensity.

Capture One. Developed by the Danish medium-format camera company Phase One, Capture One may have the most sophisticated RAW converter on the market. Capture One creams ACR on files shot on Phase One cameras and delivers something extra to files shot on cameras from the Japanese giants too. The meanings of the interface icons are not self-evident, but once you overcome that hurdle the software performs wonders.

DxO. Nobody automates RAW conversion like DxO. With a single click, the software optimizes color and contrast, suppresses noise, and sharpens. Chromatic aberration, distortion, and light falloff for most lens/camera combinations at every f-stop are modeled. It's easy to leave the comfort of automatic

processing to take control of each step. However, there is no provision for selective application of effects as yet.

BROWSERS

A browser provides a view into folders. Adobe Bridge, part of Photoshop, is a classic browser that displays the thumbnail for any kind of file, including image files. This makes it ideal for graphic artists who need to meld together files from several programs. A web ad may need files from Photoshop, Illustrator, InDesign, and Dreamweaver. Bridge is a hub for all the programs, a holding area for the files.

Double clicking on a thumbnail in Bridge opens it in ACR if it's a RAW or DNG file, in Photoshop if it's in a TIFF, JPEG, or PSD format. Browsers include tools for file management, including renaming, keywording, and directing images to specific tools in editing programs. However, photographers with large image collections find the folder-based browser architecture clumsy and limiting.

Each image is in a folder in a specific location, such as an external hard drive. In a well-organized system of nested folders (e.g., a folder titled "Birds") and subfolders (e.g., subfolders for "Eagles," "Hawks," and "Storks"), it's easy to find an image.

With larger collections, this becomes a laborious process. Imagine that you want to create a slide show about America's national parks. You'd need to move or copy images from many folders: birds, bears, mountains, meadows, rivers, states, people. Moving an image degrades the collection's organization; copying an image for a new folder uses disk space and creates redundancy. If your laptop isn't connected to the hard drive with the folders you need, you can't work on the slide show. An image selected for several projects compounds the potential chaos.

DATABASES

A database remedies a browser's limitations by changing the rules. You can park an image on any drive. The database contains a catalog with thumbnails that "remember" the location of each file and stores information about each image. The image can be anywhere, but the information and thumbnail remain available in the database on your computer, a relatively small file compared to the folders full of images. Because the database can search everything at once—sorting by any kind of metadata—the results come quickly.

It is misleading to state that the photographer "imports" images into the database. In fact, the import consists of location information, metadata, file data for generating thumbnails, and so on. The image itself resides outside the database, safely housed wherever you placed it.

The most popular digital asset managers (DAMs) are databases. Apple Aperture for Macintosh computers and Adobe's Lightroom for Windows and

Mac are the industry leaders and offer similar features. Phase One's Capture One RAW editor in combination with its Media Pro database covers the same ground. Adobe Lightroom is the most popular fully featured database with RAW editing capabilities.

LIGHTROOM

Lightroom works on both Macs and PCs, and many of its tools are found in Adobe Bridge as well. It consists of seven modules:

- *Library.* Save, organize, and perform simple edits on imported files. Convert RAW files.
- *Develop.* Enhance RAW, JPEG, and TIFF files with these tools.
- *Map.* Geotag your images with this app.
- *Book.* Create a book and export to Blurb or other publishers.
- *Slideshow.* Build a slideshow with special effects.
- *Print.* Prepare and print individual images or sets of images.
- *Web.* Create and export Flash, HTML, and other galleries.

Expect to spend most of your time in the Library and Develop modules.

TIP	LIGHTROOM 5

The latest version of Lightroom just arrived.

- ❑ Smart Previews in the Library module permit the editing of images without access to the original RAW file, allowing us to work on images while on the road.
- ❑ The Develop module gained three powerful tools: Healing Brush, Upright, and Radial Gradient.
- ❑ The Healing Brush heals imperfections and removes dust and other distractions more seamlessly than the Clone tool. Instead of being confined to a spot, the tool works with brush strokes. It also offers a setting to make dust spots more visible.
- ❑ Using several recipes, an Upright tool automatically levels horizons and straightens objects such as buildings and pine trees that suffer from a keystone effect.
- ❑ The Radial Gradient tool produces circular or oval selections that can create highlights, vignettes, or any of the effects available to the Adjustment Brush.
- ❑ The Video slideshow enables combining of still images, video clips, and music as a high-definition (HD) slideshow.
- ❑ The Book module includes new and more flexible templates as well as dozens of small upgrades.

Manage your images, add keywords and metadata, import and export, and perform simple edits in the Library module.

THE LIBRARY MODULE

The Library module provides tools for managing your image collection as well as a few rudimentary editing tools. To work in Library, you must understand the idea of a catalog.

Catalogs are repositories of image information. They contain metadata, keywords, names, thumbnails, edits, and the path to the image itself. When you look at an image in a catalog, you see a representation of a file housed somewhere else—in a folder on your hard disk, on an outboard disk, or on a DVD.

Some people like to maintain more than one catalog. I find that cumbersome. It's easy to find what you want either by searching by keywords or with folders organized in a way that makes sense to you. Changing from one catalog to another requires restarting Lightroom, an extra step with a benefit.

When you import an image or folder of images into Lightroom, the images don't go into Lightroom. Instead, the program imports information about the image files and either leaves the files where they were or moves them to a set of folders on a disk.

If you wish to move a file from one folder or drive to another, move it from Library. Moving a file outside the program severs the path so Lightroom won't be able to find it unless you import it again. In that case all your keywords and image editing will be gone.

The Import screen offers three options: Add, Copy, and Move. Copy, as you might expect, copies photos to a new location and adds them to the catalog.

TIP LIBRARY SHORTCUTS

To navigate Lightroom's menus swiftly, learn the most common shortcuts. Dozens of shortcuts are designated for each module. Here are the ones I depend on in Library and Develop, and for navigation between modules. On PCs use Control for Command and Alt for Option.

At the very least, learn the shortcuts for moving between views and modules.

Moving Between Views and Modules

G	Grid View in Library
E	Loupe View in Library
C	Compare in Library
N	Survey
D	Develop

For All Modules

F	Next Screen Mode
Tab	Show/Hide Side Panels
Shift-Tab	Show/Hide Side Panels
T	Show/Hide Toolbar
F5	Show/Hide Filmstrip
L	Cycle through Light Modes
Command-Z	Undo
W	White Balance
R	Crop Tool
K	Adjustment Brush Tool
Command-A	Select All
Command-D	Deselect
Command-E	Edit in Photoshop
Command-Option-E	Edit in Other Editor
F1	Lightroom Help

In Library

Command-'	Create Virtual Copy
=	Increase Grid Size
-	Decrease Grid Size
I	Cycle Info Display
B	Add to Quick Collection
Command-Option-B	Save Quick Collection
Command-Option-Shift-B	Set as Target Collection

CONTINUED ➤➤

TIP	LIBRARY SHORTCUTS (CONTINUED)	

Command-N	New Collection
Command-G	Group into Stack
P	Flag as Pick
X	Flag a Reject
U	Unflag

In Develop

G	Graduated Filter
Q	Spot Removal Tool
]	Increase Brush Size
[Decrease Brush Size
/	Toggle Between Brushes
O	Hide or Show Adjustment Overlay
J	Show Clipping
Y	Before and After Left/Right

Note: Holding Option/Alt often changes the effect of a slider.

Use this when importing from a card or camera. Move denotes moving photos to a new location while adding them to the catalog. I prefer Copy to Move because I like to have the images in two places until I'm satisfied they made the trip to the new location. Add means keeping the photos in the same location while importing them to the catalog.

These machinations may seem confusing and unnecessary, but there's a big two-part payoff: keeping a record of every image in your catalog while the images themselves sit safely somewhere else and the reassurance of non-destructive editing.

The Library module contains tools for managing a catalog. It includes four views of the catalog, with single-letter shortcuts to move between them. Grid (G) provides a light table overview, Loupe (E) helps determine critical sharpness, noise and fringing, Compare (C) looks at two images side by side, and Survey (N) assembles a group of selected images.

There are many ways to track your images. You can rename, assign keywords to rate, and stack images and groups of images.

VIRTUAL COPIES

A virtual copy is an exact copy of any image in Library. Once created, the copy can become a different version (such as a black-and-white interpretation of the original, or a platform for experiments). You can create multiple virtual copies, and no changes affect the original.

Press Command-' to create the copy. It appears next to the original with whatever settings have been applied. The new file has the word Copy above the file name and a white triangle in the lower left of the thumbnail.

COLLECTIONS AND THE QUICK COLLECTION

Collections and the Quick Collection allow you to assemble groups of photos without moving them from their original location. The thumbnails in the collection merely represent the actual photograph. Anything you do to an image in a Collection or Quick Collection will not affect the original, but any changes you make will be applied upon export.

Use Collections for print projects or slide shows, to gather images for an eBook, or to create galleries of your best work in different categories. An image residing in a folder in your catalog can become part of more than one Collection.

There are three types of collections. The standard Collection is static. You must add or delete images manually. A Smart Collection automatically grabs images based on rules. For example, you could create a Smart Collection that contains any image you assign a five-star rating or any image with the keyword *volcano*. Collection Sets are groups of Collections.

A Quick Collection acts as a temporary static Collection, but it's easier to add and remove images. Think of it as a waiting room for images destined for a Collection or an immediate use. Press B in Library to send an image to the Quick Collection, or click the small circle in the upper right of the thumbnail. (Note that the circle turns dark when selected and transparent when not selected.) To send more than one image at a time, select the images and press B. To remove an image from the Quick Collection, select it and press B again. This is an easy way to gather images from multiple folders.

Move images from the Quick Collection to a Collection by selecting them and dragging them to a Collection. To clear the Quick Collection, mouse over its panel and right click to open a menu. Select Clear Quick Collection.

To export, first select the images you wish to export. Select a series of images by clicking on the first in the series and Shift-click the last. Command-click adds single images. Clicking Export in the bottom left of the screen brings up the Export dialog.

Most people export for a few purposes: for the web, for prints, for archival purposes. Instead of filling out the specs every time you export, create presets, visible on the left side of the Export dialog. Define the destination for the exported file, image size, color space, file type, and quality. Resize and rename if you wish.

When exporting for printing, use the Adobe RGB or ProPhoto RGB color space, 300 or 240 pixels per inch at the original file size. When exporting for the web, use the sRGB color space at 72 pixels per inch. You'll need to resize for the web in the range of 800 to 1200 pixels per inch. You can set up export presets in the Export menu to prepare one-click menus for printing, the web, or any other output you use frequently or during a project.

SMART PREVIEW

Smart Previews in Lightroom 5 allow for the editing of images when away from the hard drive where the images are stored. Conventional previews display a JPEG thumbnail of the underlying file, but Smart Previews contain enough information to work with all the tools in the Develop module. You can alter color, contrast, and clarity; convert to black and white; or straighten a tilted shot, then apply these changes to the original files after reconnecting the hard drive. Each Smart Preview is only 5 percent as large as the original file, so it's possible to keep a large assemblage of images on a mobile computer and work on the images while on the road without lugging external drives. For photographers with many terabytes of images stored on several large drives, there are several ways to generate Smart Previews.

Select the images to convert. Go to Photo>Preview>Smart Preview. Or, select the images and click on the Smart Preview box labeled either Original Photo or displaying the number of Smart Previews. It's found to the lower left of the Histogram in Library. In either case, the program generates Smart Previews. It is also possible to create Smart Previews on import. Click on the Build Smart Previews box under File Handling.

While Library includes rudimentary tone and color sliders in Quick Develop, each tool works better in the Develop module.

Creating Smart Previews enables you to work on images in Develop when you don't have access to the original file.

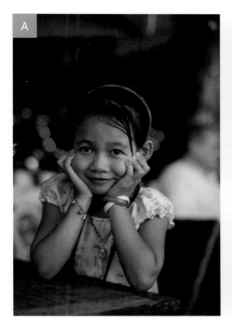

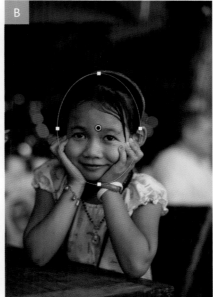

These shots show how the Radical Gradient tool in the Develop module of Lightroom 5 can brighten the important part of an image. A: *The original image;* B: *Selecting with Radical Gradient tool;* C: *After brightening exposure in the selected area*

THE DEVELOP MODULE

The Develop module bristles with tools, most found in Adobe Camera RAW. You can adjust exposure or contrast, refine highlights or shadows, and apply vibrance or saturation globally or selectively. Sliders control hue, saturation, and luminance of individual colors without layers. It's possible to convert the image to black and white and modify tonality via the underlying color. Sliders diminish noise or sharpen with great control. Automatic lens correction goes a long way toward producing an optimal file. Every operation is nondestructive.

For most photographers, Lightroom 4 comes close to performing the most important lens correction, exposure, color, and contrast editing with almost no learning curve. You can get good results using the most obvious adjustments, but the tools are deeper than they initially appear. (See "Correct Color, Contrast, and Exposure" in the next section for more details about the Develop Module.)

WORKFLOW: IN DETAIL

A consistent workflow, from importing images to preparing them for output, streamlines the process and yields a well-organized set of usable images. I use the following checklist, but every photographer can adapt the steps to meet individual needs and preferences. While the steps are specific to Lightroom, most digital asset managers offer similar tools.

TIP **WORKFLOW CHECKLIST**

Paste this checklist or its equivalent next to your computer. Refer to it until the steps become automatic. If you do, you'll save yourself extra effort and dodge the occasional disaster.

1. Import to RAW editor.
2. Organize and edit images.
3. Correct color, contrast, and exposure.
4. Make lens correction.
5. Straighten and crop.
6. Reduce noise and sharpen.
7. Export.

1: IMPORT TO RAW EDITOR

Importing your images into the Library module allows you to take care of several steps at once.

Open the Library module, connect a card reader to the computer, and install a card. (You can import from an existing folder, too.)

Click Import. The interface changes to the Import menu.

Select the images in the card under Source. Choose the operation, such as Copy or Move. Select the Destination Folder from the menu or create a new folder for the images. This should be a folder where you keep your other

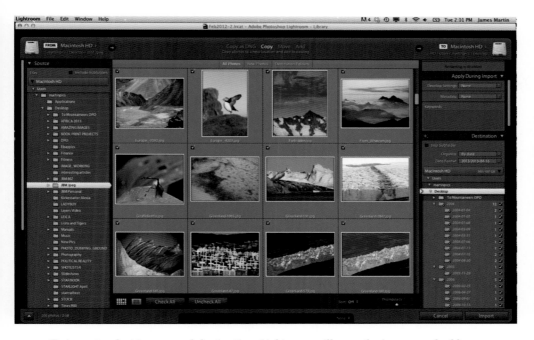

To import, select images and destination. Lightroom will save the images and add information about them to the catalog.

images. On a Mac it could be in the Pictures folder or on an external drive. I keep my principal folder of images (titled "Images") on an external drive. When I import, the images go into an appropriately named subfolder.

When you import, you always import the file information to the catalog on your computer. You may or may not move the image itself. You have four options, found at the top of the Import screen.

- **Copy** imports to the catalog and copies all files, leaving the originals on the card or folder. I usually copy so if something goes wrong, the images remain on the card.
- **Move** imports to the catalog and the folder, erasing the images from the card or original folder.
- **Add** imports to the catalog but doesn't move or copy the images from their original locations.
- **Copy as DNG** coverts the image to a DNG, leaving the original files untouched.

If you're moving or copying, you can back up to a second drive at the same time in the File Handling menu. Check Make a Second Copy before selecting the desired drive and folder. It's hard to beat backup upon import for convenience.

This is a good time to rename the imported files. Cameras assign numerical names. If you shoot long enough, they will use all possible names in that format and start again. Since two files can't have the same name, they can

overwrite your older files. Not good. Custom names can include descriptive information, such as subject and location. For example, a bear in Alaska could be bear_AK_00012.

It's possible to apply color and contrast settings and add keywords on import, but I prefer to do that later in the process. I may end up tossing a lot of images, so extensive keywording could be a waste of time. However, if large groups of the images share keywords, adding them on import can save time later.

When satisfied by the settings, click Import. The system imports the images and creates thumbnails.

2: ORGANIZE AND EDIT IMAGES

Digital has liberated photographers from the tyranny of film cost. Now we are free to shoot to our hearts' content without penalty. Sports and wildlife shooters benefit the most. The only way to get a great action shot reliably is to hold down the shutter button and let 'er rip. With film, the motor drive could thread though $10 of film in 4 seconds. Instead of money, we pay in time. We must look at each frame to determine its value, struggling to decide which images to keep and which to send to the digital round file.

Some argue that memory is cheap so why bother editing when you could be shooting? I prefer to cull the losers and also-rans so the heroes are easier to find. Plus, I can gaze upon my collection without having to confront my failure rate.

Lightroom and its fellow databases supply a dizzying array of rating and sorting options. You can rate images with numerals or assign a color, a flag, or stars. You can use the keyboard or a mouse click. Once you've applied your ratings, you may sort by metadata, keyword, name, or rating.

I go through my pictures with only two ratings: 1 is flawed and destined for deletion, and 2 is stunning success. This leaves a third category: too good to toss and too mediocre to use. When it's time to say goodbye to my mistakes, I search for the numeral 1 under the Attribute filter above the thumbnails. I select all and hit the Delete key, choosing Delete from Disk from the pop-up menu. My successes may go into a Collection or remain in the folder with their duller siblings.

Unless you are editing for a purpose, such as sending off your latest *National Geographic* article, edit for yourself. It's okay to make emotional choices and save mediocre images for sentimental reasons. Don't obsess over ratings.

Compare and Loupe allow you to look at a 100 percent blowup of an image. If you have many similars framed identically, you may compare the sharpness of two adjacent images in a side-by-side layout.

Some photographers need keywords. Natural history collections demand scientific names, common names, locations, colors, seasons, and so on. Stock agencies require a daunting amount of keywords, including concepts the image could represent. As your library of images grows, it's important

to be able to run a search by keyword. However, for most of us, the work isn't worth the time beyond typing the location once and applying it to all in the folder.

3: CORRECT COLOR, CONTRAST, AND EXPOSURE

Digital files come out of the camera looking flat and lacking contrast. This is a function of the RAW converter. Exposure may be off or "exposed to the right." The information needed to optimize the image is locked in the file and easy to release in the Develop module.

The Develop module contains tools for adjusting the image, syncing image settings, reverting to a previous History state, saving History states in a Snap-shot, and creating and managing image editing presets.

To bring the color and contrast to life, adjust the sliders in the Basic panel to effect the most important corrections. I start with White Balance. Move the slider until the whites look white or skin tone seems natural. For more precision, click the Eyedropper on something bright white in the image. Voilà.

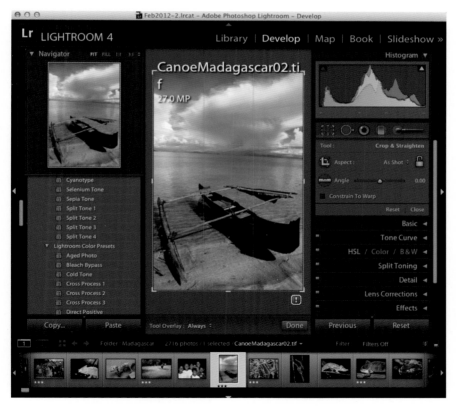

The Develop module contains flexible, nondestructive tools affecting exposure, color, contrast, and a host of other image enhancements.

Use the Basic tools to enhance tone and color globally and HSL to affect colors selectively.

The tonal sliders—the ones controlling brightness and contrast—come next. Keep the histogram within its boundaries. Exposure shifts the entire exposure to brighter or darker. Contrast expands the range between bright and dark. The other four sliders alter brightness in specific areas of the histogram, and these changes can boost or reduce contrast.

The sliders for Highlights, Shadows, Whites, and Blacks work in both directions, increasing or decreasing the strength of the effect from zero. For example, brighten Blacks by sliding to the right, darken by sliding to the left. In earlier versions of Lightroom, one could only increase the effect (i.e., darkening from the default). This new capability pays benefits.

Blacks affects the darkest part of the image without affecting the highlights, and Whites affects the brightest parts without touching the darkest part of the image. You can reduce clipping at either end of the histogram or expand the range—the white point and dark point—with these sliders. They both increase or decrease contrast, too. When used together, they slightly expand the midtones along with contrast.

Highlights and Shadows appear to do the same thing as Whites and Blacks, respectively, but they can be used in tandem with their sister sliders to extract more contrast and detail when needed. For example, you can bring out detail in shadows by moving the Shadows slider to the right. This will make the true blacks too light. Pulling Blacks to the left will restore the blacks you want without obliterating the detail in the shadows. Follow the action in the histogram as well as the image itself. I usually employ negative settings for Blacks and positive settings for Whites to expand the tonal range while moving Shadows to the right and Highlights to the left to reveal detail.

As you move the sliders, note the triangles in the upper corners. Each turns white if you begin to clip whites or blacks. Pressing J activates another clipping warning: a colored overlay on the image where clipping is occurring. Move the Exposure, Highlights, and Blacks sliders until the overlay is reduced or disappears. Highlight clipping looks worse than black clipping, especially on prints. Inkjets don't lay down ink on blowout whites, leaving the paper bare, each brand with differing texture and reflectiveness.

You can walk back through your steps in History or click Reset to start over with the original, unedited file. However, I advocate a shortcut. Before trying anything else, click Auto in the Basic panel (this is the same as Auto Tone in Library). For most images, this gets you close to an ideal result.

When I suggest this in workshops, I'm met with skepticism and astonishment. It seems like cheating. So be it. Since I "expose to the right" whenever

 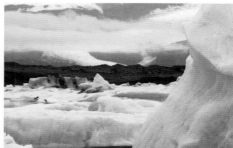

This photograph of Jökulsárlón, Iceland, lacks contrast and vibrant color. The histogram is truncated in the darkest and brightest regions.

With Auto Tone applied, the image displays richer color and greater contrast. The new histogram indicates the expansion of tonal range and contrast.

I can, a folder of images can look painfully overexposed. I make believers out of my skeptics when I select a batch of images, apply Auto Tone, and watch the whole batch transform into a collection of rich images. Note the changes in the Basic panel to see what the software did. Sometimes the software misjudges the situation. Command-Z undoes the operation, and then I can edit by hand. More often than not, I tweak the Auto results, but the heavy lifting is already done.

The Presence palette contains three tools for enhancing the impact of the image: Clarity, Vibrance, and Saturation. Clarity boosts edge contrast in the midtones. Vibrance and

The HSL panel controls the hue, saturation, and luminance of individual colors or mixed colors.

Saturation make colors more vivid. Vibrance concentrates on less saturated colors and protects skin tones instead of boosting saturation globally. Apply

Vibrance and especially Saturation with care to avoid cartoonishly saturated results with colors not found on Earth.

In the HSL/Color/B&W palette we enter the realm of selections and layer-like capabilities. Instead of making a number of selections and applying effects to a certain area, a single brush affects a given color globally.

The Hue, Saturation, and Luminance (HSL) panel adjusts any of those aspects for a given color with a slider; however, it gets a little tricky when you're working with real-world colors—for example, a warm-toned brown hillside. The hill image contains a blend of colors, so you would need to shift several colors to correctly balance the adjustment. In the upper left corner of the panel you can see two concentric circles. This is the Targeted Adjustment Brush. Choose the adjustment—hue, saturation, or luminance—and enable the brush by clicking on it. Drag the brush up and down within the brown hillside. Several sliders corresponding to information in the hill move at the same time in exactly the right proportion.

While the targeted brush works like magic, often a slider will do the job. If a sky looks washed out, darken blues with the Luminance panel slider. Working with the sliders can offer more control than the brush because the affected areas are preselected. For example, to add richness to greens, the saturation slider may produce better results across the image than adjusting all the color components of a greenish field with the brush.

Develop Tools panel. The Develop Tools panel, found below the Histogram on the right column, consists of the Crop Frame, Spot Removal, Red Eye Correction, Graduated Filter, and Adjustment Brush functions.

The Crop Frame tool crops and straightens and seems out of place amid color, contrast, or exposure.

Red Eye Correction removes the red glare a camera-mounted flash produces in the eye. Click on the red, and it disappears.

The Healing Brush is another enhancement in Lightroom 5's Develop module. It behaves more like Photoshop's context-aware Healing Brush instead of a mere cloning tool. First, set the brush size and then click or draw on the area you wish to replace with surrounding pixels. An empty circle represents the area sampled to replace the deleted area. It's possible to click on the circle and move it to an area that better matches the area around the healed area. The brush can heal along a line or by painting over an area. Opacity can be adjusted after healing.

Visualize Spots speeds dust-spot removal. It creates an adjustable monochrome view of edges that resembles Option-mask sharpening. In this case, dust appears as circular spots. You can delete the dust spots easily with the Healing Brush. You can apply the dust removal option to every image shot when that dust pattern was on the sensor, a huge time saver.

The Graduated Filter is a minor miracle. Like the filter of the same name placed in front of a lens to darken a bright sky to match a dark foreground, the Graduated Filter can accomplish the same feat but with more flexibility. The controls allow for changes in density, transitions, and angles. However, it isn't

limited to color-neutral darkening. The tool applies a graduated effect for white balance, clarity, saturation, sharpness, noise, and other attributes. It's possible to apply multiple filters across various areas of an image. The possibilities are literally endless.

The Adjustment Brush permits localized adjustments of the same parameters that the Graduated Filter affects. It is actually two brushes. You could create large brush with strong feathering (diminution of the effect from the center); this is a soft brush. The other could be smaller with less transition and is called harder. As you apply effects, you can toggle between them as needed. With Masking enabled, the brushes guess what should be affected or left untouched. Clicking Erase removes the effects. As you work, you can change the amount of an effect or kind of effect. To add a different effect while retaining your previous work, click New and begin with a new group of settings. Show Selected Mask Overlay presents a colored glow over the area affected by the brush, including the opacity. This tool, also present in ACR, presages how image editing software will work in the near future.

Radial Gradient is a new tool in Develop that applies oval vignettes anywhere in an image. This simple feature can make an image come alive. You can brighten faces or darken a distracting bright area. Create several vignettes of differing sizes and opacities, with some inverted to darken in the center instead of the surrounding area. All the effects found in the Graduated Filter and the Adjustment Brush work with Radial Gradient. Feather transition areas as needed.

a

Apply one or many settings to a specific area of the image with the Adjustment Brush. Each effect may be modified after it's applied.

The circle with a dot in the center enables the Radial Gradient tool. Note the Smart Previews box to the lower left of the Histogram.

Since all operations are nondestructive, any and all operations are reversible. The combination of Graduated Filter, Adjustment Brush, and Radial Gradient permits complex selective edits affecting tone, color, contrast, and sharpness, rendering Photoshop Layers unnecessary for most photographic purposes short of composites.

4: MAKE LENS CORRECTION

Most lenses suffer from distortion. There may be light falloff in the corners, color fringing visible in areas of high contrast, or parallax distortion that curves straight lines. Lightroom's Lens Correction panel provides tools to remedy these ills automatically or manually.

Upright is a new feature within the Lens Correction panel of Lightroom 5's Develop module. It straightens vertical and horizontal lines or lines bowed by lens distortion. It also corrects vignetting in the corners and removes color fringing, aka chromatic aberration. This is a nondestructive version of Photoshop's Lens Correction.

First, check the Enable Profile Corrections and Remove Chromatic Aberration boxes. This gives the program some baseline data. Given an image requiring different kinds of correction, try Auto first—sometimes it's all you need. For a tilted horizon, Level usually lives up to its name. Vertical fixes most tilted buildings and converging trees. If these automatic features fail to resolve the issues, work with the sliders in Manual.

The Profile menu compensates for defects seen in lenses, especially in wide-angle models. Check the Enable Corrections Profile box. If the lens is in the database, Profile corrects distortion automatically. It is possible to define parameters for lenses not in the Lightroom database.

The sliders in Color remove chromatic aberration by color. Manual includes more tools for removing distortion and increasing or decreasing vignetting.

5: STRAIGHTEN AND CROP

You may also finish framing the image by straightening the horizon and cropping out unwanted elements. From the Develop toolbar, click on the square icon on the left of the Develop module. You can tilt the image with a slider and crop by dragging the edges or corners with constrained proportions or freely. Hit Return to make the crop. You can undo your changes at any time.

The Crop tool, activated with the broken rectangle, crops and levels images.

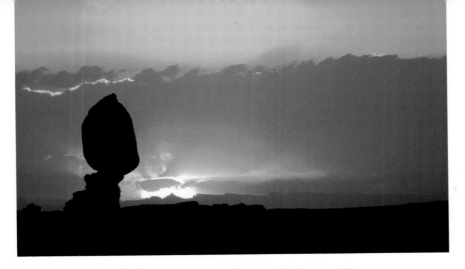

Cropping a horizontal photo can create a strong vertical composition.

6: REDUCE NOISE AND SHARPEN

Noise reduction and sharpening represent two sides of the same coin. Reducing noise compromises sharpness because noise reduction doesn't eliminate noise, it blurs it. Sharpening increases contrast that makes noise more visible. We can minimize these unwelcome effects by choosing the correct tools and applying them selectively and at optimal strengths. Lightroom's powerful noise reduction and sharpening tools can improve an image with great ease; Photoshop adds the power of layers to target specific areas of an image; and specialized plug-ins automate and improve on Photoshop's solutions. Even so, balancing noise reduction and sharpening still demands judgment and craft.

Reduce noise before sharpening. If you sharpen selectively as described in the text that follows, you can preserve noise reduction in areas where it's most conspicuous; but if you sharpen first, noise reduction will soften the effect.

Noise. The noise found in digital files is analogous to tape hiss heard on a cassette player. We have the signal—the picture or the music—and a greater or lesser amount of noise-speckled artifacts in the picture or hiss accompanying the music. The signal-to-noise ratio expresses the proportion of one to the other.

Camera sensors produce noise. Longer exposures and higher ISOs generate more noise. Cameras achieve higher ISOs (i.e., greater sensitivity to light) by increasing the voltage to the sensor. Similarly, long exposures require voltage over time, even at low ISOs. In both cases, spurious signal is seen as noise: random pixels amid the pixels comprising the image. High-end DSLRs feature sophisticated algorithms to suppress noise to a great extent; but at very long exposures or maximum ISO, even these cameras fall victim to digital snow in the file.

Noise comes in several forms. Chroma noise looks like small colored dots or blotches. Luminance noise resembles a black-and-white TV tuned to a dead channel. Most noise is random, but some sensors produce bands or other organized artifacts. You will notice more noise in the darker parts of a picture. Camera sensors capture more information at the bright end of the spectrum, so signal overwhelms noise in light areas while noise is more apparent in the dark regions where the sensor captures little information. Also, luminance noise is easier to see against a dark background, like snow falling in front of a black wall.

To limit noise as you take the picture, choose the lowest ISO that will work in a given situation. Experiment with your camera to learn when a long exposure starts to get noisy. Take a shot that includes a dark area at various longer exposures: 5, 10, 15, 20, and 30 seconds. Blow it up to at least 100 percent on the computer and see when noise jumps markedly. Try to avoid exposures longer than the last decent frame in the series. Still, it's better to get the shot and work on the computer to suppress noise while preserving sharpness than to pass up an opportunity for a striking image.

To reduce noise, open the Detail menu in Develop. Zoom to 100 percent (1:1) or higher. I prefer to tamp down Color (Chroma) noise first by moving

The Sharpening menu offers fine control over sharpening.

the Color slider until the colored speckles almost disappear. Sometimes this can leach color from edges. The Detail slider can restore color to edges without restoring the color noise, but if you overdo it, random artifacts will appear.

Reduce Luminance noise with the Luminance slider. Move it right until the grain almost disappears. Going further softens the image unnecessarily. The Detail slider brings back detail the Luminance slider smears, but too much Detail brings back unacceptable amounts of noise. The Contrast slider also adds a sense of detail. However, a high setting produces a blotchy effect. Play with Detail and Contrast to find a pleasing balance between noise reduction and edge detail.

Sharpening. Every image needs sharpening, but the amount of sharpening depends on the image and its intended use. The amount of sharpening an image destined for the web needs to look sharp would make it look edgy and garish as a big print on glossy paper. Set the image display to 1:1 to see the effect clearly.

There are four sliders in the Sharpening menu.

- **Amount** increases edge definition, adding no sharpening at the far left setting. Think of it as sharpening intensity.
- **Radius** defines the thickness of the edges where contrast will be applied. Start with a radius of 2 and vary the amount.
- **Detail** regulates how much the bright areas are affected. Lower settings reduce edge blurring, while higher settings increase overall texture. A high Detail setting can oversharpen fine details such as pores on a human face.

■ **Masking** controls the areas that sharpening affects. Higher settings focus on edges only, leaving areas with little detail, such as a pure blue sky, unsharpened and therefore exhibiting less noise. The setting on the far left applies sharpening evenly across the image.

To see the mask, move the Amount slider past zero. Hold down the Option key (Alt on a PC) and drag the Masking slider to the right, which converts the images to monochrome. As the slider moves right, the image changes from all white, indicating that sharpening is applied to the entire image, to mostly black with white edges, showing where sharpening is enhancing edge detail. The black areas gain no additional noise.

Compare the original with the edited version as you work. The Backslash key (/) toggles between the two, and Shift-Y creates a split screen.

Use Export in Library to export images in the correct file type for their intended use.

7: EXPORT

Unless you need Photoshop tools to do something special—such as assembling a panorama, dropping in a blue sky to replace a dull one, or creating a layered composition—your image is optimized and ready for use. Unless you effect more changes, it is saved in Lightroom automatically, and the original file will always remain untouched. Now you can export it to the web, print directly from Lightroom, or create a high-resolution TIFF as a digital negative.

Edit in Adobe Photoshop CS6...	⌘E
Edit in Silver Efex Pro 2...	⌥⌘E

Color Efex Pro 4
Dfine 2.0
DxO FilmPack 3
DxO FilmPack 3 (64–bit)
Exposure 4
Sharpener Pro 3.0: (1) RAW Presharpener
Sharpener Pro 3.0: (2) Output Sharpener
Silver Efex Pro 2
Viveza 2

Open as Smart Object in Photoshop...
Merge to Panorama in Photoshop...
Merge to HDR Pro in Photoshop...
Open as Layers in Photoshop...

Use Photo>Edit In to export to Photoshop. The resulting file will automatically be imported to the correct Lightroom folder.

Export in Library sets the criteria and the destination. The interface is menu driven. If you customarily export for several uses—such as slide shows, prints, and your website—you can create presets that allow you to send a batch containing those settings with one click. Set up Publishing Services to send images directly to your Facebook and Flickr accounts. The Book module consists of templates for assembling books from your images and sending the results to Blurb for publishing. Lightroom formats web galleries and builds slide shows from collections.

In the Library or Develop modules, use Photo>Edit In to send an image or images directly to another program or to Photoshop. You can do the following:

- Open as a Smart Object in Photoshop
- Merge to Panorama in Photoshop
- Merge to HDR Pro in Photoshop
- Open as Layers in Photoshop

Select the image or images you wish to export by Command-clicking on the image. Use the shortcut for Edit In (Command-E), and select Photoshop. Edit In bypasses the export menu and Bridge, saving several steps. It also creates an Edit copy of the file in Lightroom. Better yet, any file exported to and saved in Photoshop as a TIFF, PSD, or JPEG will automatically import to Lightroom adjacent to the original RAW or DNG file. It even shows up in Collections.

If you need to bring a file from Photoshop to Lightroom that wasn't originally exported with Edit In, import the edited TIFF, PSD, or JPEG with Import in the Lightroom Library to the appropriate folder.

This image of Seattle's Gum Wall was shot in open shade, requiring correction to remove the blue color cast.

To make the highest-resolution archival TIFF, export it at the highest set-tings. Go to Preferences in Lightroom and open External Editor. Choose the following settings for the default editor: Pro Photo RGB for color space since it encompasses the widest range of colors, 16 bits to record the maximum array of tones, and 300 or 350 DPI. These settings will "future proof" your images for the day printers and monitors can display all the information current technol-ogy can capture but not show.

6

THE POWER OF PHOTOSHOP

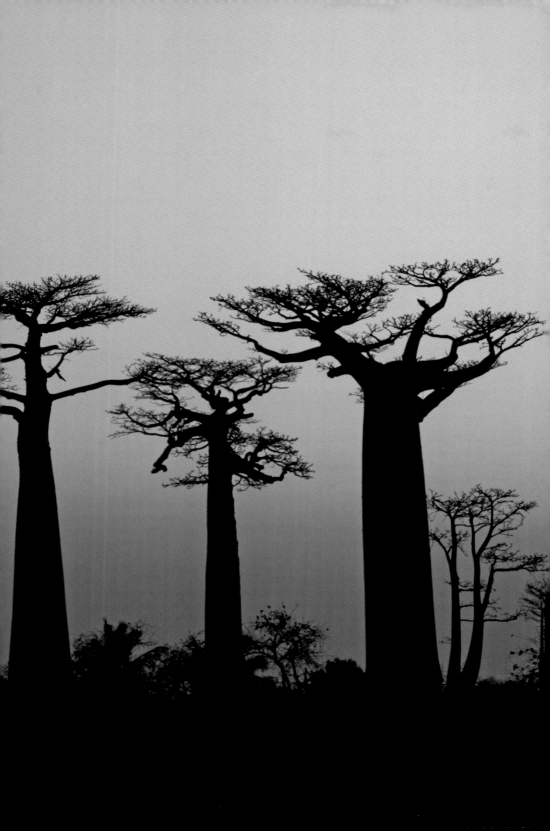

Adobe Photoshop offers a fabulously extensive array of tools and effects, some from the dawn of the program to the more recent automated processes. Operations that once took skills requiring years of practice to master are performed at the click of a mouse. With each update more tools and processes are added to the program. There are usually several paths to choose from to achieve any effect.

Layers and selections are among the features that distinguish Photoshop from RAW editors. They are central to a host of operations, from advanced color adjustment to elaborate montages. Unfortunately, proficiency demands facility with dozens of tools and an understanding of how computers look at photographic images. These tools and their applications require in-depth reading; see Resources at the end of this book for suggestions.

Layers allow you to add effects, combine image elements, paint in changes, or apply corrections that can be modified without affecting the original image. Layers are central to a nondestructive workflow in Photoshop.

The original image resides on a layer. You can duplicate the layer and effect changes on it or add a blank layer. Adjustment layers perform the same changes as their namesakes but act as instruction sets in much the same way a RAW editor does, leaving the layer attached to it untouched. A layer mask allows you to paint the contents of another layer at any level of opacity, with each step reversible.

TIP PHOTOSHOP CREATIVE CLOUD

Adobe has upgraded Photoshop periodically over the years. Each edition adds features, improves speed, or improves the interface for a fraction of the cost of the software purchased for the first time. During the life span of each version, a few free updates fix bugs and add incremental improvements.

The Creative Suite (CS) consisted of Photoshop and a host of other image, video, web, and document modules. Now, Adobe has moved to a subscription model. Every component of the CS suite is now part of the Creative Cloud (CC), wherein the software is downloaded and works only as long as the subscription continues.

The software exists on your computer, so you are not dependent on a good Internet connection to work in the software. Instead of periodic fixes and updates, there will be a continuous stream of improvements. The price remains in line with the old model, assuming you updated regularly.

Photoshop CC closely resembles CS6. The most exciting addition, Shake Reduction, reduces blurring caused by camera movement. This module includes tools to control the effect. The first iteration seems to work best at lower ISOs in bright light.

Smart Sharpen was given the ability to selectively sharpen the principal subject. New algorithms are designed to better resize images. Finally, the new tools in Lightroom 5's Develop module—Radial Gradient, Upright, and Healing Brush—are included in Adobe Camera Raw 8.

CS6 INTERFACE

OS toolbar Tabbed document window Options Bar Photoshop panels

Tools panel

Mini Bridge

Figure 3. The Photoshop CS6 interface is completely customizable.

THE CS6 INTERFACE

Although the Photoshop CS6 interface gives the impression of complexity, it provides simple pathways into a universe of capabilities. Each tool includes variations in a fly-out menu, and each menu expands to a list of capabilities.

The interface looks identical in OS X and Windows versions except for the operating system (OS) toolbar at the top of the screen containing major Photoshop menus. By default, the panels and tools "float" above the interface in the OS X version, but by selecting Application Frame in the Window menu, the components will lock with the interface. (See Figure 3.)

Below the OS bar, the Options Bar modifies selected tools and includes a Workspace options menu. The tabbed window document shows open images as tabs.

In the default arrangement, the Tools panel is on the left and Photoshop panels are on the right of the image window. The Tools panel consists of icons denoting families of tools. For example, the Healing Brush icon expands in a fly-out menu to include the Spot Healing Brush, Patch, Content-Aware Move, and Red Eye tools. Open Photoshop panels from Window in the OS bar. It's possible to nest related panels three across as tabs. You can save any arrangement of panels and tools as workspaces.

Everything is customizable. The new default background color is black, a nod to the Lightroom interface. Black makes images look great, but white

text against a black background can be fatiguing. I set the background to the darkest gray that displays black characters.

As Photoshop evolves, the placement of tools and the look of the interface changes, but so far Adobe has included legacy tools to permit folks to perform their work the old way.

SMART OBJECTS

For the ultimate nondestructive workflow, work with Smart Objects instead of a normal file.

Think of a Smart Object as a safe place to store the pixels in your image while you run "what if" simulations on a proxy of it. The original image remains unchanged while the proxy changes size, shape, color, and content. As with Adobe Camera RAW, all the changes are mere instructions, which don't change actual pixels and add little to your file size. Any Smart Object operation is reversible. You can even reduce the size of a file and restore it later with no loss of resolution.

If you open your RAW file into a Smart Object, you can return to the RAW editor at any time to change Hue, Saturation, Luminance; adjust Curves; alter Exposure; add Fill Light—anything available in RAW. However, filters and other operations run slower in a Smart Object, so you must decide which is more important: flexibility and nondestructiveness or speed. Some features in Photoshop don't affect Smart Objects.

To open a RAW file as a Smart Object, go to Photo>Edit In>Open as Smart Object in Photoshop, or Edit as Smart Object in the Edit In menu in Lightroom. When the object opens, a small icon within the thumbnail on the Layers palette indicates it is a Smart Object.

SMART FILTERS

Smart Filters allow for adjustments at any time. Previously, the effects of a filter were fixed and not editable after taking the next step in Photoshop. It was possible to reduce the effect of the filter with the Fade command immediately after applying the filter, but any other step removed that possibility. With Smart Filters you can repeatedly adjust the settings at any time. Unfortunately, Smart Filters multiply file size and work slowly. Faster computers will make them more useful in the future.

SELECTIONS

Whenever you want to modify, move, save, or delete part of an image, you must select it, but first you must enable a selection tool. In Photoshop you can employ Lassos, Magnetic Lassos that cling to edges, rectangular Marquees, Extractors, and Magic Wands. You can select a color range or employ any number of masking techniques. Sundry plug-ins, such as onOne's Perfect Mask, automate the process, but they have their own learning curves.

Figuring out how to make a clean and believable selection and place it in a new milieu is one of the toughest tasks facing an aspiring Photoshop wizard. You need to select enough materials without including unwanted pixels from the source image. Insubstantial components such as hair or smoke pose significant challenges.

A hard-edged selection tends to look fake. Soften the edges by "feathering," a scalable range of randomization that mutes the hard edge. "Fringing" occurs when bits of color from the original background attach to the selection. Erase fringing by picking a brush, selecting the color of the selection, and painting over the unwanted color at about 50 percent opacity. (The lowered opacity looks more natural.) If some unwanted color remains, brush over it again. Lowered opacity allows you to build up the correct color. If things go wrong, go to the History palette to undo mistakes. Then try again.

This book does not go over all the ins and outs of layers, selections, and Smart Objects. Martin Evening's *Adobe Photoshop CS6 for Photographers* covers these issues in great detail, and short instructional videos are easily found on the Internet to untangle their many mysteries. In the remainder of this chapter, we'll look at a few useful processes in Photoshop.

PLUG-INS

Plug-ins are programs developed by third parties that automate Photoshop, Lightroom, and other programs, replacing stacks of layers, adjustments, and many, many steps with simple, nondestructive sliders. Individual plug-ins aid in sharpening, noise reduction, controlled blur, color correction and enhancement, film mimicry, black-and-white conversion, and special effects. Some companies offer suites of plug-ins. The tools in each suite operate consistently, shortening the time needed to master them. The following are some of my favorites.

ALIEN SKIN SOFTWARE

Exposure 5. Creating the look of classic film stocks is not easy. Grain doesn't look like noise, and each film has a unique color palette or tonal character. Exposure 5 converts an image into a replica of black-and-white, color, or infrared film, including cross-processing and other effects. I stack the effects, changing exposure and grain with a black-and-white infrared exposure over a bold color shift to transform a lifeless image into a dramatic photograph. Alien Skin plug-ins work nondestructively either on a layer or as Smart Objects.

Bokeh. Bokeh refers to the quality of background blur in a photograph. Very fast lenses, especially midrange telephotos in the f/1.2 to f/1.4 range, possess ardent fans who argue over which bokeh is the creamiest; such lenses carry hefty price tags. This plug-in mimics the bokeh of fast lenses, leaving the principal subject sharp to the appropriate depth. It includes other kinds of blur, too. However, it works best with a single subject in the foreground. Numerous objects at differing distances are tough to render convincingly.

The Exposure plug-in mimics the effects of popular and obscure film stocks.

NIK SOFTWARE

Silver Efex Pro 2. This is the most powerful and flexible black-and-white conversion plug-in, the staple for many photographers. As with all Nik products, the controls are easy to master and apply selectively in a nondestructive workflow.

Color Efex Pro 4. If limited to a single plug-in, I'd choose Color Efex. You can bathe an image in sunset light, desaturate, or boost vividness beyond all imagining. Choose from several visual presets for each filter. Mimic physical filters. Apply any or several of the fifty-five filters to an image, and save as a preset.

HDR Efex Pro. This is the easiest way to create the classic HDR look.

PHOTOMATIX

Photomatix. Photomatix was among the first HDR programs and remains one of the most popular. The tools are less intuitive than Nik's offering, but it can produce any HDR effect, including a very natural rendering.

HELICON

Focus. It's easier to deal with problem areas in a focus stack with Helicon Focus than in Photoshop. It can automate capture, too.

DxO

ViewPoint. This plug-in is part of Optics Pro, a powerful set of perspective- and distortion-correcting tools. Take control or let auto settings do the work. The software depends on lens/camera profiles that look at each f-stop.

EXPANDING DYNAMIC RANGE

Because both slide film and most digital systems suffer from compressed dynamic range—five to six stops compared with eleven stops for the human eye—photographers struggle with contrast control. These media can capture detail in the shadows or the highlights but not both at the same time. Shooting toward a sunset is an egregious example. The correct exposure for the bright sky will leave the foreground unacceptably dark, whereas exposing for the foreground will make the sky too pale.

Over the years, photographers have marshaled several techniques to moderate the problem. Graduated neutral-density filters can compensate for several stops of excessive contrast. Usually these filters are rectangular, clear at one end and gradually increasing to gray at the other. (Round models place the transition in the middle, usually the last place where a horizon looks good.) They impart no color. The photographer moves the filter in front of the lens until the transition lines up with the horizon. A spiky horizon defeats the filter because dark areas extending into the bright region will be rendered even darker.

With a dark subject close to the camera—for example, a climber silhouetted against a sunset—fill flash will bring out detail without blowing out the sky. Fill works best when used judiciously. If the foreground subject is as bright as the background, it often looks artificial. Set the flash one or one-and-a-half stops underexposed for a natural effect.

Darkroom techniques enhance contrast. Flashing the print before exposure reduces excessive contrast. A contrast mask, a black-and-white negative placed over the original transparency, mutes the bright areas. Burning and dodging, manually altering the exposure of the print by blocking light during exposure, will bring out dark areas and subdue bright ones.

We can surpass the efficacy of these techniques in the digital darkroom without inhaling chemicals in a dark cramped room.

SHADOW/HIGHLIGHT

The Shadow/Highlight tool affects the shadows and highlights, as you would expect. The menu, found in the Adjustments menu under Image, is straightforward. To bring out detail in the shadows, pull the Shadows Amount slider to the right. To cool down highlights, pull the Highlights Amount slider to the right. Tonal Width regulates the range of highlight or shadow tones affected by the sliders, and Radius defines the number of pixels affected.

If you overdo it, the image will look milky and banded. Sometimes the contrast exceeds the capabilities of Shadow/Highlight to bring the image into line.

DIGITAL BLENDING

Digital blending controls contrast precisely, applying correction only where needed. By comparison, a gradient or graduated neutral-density filter is a blunt instrument. A single tall tree or a line of statues on Easter Island will

defeat a gradient, whereas digital blending allows for brightening the tree or statues while darkening the sky.

This technique requires at least two exposures and sometimes three. Shoot one to capture highlights and another for shadow detail. If neither one does a good job with midtones, shoot a third exposure. Usually autobracketing no more than one-and-a-half stops on either side of average creates three usable exposures.

Each image must be identical to the other in composition and focus. Use a tripod to make sure. Don't change the focus or the aperture between shots because depth of field will shift.

There are a number of ways to blend images. Use the exposure with the smallest properly exposed area as the background layer. Create a duplicate layer of that exposure (Command-J). Open another exposure over it. Erase the poorly exposed portions of the new top layer to uncover the properly exposed image below. Repeat the process with a third or fourth exposure if needed. Flatten the image (Layer>Flatten), and save it with a different file name when ready to save the result.

USING A LAYER MASK

You can also work on a layer mask, which allows for infinite do-overs without affecting the underlying image. First, select Duplicate Layer from the Layer pull-down menu or press Command-J (on the PC: Control-J), invoking Layer as copy, which acts as a Duplicate Layer. Then, create a layer mask by clicking on the circle in the square at the bottom of the Layers palette or by selecting Layer Mask from the Layers menu. At this point you can apply an effect to the new layer. Then pick a brush tool.

Notice two squares, one black and one white, among the tools. A little curved arrow acts as a toggle. When the white square is active, the brush will reveal the underlying image. When the black square is active, the brush will conceal it. White reveals, black conceals.

When I fail to take different exposures in a high-contrast situation, I open the file in RAW and convert it to a Photoshop file, then I open the same picture in RAW again and change the exposure to optimize areas that were over- or underexposed in the original. After converting the second version to a Photoshop file, I drag one image over the other by holding down the V key as I drag. Holding down Shift at the same time aligns the two images perfectly. Then I add a layer mask to the top layer, pick a brush, and paint out the flawed exposure, revealing the correct exposure in the lower layer.

HIGH DYNAMIC RANGE

The High Dynamic Range (HDR) look has become extremely popular. Potential dynamic range exceeds the human eye. HDR images are generated from 32-bit files, which means the color depth surpasses the capabilities of current printers and monitors. The real reason for their popularity springs from the edgy, grungy, high-contrast look most programs deliver by default. These kinds of

The Layers palette displays thumbnails of all layers and layer masks in a Photoshop document and provides access to settings and other types of layers.

conversions would seem at home in a poster for a video game but can't pass as natural renderings of what the photographer saw.

The HDR look is a consequence of the local area tone mapping required to tame contrast the sensor can't record. This may result in halos around dark subjects, an exaggerated graphic appearance, and overly vivid colors.

The program Photomatix was among the first to automate HDR processing, followed by Photoshop, Nik's HDR Efex Pro, and now many others. Photomatix remains one of the most flexible. Nik's HDR Efex Pro uses the same easy interface found in the company's other programs and creates classic HDR images in concert with other effects. I find that a Lightroom to Photoshop to Lightroom workflow is the easiest way to craft natural HDR images. This became possible when Adobe implemented 32-bit in Lightroom 4.1.

First, take a series of pictures exposed one to two stops apart, exposing in a range that captures both shadow and highlight detail. Since the images should line up exactly, use a tripod. Photoshop's Auto-Align may work if you must hand-hold, but a tripod delivers images with perfect registration. Use a cable release so camera shake doesn't degrade alignment.

HDR expands tonal range by combining different exposures. Here, overexposed (A), underexposed (B), and middle (C) captures are blended to create an image resembling what the eye saw (D).

Make sure nothing is moving. A breath of wind can move leaves or grasses enough to foil the program. Rivers, traffic, or any other movement defeats HDR.

Take at least three exposures. Don't change the focus or the aperture from shot to shot. Any change of the center of focus will mess up the alignment and confuse the program. So shoot with aperture priority or change only shutter speed in manual mode.

Lightroom/Photoshop HDR. Select the bracketed images in Lightroom Library. Activate Auto Sync and set the Profile in the Camera Calibration palette to Camera Neutral. This setting reduces contrast slightly, which allows the HDR processing to work better.

Under the Photo menu, choose Edit In>Merge to HDR Pro in Photoshop. The images open as a stack in Photoshop's HDR Pro.

Once in Photoshop, remove ghosting if it appears. Use the slider under the Histogram to darken the image a little to find any bright blurs. If any exist, click Remove Ghosts above the Histogram and click OK. The resulting image is likely to be underwhelming. Not to worry. Lightroom will breathe life into it. Save the file and Close in the File menu.

When you return to Lightroom, find the images used to make the HDR image and the image itself. Open the HDR image in the Develop module (D). All the tools in Develop apply to your 32-bit HDR image. You can add contrast, pump up saturation, sharpen, and so on. After optimizing the HDR image in Lightroom, compare the result to the best exposure from the bracketed exposures. The difference in detail and tonal range should be dramatic yet natural.

Some folks love dramatic HDR images while the look leaves others cold. Do what you like. You can always go back and reprocess old images if you want to explore other avenues.

REPAIR AND RESTORE

It happens all the time. The composition works, the light glows, the decisive moment arrives, and some oblivious person walks into your picture and stops. Just as he begins to leave, another arrives clad in loud colors, but by now the light is gone.

Photoshop has featured ever more powerful tools to move or remove unwanted features, from sensor dust to bits of trash, from cars to tourists, and these older tools are still part of Photoshop. The Clone tool replaces a selected area with an adjacent one. The Healing Brush replaces the area with a version of nearby pixels. The Patch tool allows you to draw a selection, and it can blend more seamlessly than the circular Healing Brush if done with care.

With Content-Aware Fill, Patch, and Scale, removing extraneous elements, moving an object, and expanding a canvas is easier, more powerful, and more flexible than ever. Content-Aware analyzes the pixels around the selected object and calculates how to create similar tones, patterns, and textures to fill the void.

CONTENT-AWARE FILL AND PATCH

Given a simple background, these tools work like magic. When the background is more complicated, the tools may yield odd results that require some editing, but in most cases they save time, effort, and frustration.

To remove an object with Content-Aware Fill:
1. Draw a selection around the object. Use the Lasso or Quick Select tool.
2. Expand the selection by 4 pixels: Select>Modify>Expand>4 Pixels>OK
3. Enable Content-Aware Fill: Edit>Content-Aware Fill>OK
4. Deselect: Command-D.

Expanding the selection by a few pixels gives the software the information it needs to build the fill. If the result looks unconvincing, try again. The results are not identical each time you run the effect. If the effect seems off, undo with Command-Z and try again.

*The Patch icon on the Tools panel expands
to include four other tools for local repairs.*

When the results look good but require some cleanup, swipe the errors with the Spot Healing Brush. You can enable the brush from the Tools panel (it may be hidden in a fly-out menu) or click Shift-J to cycle through the tools in the fly-out menu. By default, it works as a Content-Aware tool. Change the size of the brush so it covers a somewhat broader area than the area needing repair. Paint over the area to remove, and release the mouse.

If the Spot Healing Brush delivers an unsatisfactory result, try Content-Aware Patch, found in the same fly-out menu as the Spot Healing Brush. (Again, Shift-J cycles to the tool, a square with stitches.) Draw a selection around the target, click inside the selection, move it to an area that looks like the target's surroundings, and release.

Occasionally these tools capture objects close to the selection, creating a weird result. Draw a selection around the area you wish to protect, and choose Save Selection in the Selection menu. This tells the tools to leave that area unmolested.

CONTENT-AWARE MOVE

Photoshop wizards have moved objects in a scene for years. A seamless result demanded careful selections, appropriate feathering, cloning, and healing on a stack of layers. Content-Aware Move reduces that toil to a few easy steps.

To move an object using Content-Aware Move:

1. Draw a selection around the object with the Content-Aware Move tool in the fly-out menu. (It looks like curved arrows.)
2. Expand the selection by 4 pixels: Select>Modify>Expand>4 Pixels>OK
3. Click on the selected object and drag it to the new position. Release the mouse.
4. After a moment when both images are on screen, the original will disappear, replaced by computer-generated fill, and the other will blend into its new background.
5. If the fill or blend is unconvincing, try each of the choices under Adaptation on the Options Bar above the image. If more cleanup is required, Deselect (Command-D) and use the Spot Healing Brush or other tools to fix transitions and artifacts.

CONTENT-AWARE SCALE

To change the aspect ratio—the proportions of a picture—an image must stretch or compress. With Content-Aware Scale, it's possible to transform a vertical image into a horizontal one without apparent distortion. It's also possible to expand the canvas and fill the new space with similar imagery (e.g., expanding the sky). The key is to protect the important part of the image from stretching.

First, select the area you wish to preserve by outlining it with the Lasso tool. Include some of the area around the subject. Go to Image>Canvas Size and expand the canvas as needed. Select the new white canvas with the Magic Wand, and click Delete on the keyboard. A Fill dialog box appears. Under Use, select Content-Aware. Hit Return. If the results are imperfect, clean up the mistakes with either the Healing Brush set to Content-Aware or with the Patch tool.

MIMICKING VIEW-CAMERA MOVEMENTS

View cameras enjoy a number of advantages, among them the ability to tilt and shift the film plane and lens board. These movements allow the photographer to correct parallax and increase depth of field. Some of the technical excellence of Ansel Adams can be attributed to his mastery of tilts and shifts. With digital photography, you can apply these effects in the digital darkroom.

Content-Aware Scale can change the shape of an image by filling a stretched canvas.

First, select the principal object, but not too tightly.

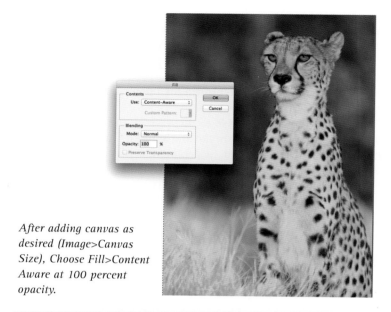

After adding canvas as desired (Image>Canvas Size), Choose Fill>Content Aware at 100 percent opacity.

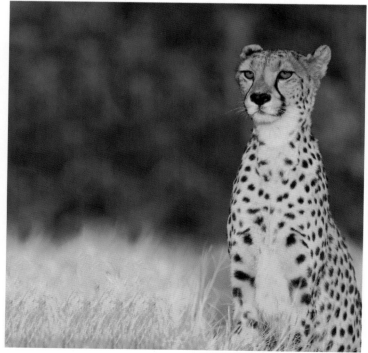

The new canvas is filled with a representation of the background, but the main object remains untouched.

DIGITAL SHIFTS: PARALLAX CONTROL

Parallax is a fancy word for perspective. An object close to us looks bigger than it would farther away. While this seems normal when we photograph a landscape stretching into the distance, it causes distortion in the vertical plane if we tilt the camera. If you take a picture of a picket fence straight on, you will see a series of parallel lines. If you lie on the ground and point the camera up at the fence, the pickets will look wide at the bottom and narrow at the top. Furthermore, instead of remaining parallel, the lines converge. The same distortion occurs when you tilt a camera up to photograph a forest or a ridge of high mountain peaks.

You can counteract parallax distortion by moving the film plane so it becomes parallel to the subject. However, in practice this can prove impossible. The only way to get the film plane parallel to nearby tall trees would be to climb halfway to the top of a neighboring tree. (If you can get far enough away, you could use a longer lens that will let you keep the film plane—or, in the digital case, sensor plane—parallel with the subject.)

The shift movements found on view cameras and on some specialized lenses for 35mm camera systems keep the camera body parallel to the subject as the front of the lens shifts upward to capture the top of the subject. While this technique solves the problem, the lenses are expensive and heavy, and you would need several of them to cover various focal lengths.

In the digital darkroom, you can stretch the top of the image like taffy and restore the parallel lines—in other words, parallax—at your convenience. The computer doesn't know you want to mimic a view-camera shift, so it doesn't automatically adjust the proportions the eye expects between near and far. To look natural, images require both of these adjustments.

The tools in the Lens Correction panel in Lightroom's Develop module provide effective tools for correcting the perspective issues of keystoning (converging vertical lines), barrel distortion (bulging lines), and pincushion distortion (lines bowing inward). Photoshop and DxO offer more controls for superior realism.

LENS CORRECTION

Lens Correction compensates for lens distortion on non-RAW files using tools similar to Lightroom's. It's found near the top of the Filter menu.

The menu opens with the image overlaid by a grid and the Auto Correction tab open. This tool can fix pincushion and barrel distortion automatically if the lens and camera are in the Photoshop database or were previously manually defined. Auto also corrects vignetting and chromatic aberration effects.

Perspective-corrected images need cropping because the borders bow in or out, revealing the underlying canvas. Edge Extension, part of the Edge menu, stretches the image to fill the canvas. This works well for skies and other evenly colored and textured areas but can look wrong in more complex areas. If that's the case, the Healing Brush may be able to create more convincing

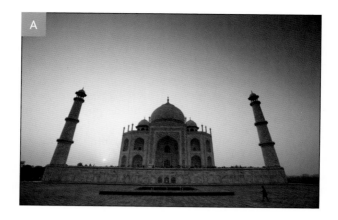

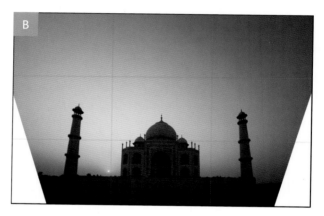

A: Strong parallax distortion forces the minarets to converge. B: After correction, the minarets still tilt. C: Because the tilts were so severe, the image becomes a vertical after cropping.

A: The vertical lines converge before correction.

B: The corrected image is narrower than the original after cropping out black canvas.

fill. I prefer to shoot a slightly wider image so I can crop out uncovered canvas and unwanted image elements later.

The Custom tab offers manual controls. The Distortion slider in Geometric affects pincushion and barrel distortion; chromatic aberration sliders allow for more control over color fringing than Lightroom; and Vignetting works per usual.

The Vertical slider tilts the image to align keystoning lines so buildings don't appear to lean back and evergreens converge at their tops. Horizontal swings the image left and right. Scale prepares the crop.

Lens correction in the RAW editing suite DxO Optics Pro corrects distortion fantastically well, automatically or hands on. DxO offers the feature as a stand-alone product called ViewPoint, which works in Photoshop, Lightroom, or on its own. It performs every perspective and straightening function available in the Adobe products in a slick interface.

Vertical lines converge when a wide-angle lens points up.

Straighten vertical lines either automatically or manually.

ADAPTIVE WIDE-ANGLE FILTER

The Adaptive Wide-Angle Filter, found above Lens Correction in the Filter menu, corrects distortion found in very wide-angle lenses, from fisheyes to 24mm. The filter settings try to present a rectangular representation of a spherical image, a consequence of their wide angle of view. Inevitably, distortion occurs and becomes more apparent when the camera points above the horizon, curving straight lines and stretching circles (e.g., faces). While distortion may serve as a design element, most folks opt for an image resembling what we see.

Unbending radical distortion is a neat trick. It works by constraining curved lines, defining them as straight. Each time a line unbends, the entire image shifts toward the rectilinear. Start with an image without perspective edits. The software depends on lens data in the exchangeable image file format (Exif) metadata to work its magic. Absent that information, the tools fail.

Open the filter. Note that it applies some automatic correction, but not as much as the Len Correction filter—yet.

To straighten curved lines, select one of the constraint tools in the upper left of the screen.

Shift-click and drag across a horizontal straight line. This lays down a constraint, a path that will straighten the curve from point to point. Note that the line curves with the curved line, automatically recognizing the inherent curvature of the lens/camera combination. A mouse click applies the correction and the line becomes straight, reducing the warp of the surrounding area.

Apply vertical constraints next. Shift-click and drag down a vertical component of the image. Add a second vertical constraint. Additional vertical constraints will subtly enhance the image. The vertical constraints affect the area between them, unwarping it.

As the image loses its distortion, it reveals more of the underlying canvas. Zoom in with the Scale slider so more of the image covers the frame. Click OK to apply the filter. Open the Crop tool and drag the handles until no canvas is visible. Hit Return.

The Adaptive Wide-Angle Filter does a more convincing job with images shot on extreme wide-angle lenses than Lens Correction in Photoshop or Lightroom.

FOCUS STACKING FOR INFINITE DEPTH OF FIELD

A view camera can enlarge depth of field by tilting the front or the back of the camera so it becomes parallel with the plane of the subject. You can mimic this effect by blending depths of field digitally. Combine the in-focus elements of two or more images, creating a single image with everything in focus.

Photographers use wide-angle lenses and small apertures to gain maximum depth of field, but there are limits to the effectiveness of this strategy. The smallest aperture of the lens—f/16 or f/22, for example—delivers deeper depth of field than wider apertures, but diffraction effects caused by light bending as

Merging a number of images with sequential focus points delivers perfect focus.

it passes through narrow apertures soften the image. Since depth of field falls away on either side of the point of maximum focus, infinity and the closest foreground may be unacceptably blurred.

These issues arise when shooting extreme macro photographs, when depth of field may extend mere millimeters, even at the smallest apertures. Landscapes with nearby foreground elements demand greater depth of field than any lens can deliver without diffraction effects—or at all.

You can get around the physics of optics by focus stacking. This involves bracketing focus; capturing a series of images of an identically framed scene, each with a different point of focus; and blending the results into a single image. With enough focus points, infinite depth of field is possible using the sharpest aperture of the lens.

Make it easy for the software to align the images perfectly by shooting with a tripod whenever possible. With practice you get a sense of how many images you will need and the optimal distance between focus points. The distance between focus points becomes wider as the distance from the lens

becomes greater. As you learn, instead of taking too few exposures and producing blurred regions, take more than you think you will need and disregard frames you don't need.

Before converting the RAW files, perform any adjustments required—for example, contrast, exposure, lens correction, or dust removal on one image—and then sync those settings to the other images in the stack.

Now you're ready to merge images and allow software to perfectly align them, masking out everything not in focus. You can do this in Photoshop or the dedicated program Helicon Focus.

In Lightroom, go to the stack of images, select all of them, and go to Photo>Edit In>Open as Layers in Photoshop. Photoshop opens a single document with the stack of layers.

If you are unsure that the layers are in perfect registration, Auto-Align before blending the images. Select Auto-Align in the Edit menu. After aligning, go to the Edit menu to select Auto-Blend Layers. Photoshop masks and blends the layers. If small errors exist, work in the layer mask of the problem image to hide or reveal a flaw or missed detail.

Helicon Focus does much the same thing and comes equipped with more tools for enhancing sharpness and smoothing transitions.

TIP	DEPTH OF FIELD

The focal length of a lens combined with its aperture determines depth of field, which is the range of focus. Shorter focal length and smaller apertures increase depth of field, independently or in concert. For any given lens, f/16 produces a greater area in focus than f/2.8, a very wide aperture. Focal length affects depth of field even more. At f/4, a 500mm telephoto lens focused on a nearby object will exhibit only a few inches in focus, whereas at the same aperture, a 14mm super wide angle set on infinity will show the entirety of the scene in focus.

BLACK AND WHITE

Photoshop converts color images to black and white in a single click in the Image menu or by using any number of tools, from Channels to Calculations (don't ask). Clicking on Desaturate (Image>Adjustments>Desaturate) creates a black-and-white version of the color picture. However, this operation usually generates a drab result. Black and White Image Adjustment includes sliders affecting the luminance of the RGB colors, something like color filters used in black-and-white photography. You can enter the adjustments directly—Image>Adjustments>Black and White—or create a black-and-white adjustment layer, which is an editable, nondestructive alternative. Click the half-black, half-white box in the Adjustments window. Go to Window to open Adjustments if it's not visible.

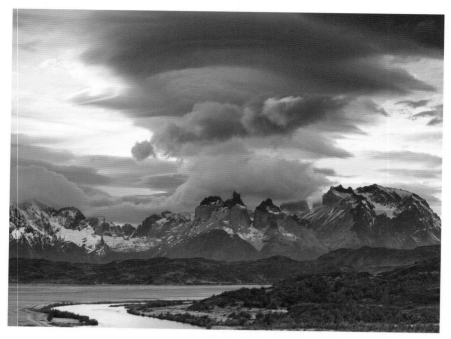

The black-and-white treatment of this image of Chile's Torres del Paine emphasizes tonal gradations, endowing the scene with more drama.

Lightroom's B&W panel found in the HSL/Color/B&W palette of the Develop module offers a larger selection of slider colors. Aperture, Capture One, and DxO RAW editors include analogous tools.

While Lightroom can produce a fine black-and-white rendition and Photoshop (in concert with layer masks and selections) can yield stellar results, Nik's Silver Efex Pro has earned a reputation as the premier black-and-white editing software. It features a powerful set of simple tools for optimizing a black-and-white picture, including selective application of effects. It runs in Lightroom, Aperture, and Photoshop. It can apply global changes or selective changes by area or color. The interface allows for control structure, contrast, and color tinting. The program can open the image as a Smart Object. You may reopen the file after saving to edit any Silver Efex Pro parameters. All the Nik filters use the same kind of interface: an intuitive and powerful set of controls visible on the image as you work.

Topaz B&W Effects offers more preset effects but less sophisticated tools for refining an effect. DxO FilmPack and Alien Skin Software's Exposure mimic classic black-and-white film stocks, including the grain and other peculiarities. If you favor black-and-white photography, apply effects from several programs to optimize an image.

As mentioned, a few digital cameras capture black-and-white images directly, without conversion from a Bayer array designed to capture color. This results in higher resolution per megapixel, all things being equal. Black-and-white plug-ins do a fine job of monochrome image enhancement. Many cameras include a black-and-white setting, but they are in-camera versions of the software conversions.

DIGITAL PANORAMAS

Stitching a sequence of images together on the computer takes the place of dedicated panorama film cameras.

PANORAMAS

Our eyes don't view the world vertically or horizontally; we see panoramas. Heretofore, photographing panoramas required either special equipment or manipulation of the negative or slide. Medium-format 6cm by 17cm cameras, such as the Fuji or the Linhof, cost many thousands of dollars for a body and a few lenses but produce stunning results.

Digital photography allows us to stitch together adjacent images to create a high-resolution panorama with our existing lenses and digital camera. As an added advantage, each element of the panorama adds information and increases the file size and thus the resolution of the finished print.

You can effectively increase the resolution of a low-resolution camera by stitching together three verticals side by side to create a single horizontal image. This image will have more than double the resolution of a single horizontal image shot with that camera. I use this trick when I want to carry my lower-resolution (and much lighter) camera on a hike instead of my brick-heavy main camera body.

This was shot with the Leica Monochrom in a series of six handheld verticals (no tripods allowed at the Taj Mahal). It was stitched together in Photoshop and enhanced with Silver Efex Pro.

If you want to create a true panorama, which is at least twice as wide as a wide-angle shot, shoot three adjacent horizontal pictures and stitch them together in Photoshop. You can also stitch together a series of verticals; however, the file size of your final image becomes quite large. If you shoot several rows stacked one atop the other, file size becomes ridiculous. Large files can be stunning in very large prints.

SHOOTING A PANORAMA

Creating the raw materials needed for effective stitching demands care and luck while shooting. The following are some examples of the difficulties:

- On a windy day, the branches of trees waving in the wind won't line up properly where two images meet.
- A horizontal panorama that covers a large area of sky shot with polarizers can vignette ferociously and require significant tinkering in an editing program to blend the blue.
- If people or animals walk through the shot, they may show up twice in the same panorama; easy to delete with Content-Aware Patch, but the efficient photographer will avoid such a problem while shooting.

Shoot in manual mode. Program, aperture priority, and shutter priority often change exposure from frame to frame, which makes blending the images more difficult. Autofocus can change focus for each exposure. Shoot in manual mode and turn off autofocus. Determine your exposure from the middle of the panorama. This minimizes changes in brightness across the composition.

First, make sure the edges of each picture—at least 20 percent of each image and more with a wide-angle lens—overlap. This will give the program enough common points to align the images correctly.

Second, use a tripod. While it's possible to create a panorama of a series of handheld images, swiveling the camera using the horizontal movement of the tripod head will produce the most common points in adjacent images, which helps Photoshop or another program align the images and also will give you more usable space. When hand-holding, one tends to move the camera vertically, creating areas that will have to be cropped out to create the final rectangle. Using a tripod also yields a larger file—in other words, more information.

Wide-angle lenses are naturally optically distorted. Use 35mm or higher. For the very best results, shoot verticals. The panorama composed of verticals requires more shots to complete, but there will be less optical distortion because you use a longer lens, plus more images mean more pixels for a larger, higher-resolution file.

If you shoot in RAW format, make sure you apply identical settings in the RAW editor by syncing the settings. Turn off Auto Correction and Auto White Balance. Most editors have provisions for applying the same settings from the previous image to the next or to batch-edit a group of pictures. Place the edited images in a folder.

The major editing programs all offer tools for creating panoramas, and a number of plug-ins exist to automate the process. As usual, Photoshop provides several methods for stitching together pictures. Photomerge performs many steps automatically and will yield excellent results if you take care while capturing the image.

USING PHOTOMERGE

Go to Photomerge from Lightroom, Photoshop, or Bridge. In the Library module of Lightroom, click on Edit In under Photo. Select Merge to Panorama in Photoshop. Photomerge then opens in Photoshop. In Bridge, select the images and open Photomerge via Tools>Photoshop. If starting in Photoshop, go to File>Automate>Photomerge. Choose Auto in Layout, click Blend

The expansive panoramic aspect ratio gives a more effective impression of the rice fields in central Bali.

Above: *These images of the midnight sun illuminating Greenland's Ilulissat Ice Fjord will be combined into a single panoramic image.*

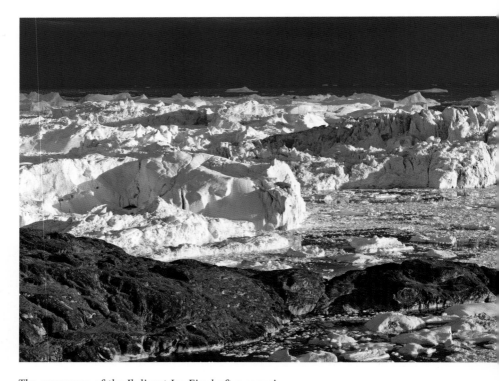

The panorama of the Ilulissat Ice Fjord after cropping.

160

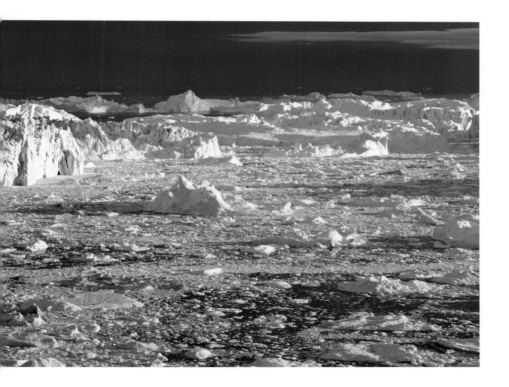

Images Together, Vignette Removal, and Geometric Distortion Correction. Click Browse, find the images you wish to merge, and select them. Click OK. If you shot with enough overlap, Photomerge opens, tiles, merges, and displays the new panorama.

At this point the panorama will have irregular borders. To crop, create the largest possible rectangle that doesn't include empty canvas (i.e., background) by selecting the Crop tool (shortcut C) and cropping out empty space by dragging the tool across the image. If you're satisfied, hit Return to make the crop. This will cut some of the image, leaving a clean rectangular panorama.

Keep a full layered copy as a backup. Flatten the image and rename it so you don't overwrite the editable archive. You can tweak the final image with adjustment layers and layer masks to perfect the file.

DIGITAL STAR TRAILS

A 2-hour star trail shot on digital will suffer from excessive noise, although the very best SLRs do a good job of noise suppression. We can minimize the noise by taking sixty 2-minute exposures and stacking them as layers. The addition of one black layer further suppresses noise. Star trails look best when taken during the dark nights of the new moon.

SHOOTING STAR TRAILS

Snapping a shot every 2 minutes manually for 2 hours is tedious and unnecessary since major camera manufacturers offer combination timer/cable releases to do the work for you. Set the intervalometer for 4-minute exposures with 2-second intervals.

Set the camera to bulb mode. If your widest aperture is f/2.8, set your ISO to 800. With the lens at f/2.8 or faster, select a white balance of 4000° K (adjust 500° or so either way for warmer or cooler looks). Turn off Autofocus, Image Stabilization, Mirror Lockup, and Noise Reduction, which would cause gaps in the trails.

Place the camera on a tripod and focus manually, using the LCD highly magnified if available. Turn off sharpening filters in the camera, which can create unwelcome artifacts. Make sure your batteries are charged. Since digital cameras gobble power, especially when the mercury dips, use a separate battery pack for long exposures. Employ a memory card with room for the files.

Pay attention to foreground and the compass. Star trails in isolation have no context or impact. Silhouettes of cacti, trees, or pinnacles anchor the image. You can "paint" the foreground with a flashlight or a flash to add detail and interest. Cover the light with a colored gel for an otherworldly effect (or wait to do that in Photoshop). If you include the North Star, the other stars will wheel around it.

Take one shot with the lens cap on. You will use this file, a digital dark slide, to reduce noise.

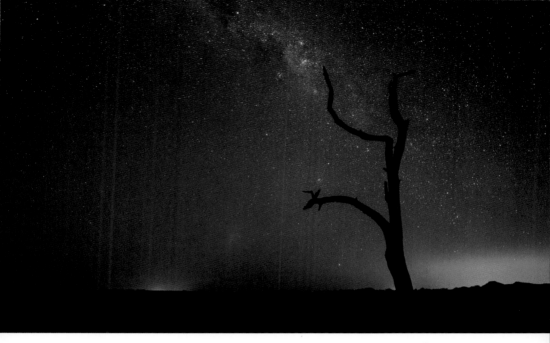

A 20-second exposure was fast enough for sharp stars but emphasized the glow of a distant airport.

ASSEMBLING THE PHOTOGRAPH

After transferring all the image files to a folder on the computer, it's time to assemble the photograph. You can open the images as layers from Photoshop, Bridge, or Lightroom.

In Lightroom, import the images into a folder. Press G for Grid and select the folder. Select one image and press D for Develop. Change the Temperature (White Balance) to taste. Adjust Exposure and Contrast. Perform color Noise Reduction and then apply Sharpening without increasing noise. Reduce color fringing in Lens Correction>Color.

Return to the Grid. Select all images in the folder and click Sync Settings. All the settings will now apply to all images. With the images still selected, go to: Photo>Edit In>Open as Layers in Photoshop.

Select all the layers from the Layers palette. Open the blending mode menu on the palette and click on the Lighten mode.

As the number of images in the stack grows and the resultant star trails lengthen, the advantages of digital long exposures become apparent. With film, long exposures accumulate light scattered throughout the atmosphere. This reduces the contrast between star and background. The Lighten mode in Photoshop selects the brightest pixel from each layer but doesn't add them together. Thus, dark sky remains dark and bright objects get no brighter than they appear on the brightest layer. This means that a foreground won't blow out even if it receives repeated exposure from a full moon, headlights, or some other source.

7

A DIGITAL APPROACH TO SUBJECTS

Opposite: *Leopard, Namibia*

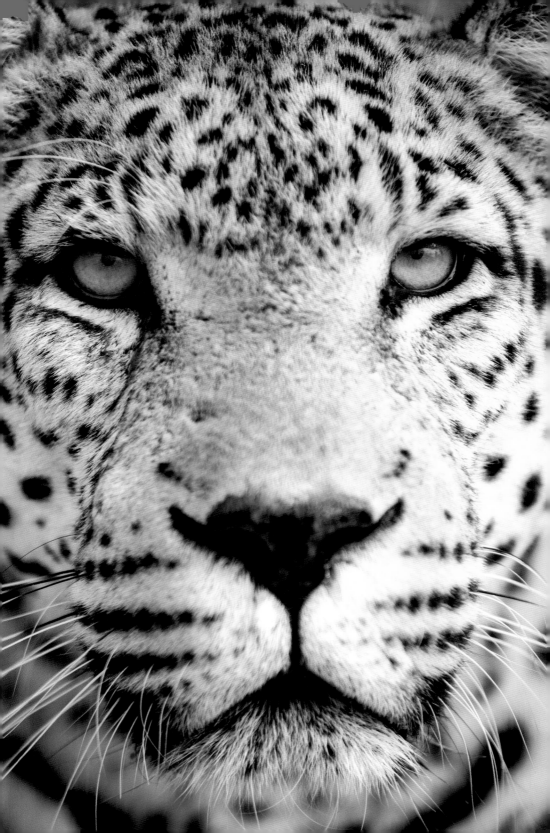

A photographer needs to understand which techniques work best for each subject. A sharp shot of a moving athlete necessitates different shutter speeds, depth-of-field decisions, color temperatures, and so on than does a landscape with a strong foreground element. Equipping yourself with a set of precepts for commonly shot subjects enhances your chances for creating technically proficient images.

THE ENVIRONMENT

Certain situations present consistent challenges and opportunities. Rules of thumb tailored to a subject give us a starting point when we consider how to create the best image.

WATER

Water covers 70 percent of Earth. Unless we don scuba gear, we photograph only its surface, but we should learn to do it well.

Motionless water reflects its surroundings. It adopts the blue of a clear sky or the leaden gray of a dark, cloudy day. It mirrors the surrounding landscape, albeit less brightly. (Use a graduated neutral-density filter to bring tonalities in line.) Often, lowering the angle of view to just above the waterline affords the best view of a reflection.

Last light in the Weddell Sea, Antarctica

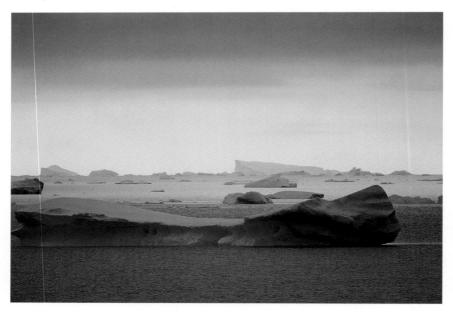

Opposite: *Lower Lewis River Falls, Washington, shot with a neutral-density filter*

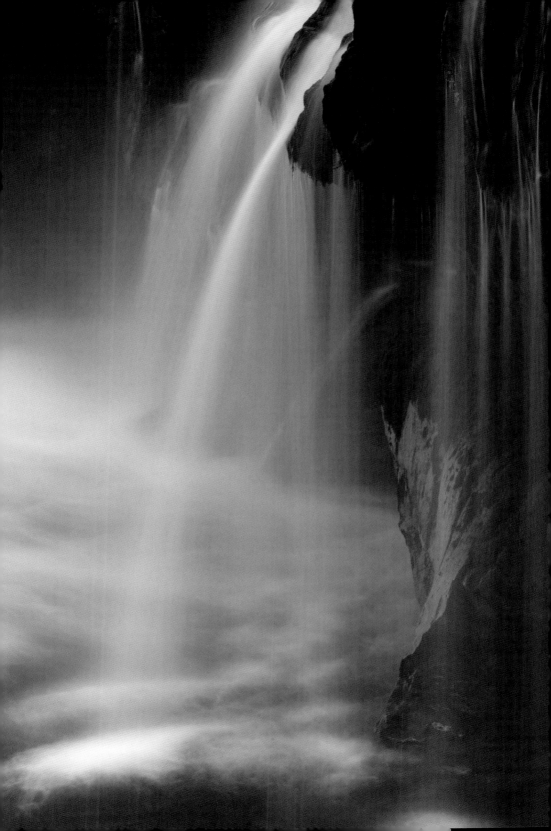

Capturing the dynamism of a waterfall demands the correct selection of shutter speed. A little blurring augments the sense of movement. Too little blur results in a static, crystalline effect, whereas too much obscures shape and internal shadows. The correct shutter speed varies with distance. Shooting a cascade a few feet away could work at $1/250$ second, but that shutter speed would turn a distant cascade to glass.

Experiment to find the ratio of shutter speed to distance to create the effect you prefer. Low-volume waterfalls and moving streams acquire a painterly effect with long exposures. They don't turn into an undifferentiated white, the fate of a furious cascade shot at a slow speed.

DESERTS

Deserts are landscapes stripped of extraneous elements. We find strong designs in rock laid bare. The plants and animals living in these harsh environments develop unusual forms and behaviors, and they stand out in the austere environment. Saguaro cactus in the American Southwest or the spiny forests in Madagascar can look as alien as the set of a bad science-fiction movie. Animal adaptations such as the movement of a sidewinder or the hump of a camel signify "desert" as strongly as a sand dune.

Almost all desert photography occurs near sunrise and sunset. The harsh light of midday, which begins early and ends late, casts distracting shadows and bleaches the colors of the rock. However, during magic light, the rock glows. We can see the reds, yellows, and even blues and greens of naked rock. In many areas, these vivid colors complement powerful forms.

Foregrounds are especially important in the desert. They endow a scene with a sense of depth and break up the uniformity of a monotone landscape. Look for a flower, a large puddle for reflections, or an interesting rock. Using a wide-angle lens, try to fill about one-third of your frame with foreground.

Because we shoot most desert photography when the sun is low, polarizers work especially well. They can cut persistent dust in the atmosphere to let a little more blue through, and they boost the color saturation of plants and rock.

The red sandstone found on the Colorado Plateau in the United States presents unique opportunities. Slot canyons carved by flash floods or intermittent streams abound. Some are a hundred feet deep, narrowing down to a few feet across. In such constricted canyons, little direct light penetrates to the bottom. However, if the sun hits the upper wall of a slot canyon just right, the light bounces into the canyon, red light illuminating red rock. The effect can be quite dramatic. When shooting a slot canyon, take care to avoid getting any directly lit rock or sky in the photograph unless you intend to blend together two exposures to reduce contrast: one exposure for the rock and the other for the highlights.

Deserts take a toll on camera equipment. Try to keep your gear out of direct sun when it is not in use. If you're driving, cover your camera bag with a coat. In extended periods of brutal heat, consider storing your gear in a cooler as you travel. Dust is a persistent enemy. Switch your lenses quickly. Use compressed

A long lens creates a flattened perspective of sand dunes at sunset.

air (but not on the sensor!) to blast dust away. Keep your gear wrapped up as much as possible.

MOUNTAINS

For a landscape photographer, mountains have it all: powerful shapes, vivid colors, clear air. Near the summits, we find restricted color palettes where form dominates. In the highest mountains, winter reigns permanently. In the forests and meadows below the peaks, greens and blues predominate.

Up high, a cooler color temperature prevails. Although we can compensate with filters or by adjusting color temperature in the camera, the blue cast often suits the subject.

The sky adopts a richer blue at higher elevations. Polarizers can easily convert blue to black, so they must be used judiciously. No law says you must use a polarizer at full power. If you want to get rid of glare on a lake without obliterating the sky, twist the ring on the polarizer just enough to minimize the glare.

Fitzroy and Cerro Torre appear briefly in the Patagonian dawn.

Finding a good exposure for snow is easy, but determining an ideal exposure can be tricky. Snow isn't pure white. It has a texture, and that texture is represented in grays. Pointing the camera at snow and overexposing about a stop and a half will produce an acceptable exposure. Average metering produces grayish snow. For an ideal exposure, use the histogram. Take test shots and keep boosting exposure until the histogram starts to rise just left of the right border. This prevents clipping and pulls the highlights down from pure white.

Find ways to lead the eye toward the mountains by using foreground elements such as lakeshores, trails, and fallen trees. Mountains are well suited for verticals and panoramas. Instead of trying to capture everything in a single image—usually a prescription for a muddle—look for compositions embedded in the scene. Try to isolate clusters of strong elements with a long telephoto lens. When a chaos of peaks camouflages a great picture, extract it with big glass.

Don't put away the camera in bad weather. Storms have their own beauty, and some of the most dramatic light occurs as storms break up.

Traveling in the mountains stresses camera gear. It must be protected from heat, cold, dust, and impacts. In the course of a day in the mountains, a pack takes a beating that we would never notice unless we remember it contains expensive and delicate camera gear. Camera gear requires its own water-resistant cases inside a pack.

Even in summer, nights in the mountains can be as cold as winter, and the cold saps battery strength. To keep batteries at full strength, place them

in your sleeping bag while you sleep or slip them into your pocket as you get ready in the morning. In really cold conditions, place chemical heating packets in the case with your batteries. Sometimes heating a dead battery will bring it back to life.

CAVES

Most caves are found in limestone formations around the world. Water dissolves the rock, and minerals in the water precipitate into fantastic forms. Photographers must contend with low light or absolute darkness, which necessitates the use of flash unless the cave's caretakers installed lighting.

Approach caves with lenses of a variety of focal lengths. Stalagmites, fallen rocks, low ceilings, or confining walkways can limit the range of compositions. A wide-angle lens can encompass a large part of a cave; however, such photographs can look chaotic unless anchored by a strong foreground or large design element. Tilting the camera up while using a wide-angle lens makes tall stalagmites appear to converge. In such cases, make sure there is extra space in the frame. When you get back to your computer, you can use the Free Transform command to straighten the stalagmites.

The variable lighting in a prewired cave can highlight interesting forms such as a cluster of stalactites on the ceiling, which a telephoto lens can isolate. A macro telephoto can capture extremely delicate forms.

If light from the entrance or a hole in the ceiling illuminates the cave dimly, long exposures will work as long as no direct light is in the frame. In prelit caves, you can set the white balance on your camera to deliver an accurate rendering of the rock's color, or you can opt for a color temperature that imbues the rock with a specific hue. For example, a white balance set to Daylight (around 5000° K) will add an orange tint. Using the Tungsten setting to shoot a cave lit by daylight adds a blue cast.

A single flash is almost useless for illuminating a large cave because of light falloff. If you have several remote flashes you can trigger from your camera, you can set up a shot. With a single flash, frame your shot with the camera on a tripod, set the camera to bulb mode, trip the shutter, and walk around with a handheld flash, triggering it by hand to paint the rock with light. Try a few test shots to see how far from the rock you should stand. If you're too close, your image will be marred by bright spots. Look for opportunities to bounce light off the wall to avoid areas of overexposure. Experiment with covering your flash heads with colored gels attached with gaffer's tape to create the effect you desire.

Bring a high-powered flashlight to aid focusing in underlit caves. Caves are damp, so protect your gear from moisture.

FORESTS

The complexity of forests and their high contrast on sunny days challenge the photographer's ability to create properly exposed, strong compositions.

A long lens isolates well-lit stalactites in Carlsbad Caverns, New Mexico.

This early morning shot of the upper Amazon Basin, taken in Yasuni National Park, Ecudor, is almost monochromatic.

Cropping changes the character of the composition.

Interlaced branches, heavy underbrush, and the juxtaposition of highlight and shadow bereft of midtones can frustrate the best efforts.

Open spaces created by meadows, ravines, streams, and lakes provide an uncluttered window into the forest. These openings provide opportunities to record conventional views or isolate abstract patterns. A simple row of giant

sequoias cropped so we see only vertical reddish trunks can make a strong visual impression where a more expansive view would have little impact.

Once you are in the forest, foregrounds become critical. A bouquet of ferns occupying the lower third of a vertical composition adds much-needed simplicity. The forest becomes context rather than subject.

Every forest offers plenty of macro opportunities. Tropical rain forests abound with orchids, carnivorous plants, interesting insects, dangling moss, lichen patterns, and bizarre fungi. While less diverse, temperate forests offer analogous opportunities. A hiker enjoying an early season stroll through the sugar pine forests of the Sierra Nevada could encounter scarlet snow plants, unfurling ferns, and the first round of wildflowers. We tend to shoot macro images as if they were aerial views. If we move our point of view to ground level, we enter a different world.

Obtaining a good exposure while shooting in dense forest is tough. If the sun is out, the range between light and shadow exceeds the capacity of any digital sensor. While it's possible to minimize contrast by taking two exposures with the intent of blending them together to bring up the shadows while muting the highlights on the computer, waiting for overcast conditions will produce even better results. The range between light and dark compresses automatically, and midtones become prominent.

Indirect light reduces the glare on leaves, too. However, even with indirect light, some glare is inevitable, especially if the foliage is wet. While our brain edits highlights caused by glare, whereby we think we see a pure green scene, the camera captures every bright point in the picture. A polarizer cuts through the glare to reveal the underlying colors. I can't imagine photographing in a forest without a polarizer.

Some compositions work inside a dense forest on sunny days. Shafts of light slashing through a redwood forest in light fog or a backlit individual tree are classic subjects. For macro photography, use a reflector to bounce a shaft of light toward your subject or to bring the color temperature back to 5500° K or thereabouts to compensate for the blue cast that a clear sky reflects on the scene. Use a flash to balance the light on small-scale subjects.

CITIES AND RUINS

Look for opportunities to symbolize the character of a city. Postcard shots are fine, but better opportunities abound in even the most overphotographed locales. A carnival mask shot in Venice immediately signifies a specific place. Endless photographs of temples, churches, and monuments will send a slide show audience to dreamland; rather than documenting a location, search for images that evoke a sense of the environment. Try to capture action, people being themselves, or characteristic details such as regional food or decoration. Although trying to include too much in an image is a cardinal sin, panoramas provide a fresh view of common scenes. Shoot with parallax correction in mind; in other words, include extra space in the frame to allow for correcting converging lines on the computer.

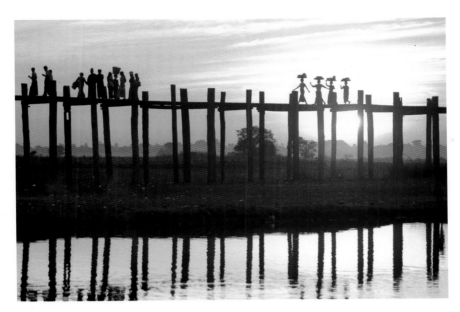

A sunset silhouette emphasizes the structure of the O Bein bridge near Mandalay, Myanmar, the longest teak bridge in the world.

Filters add punch to a Shanghai sunrise.

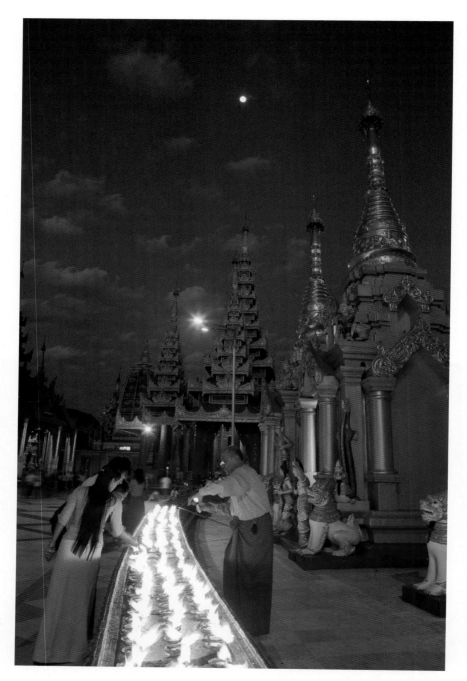

The last blue tints of dusk contrast with the warmth of candlelight at the Shwedagon Pagoda, Rangoon, Myanmar.

As I shot this image, I had no idea that from my position under a bridge in Singapore, the streetlights above would be rendered this way.

NIGHT

Cities come alive at night. Darkness masks smog while streetlights, windows, and neon transform the landscape. However, shooting at night presents challenges. Long exposures generate noise, and moving vehicles and people blur in the frame. Lights with varied color temperatures shift hue unpredictably, and no single capture will record them all correctly. Even so, the results can be dramatic.

Each night two magic moments occur when artificial lights burn brightly while the sky still displays some blue color: about a half hour after sunset and again a half hour before sunrise. The time varies according to position relative to the equator: the shorter the distance, the shorter the interval between sunset and a black sky.

A single red LED in a headlamp was sufficient to light this ruined bank.

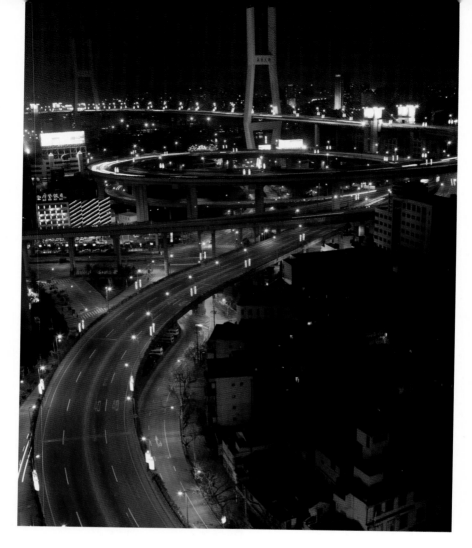

Filters and Curves within Layer Masks control contrast and add color, contributing to the drama in this shot of Shanghai's Nanpu Bridge.

With multiple color temperatures in play, you have two choices. First, you could shoot several identical images, changing the color temperature on each to match all the light sources. Then in the digital darkroom, you could stack the layers and reveal only the proper colors. Or you could do the same thing by creating several versions of the same shot with different color temperatures.

I prefer to leave those techniques to those more obsessive than I. Instead, I take the jumble of color temperatures as a license to use my imagination. The shot of the Nanpu Bridge in Shanghai looked rather drab straight from the camera. I ran Nik's Sunshine filter to shift the color. Then I created a Curves Adjustment Layer and brightened it so the small buildings in the foreground showed up. I used a large soft brush to reveal the changes, leaving most of the

image untouched. Finally, I added another layer with a blue tint and painted it on the bridge with a layer mask. Voilà. The result strays far from the literal, but it conveys the impact that the scene had on me more than the straight capture did.

At night the camera captures light in a way the eye can't perceive. Each light source, from stars and the moon to candlelight or a glowing city, infuses a photograph with a particular character.

When no light is available, bring your own. You can paint a nearby object with a flashlight or headlamp. Car headlights can be used to illuminate a hillside. Cover the light with colored gels or try a tinted LED. Exposure differs with ISO, aperture, strength of the light, distance to the subject, and duration of the painting. Experiment.

WILDLIFE

Digital cameras give a photographer a number of advantages when photographing wildlife but also impose a number of limitations. In some situations, film cameras retain an edge.

Digital cameras' two major advantages are the ability to change ISO settings to accommodate available light and the ability to confirm proper exposure before photographing an animal. When shooting wildlife, we often get one moment to capture magic. If the photographer isn't ready and squanders that moment with poor focus or incorrect exposure, there is no remedy. If 90 percent of photography is showing up, for a wildlife photographer 90

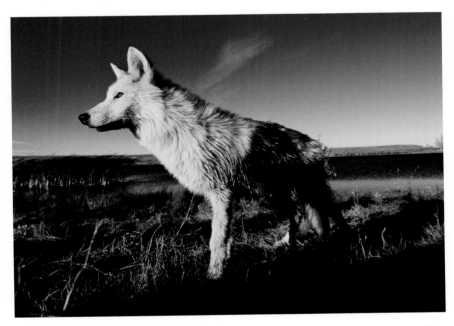

Don't try this in the wild. As a group of captive wolves tore into a deer carcass, this wolf approached, ignoring me as I lay on the ground.

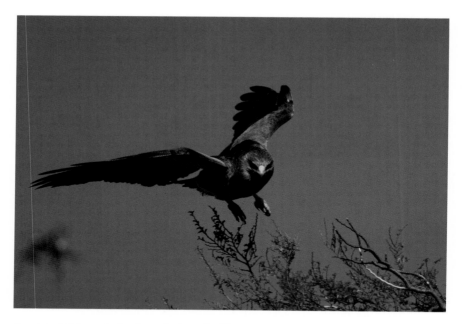

I watched this eagle land on the branch. The next time it flew away, I prefocused on the branch and awaited the bird's return.

percent of showing up consists of waiting. This allows plenty of time for anticipating where animals will appear and taking steps to be ready to get the shot when the moment arrives.

Often we work at the edge of the camera's capability. A moving animal in low light comes out soft or blurred at a low ISO. As lighting conditions change throughout the day, we can bump the digital camera's ISO when heavy clouds block the sun and return to a low ISO in bright light. With a film camera, there's no way to optimize film speed for lighting conditions except to guess how light will change during the day. In very low light, we can make a virtue of necessity by blurring moving animals. A moving herd of zebras or a flying flock of geese shot at a slow shutter speed dissolves into brush strokes that convey motion.

Before photographing wildlife, it's wise to take test shots to confirm proper exposure. Once you have the right exposure dialed in, trash the test shots in-camera. If you carry a backup body, attach it to a different focal length lens and set it up in concert with your primary system. Then you can quickly take advantage of different compositional opportunities as the animal moves.

Make sure the eyes are in focus. Viewers' attention gravitates toward the eyes, and if they look soft in your photo, the entire image suffers.

Don't photograph animals in just one way. A tight portrait can be beautiful, but behavior, context, and detail usually create more interest. Try to anticipate when animals are likely to interact. A baby elephant playing around its

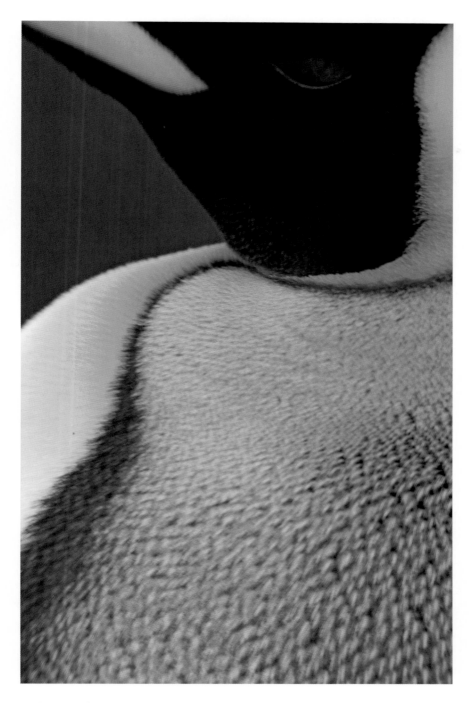

A close-up of a king penguin becomes a study in color, texture, and curves.

I clamped the plant to my tripod to keep it still before shooting the beetle with a macro lens on a medium-format camera.

A caracal cat leaps to a lower branch. With a manual camera, I prefocused on the branch and caught the ideal moment in a single shot. Luck played a part too.

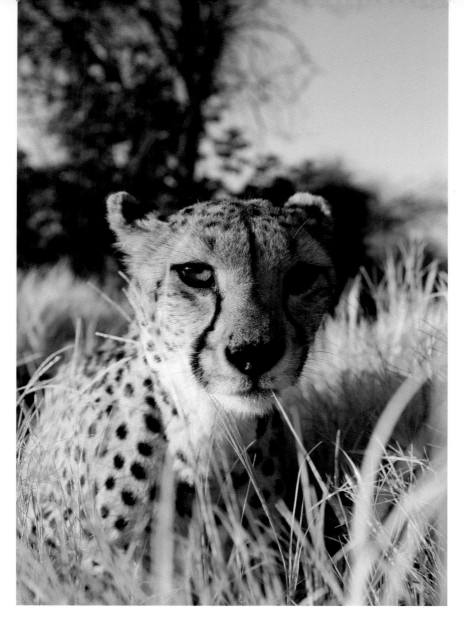

A tame cheetah allowed me to approach within a foot of her face. I shot this image with a wide-angle lens.

mother or a cheetah stalking an oblivious gazelle let us see into the world of the animal as opposed to setting it up on a pedestal. Use shorter focal length lenses so we can see the animal in its environment and get a sense of scale. The principle of "small person, large landscape" applies in wildlife photography as well. Again, this places us in the wild, and the photograph is immediately distinguished from a zoo shot.

If you can get close enough, isolate parts of the animal. The legs and trunk of an elephant divorced from its torso, the pattern of a peacock's tail feathers, or the burning eyes of a cougar force us to look at the animal differently.

Look for groups of animals creating patterns. A cluster of flamingos or a herd of bison can become abstract, Escher-like designs.

Although the charismatic megafauna get the most attention, a photographer who seeks out smaller creatures reaps great dividends. A brilliant chameleon in Africa is as wild and strange as a rhinoceros. The face of a praying mantis close up is as terrifying as an alligator. A macro lens opens a strange and colorful world. Don't ignore it.

Digital cameras do present shortcomings for shooting wildlife. First, the shutter lag on consumer cameras can allow the magic moment to disappear. A lot can happen in half a second. DSLRs don't present this problem. Second, high-resolution cameras can't shoot as many shots in a few seconds as a good motor-drive film-based camera can, with a couple of exceptions: Some professional film-based cameras can fire ten frames per second and burn through a thirty-six-exposure roll in 3.5 seconds. By contrast, my high-resolution DSLR will shoot about three frames per second. After ten shots, the camera must pause to process the files. If you're photographing a running cat, the more frames you shoot in a short time, the more keepers you'll get. There is no way to anticipate the exact moment for a single great shot. Animals don't wait for us to be ready.

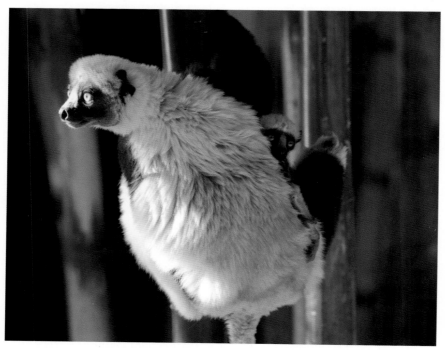

A sunbeam adds extra interest to this shot of sifaka lemurs in Madagascar.

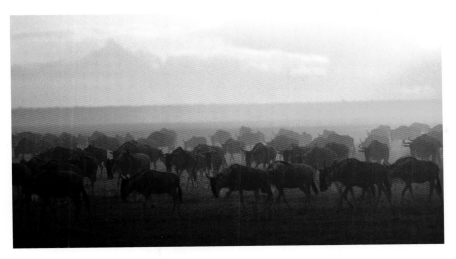

Backlighting from the rising sun and dust kicked up by hooves endow this scene of a herd of wildebeest crossing Kenya's Amboseli Plain with mystery.

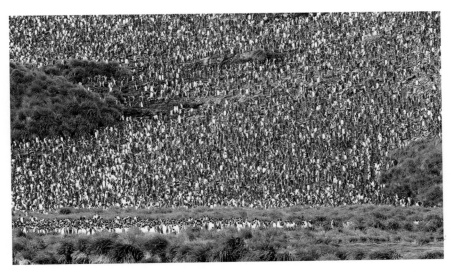

A 500mm lens compresses this image of thousands of king penguins on South Georgia Island's Salisbury Plain.

Remember that we are visitors to the animals' world, both for their well-being and our own. Ideally, don't let critters know where you are. Stay downwind and try to avoid making excess noise or moving where you can be seen. Causing a disturbance can interrupt hunting or grazing, which potentially can cause harm. With some animals, such as grizzly bears or bison, you may be chastised on the spot for bad manners.

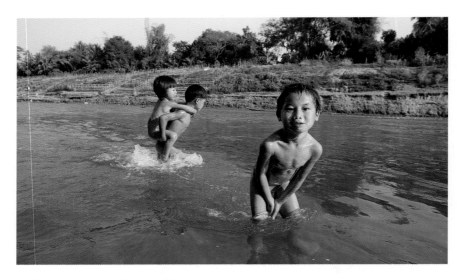

Children play in the Mekong River in Laos. There is not much difference between photographing wildlife and children: Both involve anticipation, action, and serendipity.

PEOPLE

People like to see people in photographs. Perhaps it allows viewers to imagine they are there, or perhaps seeing images of people in the wild mutes discomfort when contemplating the nonhuman world. Certainly, photographs with people sell better in advertising and for editorial uses.

Emotional considerations aside, people in photographs help establish scale. "Small person, large landscape" may be a cliché, but that doesn't diminish its effectiveness. It underscores our true position on the planet while allowing the grandeur of nature to take center stage.

People make good foregrounds as well. The head and shoulders of a hiker looking toward the mountains can anchor compositions and direct the eye toward the primary subject. Blurred feet walking along the trail can accomplish the same thing.

An image of people in action changes the emphasis to the people themselves. A mountain biker jumping off a stone ramp, a rock climber lunging for a handhold, or even a backpacker ambling across a meadow shifts attention from background to foreground.

In backlit or dark conditions, fill flash pumps up the impact of people in the picture. Meter for the background and set the flash at −1 or −1.5, just enough to highlight the person and bring up the colors.

As with running animals, blurs are an effective way to convey action. Experiment to find the correct shutter speed to suggest action without blurring the person excessively. Second-curtain flash—flash that fires just before

the shutter slaps shut—freezes the subject and leaves a blur behind the subject, suggesting motion, the best of both worlds.

Try different angles. Shoot from the ground with a wide-angle lens as a hiker walks past, or shoot down on a climber inches from extended fingertips. Try close-ups such as a climber's hands after a rough route or perhaps a mountain biker's shins and feet covered in mud standing in front of bicycle wheels. Only an unexercised imagination restricts the possibilities.

CLOSE-UPS

The closer the subject, the shallower the depth of field. Macro photographers struggle to get everything in focus. Very small subjects, such as a lizard's face, require the smallest apertures. At the highest magnifications, even the smallest aperture will yield only a narrow range of focus. Make sure the central element of the photograph is in focus. In animal or people photography, concentrate on getting the eyes in focus. Remember that the area in focus will be about the same distance in front of and in back of the center of focus.

Since small apertures go hand in hand with long exposures, flashes are often necessary to prevent the subject's movement from blurring the image. Try to get the flash as close to the subject as possible. This will soften the light and prevent the harsh, specular look of the distant flash. Flash often produces glare a polarizer can minimize.

If adequate depth of field is not possible in-camera, take several exposures of progressively distant focal points and blend the in-focus elements together on the computer as described in "Focus Stacking for Infinite Depth of Field" in Chapter 6: The Power of Photoshop.

A patch of light separates the leopard chameleon's face from a dark background.

PLAYING WITH LIGHT

Photography literally means "representation with light." A painter uses oils, watercolors, or other substances, whereas a photographer uses light itself. Like the painter, there is no reason for a photographer to represent the world literally. We can play Impressionist Master by painting with light using our camera as a brush and the sensor as a canvas.

Play. Toss the rules. Everything is permitted; however, not everything produces an effective result.

BLURS

Blurs suggest motion, mystery, art. One can create blurs by defocusing, panning, smearing petroleum jelly on a filter, blending multiple exposures, or zooming during exposure. Digital cameras greatly increase the chances of capturing an effective blur. You can try a technique, check the results, and try again. With film, you wait at least a day to learn from each failure.

LENSBABY

Since switching to digital, nothing has enhanced my enjoyment of photography more than the Lensbaby. The Lensbaby mimics the effect of the old Holga cameras, which featured inexpensive lenses that blurred most of the image while leaving part of it reasonably sharp. The Lensbaby allows the photographer to control which part of the frame stays in focus by twisting a silly-looking bellows system that allows for shifts and tilts like a view camera.

I walked alongside a group of women in Haridwar, India, while shooting six frames per second with my camera at my hip. Only one shot produced enough definition to suggest human forms, which is what I had imagined.

The Lensbaby blur transforms this shot of counterfeit watches in Bangkok.

Controlling the area of sharpness demands some practice, and maintaining focus for a long exposure is almost impossible. The manufacturer recognized the problem and offers a model that fixes tilt positions.

The Lensbaby 1.0 is very blurry, whereas the Lensbaby 2.0 provides greater sharpness. Changing aperture requires swapping flat aperture rings in the back

Camel thorn trees that have been dead for centuries seem to dance amid the dunes of Namibia.

of the lens. Magnets hold them in place. The price of entry is no barrier. I have filters that cost more than both Lensbabies combined.

PANNING

Most photographers pan horizontally. You can freeze a runner while blurring the background with a fast exposure or blur the subject slightly while turning the background into a wash of color with a slow exposure. A second-curtain flash keeps the leading edge of a blurred subject sharp (see "Flash" in Chapter 1: The Old Rules of Photography Still Apply).

Try vertical pans for vertical subjects. Slight vertical movement during a slow exposure of a stand of trees can create a dreamy effect. I prefer soft, indirect light so highlights don't become distracting.

Finally, there is "straight ahead" panning. Shoot while walking, riding a bike, or moving in a car. This generates streaks on either side of the frame.

A NOTE OF ENCOURAGEMENT

The mechanics and techniques of photography will surely change, and probably with astonishing speed. In the near future, cameras may automate color and contrast optimization while generating infinite depth of field and enhanced focus. We may describe the effects we desire via voice command. The most amazing technology is as yet unimagined.

However, photography is a human endeavor, and its point consists of seeing clearly. Seeing in photography melds imagination and recognition. Once we master technique, or even if we hand much of it over to hardware and software, we can grapple with the challenges of composition and spin our personal visions. And, we can do something magical: We can play. There is joy in creation. Only we have the power to recognize when we've fashioned an image with the power to affect other people, to perfectly convey the moment when the shutter clicked. That is a goal worth pursuing.

GLOSSARY

action: A set of instructions equivalent to a macro in a word-processing program.

aperture priority: An auto-exposure setting in which the aperture remains constant while the shutter speed varies according to light intensity.

Apple Aperture: A RAW editor and database for Apple computers.

artifact: A digitally generated anomaly, such as noise or halos.

average metering: Metering in which all the light in a scene is averaged.

bit: A unit of computer information equivalent to the result of a choice between two alternatives, as yes or no, on or off; derived from binary digit.

bitmap: A digital image for which an array of binary data specifies the value of each pixel.

bracketing: Shooting at least three exposures, including the metered exposure and one or more overexposed and underexposed images, to increase the chances of shooting at least one correct exposure.

byte: A unit of computer information or data-storage capacity consisting of a group of eight bits.

CCD: Charge-coupled device; a photocell sensor arranged in densely packed arrays that records light in digital cameras.

CD: Compact disc; an optical digital storage medium with a limit of 600 megabytes.

chromatic aberration: Spurious color generated by lens imperfections seen on sharp edges in a photograph.

clipping: When the dynamic range of the scene exceeds the capacity of the sensor, information at the extremes (for example, very light and/or very dark frequencies) is clipped from the file.

cloning: Copying a portion of an image and pasting it elsewhere.

CMOS: Complementary metal-oxide semiconductor; a digital camera sensor that uses less energy than other designs, such as CCD.

CMYK: Cyan, magenta, yellow, and key (black); the color space used in the four-color printing industry.

color depth: A synonym for bit depth, the number of bits per pixel. The more bits, the more gradations of color and brightness that can be displayed.

color space: The range of hue, brightness, and saturation of color.

color temperature: The temperature of light, corresponding to the color of a blackbody at a given temperature on the Kelvin scale.

compression: Compression file systems discard redundant data to reduce storage size and then reconstruct the original file when it is reopened. All compression systems, including JPEG, lose some data during the process.

Opposite: *A cheetah yawns in a dead tree.*

contrast: The tonal range between the brightest and darkest pixels.

CPU: Central processing unit; the brains of a computer.

crop factor: The amount of magnification produced by small sensors in digital cameras, generally ranging between 30 percent and 60 percent.

cropping: Either the act of cutting out some of the area of an image or the area of a cropped image.

depth of field: The range of an image in focus. measured in distance from the camera.

diffuser: A device to reduce the intensity and harshness of light.

dpi: Dots per inch; a measure of resolution referring to digital files and printer output.

DVD: Digital video disc; a DVD can store up to 4.7 gigabytes of digital information, almost eight times as much as a CD.

dynamic range: The range of tones that any device that detects a range of frequencies can distinguish.

8-bit: A measure of the number of values (256 for 8-bit) each pixel can have.

Exif: Exchangeable image file format.

exposure compensation: A camera setting that compensates for predominantly bright or predominantly dark scenes that confuse light meters.

f-stop: The aperture setting of a lens.

falloff: A decline in quality or quantity of light.

feathering: Creating a blurred edge on a selection.

fill flash: Flash used to illuminate shadows, usually underexposed one to two stops to look more natural.

filter factor: The amount of underexposure induced by a filter, represented as f-stops.

FireWire: A fast cabling system for transferring files; also called IEEE 1394.

focal length: The length of a lens, measured in millimeters.

focus stacking: Blending together a series of identical images with differing focus points to create greater depth of field than possible from a single capture.

focus tracking: Matching focus as a subject moves, either manually or by using servo autofocus.

Gaussian blur: A blur filter in Photoshop that follows a random distribution defined by the mathematician Gauss.

ghosting: Blurred areas in an HDR image caused by moving objects.

GND: Graduated neutral-density filter, a filter that blocks light from part of a scene without affecting color.

grain: Film consists of chemical grains applied to a transparent surface. Generally, the slower the film, the smaller the grains. Fast film with larger grains produces a pointillist effect. Noise is the digital equivalent of film grain.

grayscale: An image composed of 256 gradations of gray between black and white.

histogram: A graph mapping the distribution of tones in an image; found in editing programs such as Photoshop and on camera LCDs.

A slow exposure turns lights into brushstrokes in the Shanghai tourist tunnel under the Huangpu River.

hue: A synonym for color.

hyperfocal distance: The distance of the nearest object in acceptable focus when the lens is set on infinity. It gives the greatest depth of field for a given f-stop.

incident light meter: A handheld meter that measures light falling on a subject, as opposed to light reflecting from a subject.

ISO: The acronym for International Standards Organization; a standard for rating film speed, which roughly correlates to the ISO settings on a digital camera.

JPEG: The acronym for joint photographic experts group; a compression file format that reduces file size ten to twenty times, expressed in a file name as .jpg.

Kelvin: The temperature scale beginning at absolute zero (−459.67° F), using the same increments as the Celsius scale.

keystone effect: Perspective distortion where vertical elements converge at the top. Common with wide-angle lenses.

layer: A working space in an editing program that can overlay other layers and be merged into a final single image.

LCD: Liquid crystal display; a type of screen found on digital cameras and computers.

lens flare: A bright spot on an image caused by a light source shining on the front element of the lens and then reflecting and refracting through the other elements of the lens.

macro: A lens that allows for very close focusing; in computer language, a set of commands that can be repeated with a minimum of keystrokes.

magic light: Sunlight just after sunrise and just before sunset.

matrix metering: An averaging metering system that uses algorithms to compensate for difficult lighting situations, such as backlighting.

MB: Megabyte, one million bytes.

megapixel: A measure of resolution for digital cameras corresponding to the number of pixels (picture elements) produced by a sensor. Larger numbers correspond to higher resolutions.

memory card: Storage cards used in digital cameras and other devices.

moiré: A shimmering pattern produced when two geometrically regular patterns (such as parallel lines or halftone screens) are superimposed, especially at an acute angle.

noise: The digital equivalent of film grain; also called a digital artifact.

palette: Type of menu in Adobe Photoshop; also, a particular range, quality, or use of color.

panning: Moving a lens to follow a moving object.

parallax: The difference in apparent angle of an object as seen from two different points.

Photoshop: An Adobe image-editing program.

pixel: Shortened form of "picture element," the smallest component of a digital image.

pixelated: Said of a digital image with noticeable "sawblade" edges where smooth lines should be.

platform: The computer architecture and equipment using a particular operating system, usually PC (Windows) or Mac (Macintosh).

plug-in: Software that works in concert with an editing program to perform specific tasks.

polarizer: A filter commonly used to darken hazy blue skies and cut glare on water and foliage.

prosumer: A marketing term (derived from *professional* and *consumer*) describing higher-resolution point-and-shoot cameras.

RAM: Random-access memory; computer memory on which data can be both read and written.

RAW: A lossless image format that requires conversion for use in editing programs; though not an acronym, it is usually expressed in all caps in digital photography parlance.

reflector: A shiny or light-colored implement used to bounce light onto a subject, and which produces a soft light.

resolution: A measure of sharpness and detail in a digital image, corresponding to the number of pixels or lines per inch.

RGB: Red, green, blue; the primary colors used to create all the colors in computer and television monitors.

saturation: A measure of color purity and intensity.

scratch disk: A portion of a hard drive used as random-access memory when file sizes grow too large for existing RAM.

sensor: A photosensitive device, the first step in converting light to digital information in a digital camera.

shutter lag: The delay between pressing the shutter button and capturing the image; a design compromise found in less-expensive cameras.

shutter priority: An automatic exposure mode that maintains a constant shutter speed while varying aperture as needed.

16-bit: A measure of the number of different values a single pixel can exhibit, in this case 65,000.

SLR: Single-lens reflex; a camera design employing a mirror that permits the photographer to focus and meter directly through the lens and any filters affixed to it.

spot meter: An in-camera or handheld light metering system that samples a restricted percentage of the scene.

stitching: Merging several overlapping images into a single picture using tools in a computer imaging program.

Sunny 16: A rule of exposure: for a front-lit subject in full sun, shutter speed should equal ISO at f/16 (e.g., for a digital camera set to ISO 100, proper exposure would be $^{1}/_{125}$ second at f/16 or equivalent).

thumbnail: A low-resolution, usually small (hence the term) version of an image.

TIFF: Tagged image file format; a lossless, platform-independent bitmapped file format, often the preferred file format in the design industry.

TTL: Through the lens; refers to metering light directly from the camera.

USB: Universal serial bus; a standardized serial computer interface that allows simplified attachment of peripherals.

vignette: Light falloff near the margins of the frame, often exacerbated by filters.

white balance: The provision in digital cameras and RAW editors for optimizing color balance for a given color temperature.

RESOURCES

BOOKS

ABOUT PHOTOSHOP AND LIGHTROOM

Evening, Martin. *Adobe Photoshop CS6 for Photographers: A Professional Image Editor's Guide to the Creative Use of Photoshop for the Macintosh and PC.* New York: Focal Press, 2012.

–––. *The Adobe Photoshop Lightroom 5 Book: The Complete Guide for Photographers.* San Francisco: Adobe Press, 2013.

Kelby, Scott. *The Adobe Photoshop CS6 Book for Digital Photographers.* San Francisco: Peachpit Press, 2012.

ABOUT PHOTOGRAPHY

Shaw, John. *John Shaw's Nature Photography Field Guide*, rev. ed. New York: Amphoto Books, 2001.

Wolfe, Art, and Martha Hill. *The New Art of Photographing Nature: An Updated Guide to Composing Stunning Images of Animals, Nature, and Landscapes.* New York: Amphoto Books, 2013.

Wu, Jennifer, and James Martin. *Photography: Night Sky: A Field Guide for Shooting After Dark.* Seattle: Mountaineers Books, 2014.

INTERNET SITES

www.adobe.com: Creator of Photoshop, Elements, Lightroom, and Adobe Camera RAW.

www.russellbrown.com/tips_tech.html: Tutorials and scripts from Russell Brown, the madcap Adobe pioneer.

http://jkost.com/lightroom.html: Julieanne Kost's tips and tutorials on Lightroom and Photoshop.

www.luminous-landscape.com: Packed with how-to articles and reviews concerning digital photography.

www.niksoftware.com/nikcollection/usa/intro.html: How-to videos from the manufacturer of Photoshop plug-ins.

MAGAZINES

Digital Photo Pro (www.digitalphotopro.com) is a publication from Werner Publishing, the publishers of *Outdoor Photographer.* It covers all aspects of outdoor digital photography.

Photoshop User (www.photoshopuser.com) concentrates on Photoshop, other Adobe products, plug-ins, and imaging hardware. I learned about many Photoshop techniques by studying articles on this website.

Opposite: *Uluwatu temple at sunset, Bali, Indonesia*

INDEX

Opposite: *Orion and Sirius over Zabriski Point, Death Valley, California*

A rainbow forms over thousands of king penguins on a South Georgia beach.

ABOUT THE AUTHOR

James Martin has written and photographed for *Sports Illustrated, Smithsonian, Outside, Backpacker, Climbing, Boys' Life, Ranger Rick, Outdoor Photographer, Blue, Audubon, Rock & Ice,* and other publications. He has written many scientific books for children, including *Hiding Out: Camouflage in the Wild* and *Chameleons: Dragons in the Trees* with Art Wolfe. Both were recognized as Outstanding Science Trade Books by the National Science Teachers Association and were Booklist Editors' Choices, ALA Best Book selections, and ALA Notable Books for Children. *Dragons in the Trees* was named the 1992 Outstanding Nature Book by the John Burroughs Association and was a recommended book for children by the Children's Literature Center of the Library of Congress.

Jim also wrote *Masters of Disguise: A Natural History of Chameleons,* the first comprehensive book in English on chameleons. He spent ten years photographing for his books on the mountains of the West, which include *North Cascades Crest, Mount Rainier,* and *Sierra. Extreme Alpinism,* written and photographed with Mark Twight, covers techniques for climbing and surviving the most difficult mountains. *Planet Ice* is a worldwide survey of ice, its beauty, importance, and the threats against it. Getty Images represents his photography.

His travels have led him to Africa, Madagascar, Antarctica, Europe, Borneo, Indonesia, and Southeast Asia, sometimes as a trip leader for Joseph Van Os Photo Safaris. Over the last three decades he has hiked thousands of miles and climbed extensively. He calls Seattle home between adventures.

Next page: *Mount Garibaldi and Garibaldi Lake
from Panorama Ridge, British Columbia*

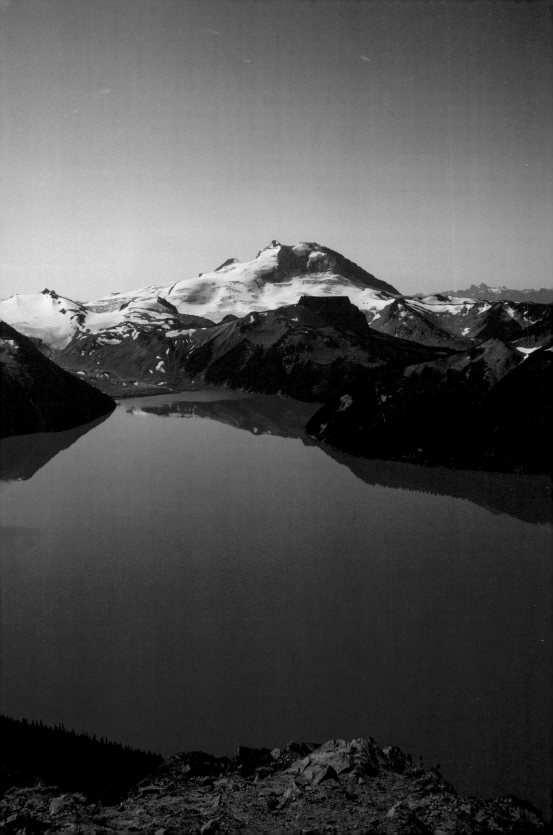